east anglian coast

east anglian coast

david brandon

AMBERLEY

First published 2012

Amberley Publishing
The Hill, Stroud
Gloucestershire, GL5 4EP

www.amberleybooks.com

Copyright © David Brandon 2012

British Library Cataloguing in Publication Data.
A catalogue record for this book is available from the British Library.

ISBN 978 1 84868 256 6

Typesetting and Origination by Amberley Publishing.
Printed in the UK.

Contents

Introduction 7

1 The North Sea 9

2 The Norfolk Coast 15

3 The Suffolk Coast 50

4 The Essex Coast 92

Introduction

This book takes the reader on a journey along the coasts of Norfolk, Suffolk and part of Essex. It starts at King's Lynn and finishes at Burnham-on-Crouch. The author is aware that there is more maritime Essex beyond Burnham but he does not feel that Southend, Westcliff and Leigh-on-Sea, for example, qualify as being in East Anglia, whereas Burnham still has some residual character typical of that part of the country.

This book is emphatically not a guide book, a history or a treatise on the buildings of architectural interest to be found along the coast. After all, who could compete with the magisterial Professor Pevsner in his *Buildings of England* series? These provide a far more learned and comprehensive coverage than the author could ever aspire to. Instead, he tries to visit most of the places along the coast and some actually a distance inland that have strong associations with the sea.

So the book looks at some of the topographical features, mentions examples of people associated with these places and nods towards the economic, social and cultural developments that have taken place. It attempts to understand the events of the past and, where possible, to find meaning, humour and humanity in them. The coastlines of the three counties are very different in character, part of the extraordinary diversity which is such an attractive feature of the collection of islands making up the United Kingdom. This book attempts to celebrate that diversity. The author was neither born nor brought up in East Anglia but he has come to know it well and it is hoped that his affection is evident in what follows.

chapter one
The North Sea

The North Sea maintains a massive presence along the whole of this coast. Until the eighteenth and nineteenth centuries it was also referred to as the 'German Ocean' and the 'North Sea' is a comparatively recent introduction. It was a liquid highway along which travelled vast amounts of trade, especially during the heyday of the Hanseatic League. More will be said about this shortly but the League was an extremely powerful confederation of traders and merchants in ports in the North German states and around the Baltic. The League dominated the large and lucrative seaborne trade between Britain and the countries of Northern Europe. Several English monarchs actively encouraged the League and it established bases in a number of East Coast towns including Ipswich and Yarmouth.

Several things are rather unusual about the coast of East Anglia. It has a very different atmosphere from any other part of Britain's coastline. The prevailing wind is from the north-east and this serves up cold winters and bracing springs. The coastlines are low and there is a particularly strong quality of light where the land meets the sea; this has been appreciated by thousands of artists over the centuries. It is a coastline of erosion and of deposition. The erosion is currently most marked between Cromer and Great Yarmouth and from Lowestoft to Aldeburgh. By contrast, spectacular deposition has taken place, for example, at the suitably named Shingle Street. Given the proximity of its people to the sea and the erosion that has occurred, it is not surprising to hear stories of bells ringing from the belfries of churches long since gone beneath the waves. There are also fanciful stories of bearded mermen and entrancing mermaids that have managed to get themselves entangled in fishermen's nets. The coastal waters contain many shipwrecks because this coast, which can often look so tranquil, has not only got treacherous reefs offshore but can produce mountainous seas making them extremely hazardous for mariners. The coast of Essex is different from that of the rest of East Anglia. Parts of it are riddled with mudflats, islands and brackish creeks which exude, to those who know them, a strangely likeable but indefinable sense of loneliness and bleakness. Some have likened it to a Dutch landscape and, indeed, the Dutch have made an impression on this coast when, for example, Joas Coppenburgh from Holland carried out the reclamation work that created Canvey Island. The complex indentations of much of this coast have compelled the main roads and railways to stay further inland and have contributed to the sense of isolation and dependence on the sea of numerous small Essex coastal communities.

Throughout much of the past, while many of the people who inhabited the coastal regions of East Anglia may have obtained their living from the sea, they would have regarded it as a largely hostile element. In places it was literally eating away at the land

and on occasions it assaulted the coast with unspeakable ferocity, causing damage, destruction and death. The grey waters of the German Ocean were unpredictable, hungry and inhospitable and from time to time they provided the route along which foreign raiders, invaders and pirates appeared and proceeded to plunder, rape and pillage. The modern idea that the coast was an amenity to be enjoyed for its fresh air, its scenery and the opportunities for leisure and recreation that it offered would have been considered nothing less than absurd and literally fantastic by our distant ancestors.

At one time the North Sea was an inland lake because of land bridges linking what eventually became Britain with Scandinavia and Western Europe. Later on, around 300,000 years ago, most of it was covered by a polar ice sheet. About 7,500 years ago, what are now the Straits of Dover were breached and the North Sea grew considerably, much of its southern parts having previously been dry land. One important feature of the North Sea is that it is shallow. Going northwards, only when the Shetland Islands are reached does it exceed a depth of 100 fathoms. The area of the Dogger Bank is particularly shallow.

The shape of the North Sea has rendered it prone to disasters. When the Atlantic Ocean is experiencing severe weather conditions and if these are combined with high spring tides, the shape of the North Sea is something like a funnel and what is displaced can flood low-lying parts of the East Anglian coast. The most memorable time it has done this within living memory was of course in 1953 when around 300 people died. Yet for all that primeval violence there is serenity and beauty on this coast. It attracts large numbers of migrant birds to its rich feeding grounds in that firmament of which it has so much – mud. There are large areas of reeds which are cut to repair or re-roof some of the most prototypical and idyllic country cottages to be seen anywhere. Children gather cockles, lobster pots and fishermen's nets decorate salty quays, and church towers – some of them of imposing size – punctuate the skyline and give a vertical accent to what is mostly a flat landscape which seems to contain an abnormal amount of water and sky.

As mentioned, the North Sea has been the route by which many invaders have arrived on these shores. Some came firstly as raiders who plundered easily accessible coastal settlements and then headed back across the sea with whatever booty they could grab and carry away. Some came as raiders and, liking what they saw, decided to settle. In doing so, they radically changed existing ethnic and cultural patterns. Very significant Germanic and Nordic elements took root and in doing so they tended to push the Celtic elements of the population to the more westerly parts of the British Isles. It was from the melting pot consisting of these major and some other minor elements that a distinctive English language developed which proved strong enough to survive the later imposition of Norman-French.

Attacks on the East Anglian coast began during the Roman occupation. Invaders included Saxons, Angles and Jutes. Those that settled tended to develop a lifestyle based on agriculture and perhaps fishing but then, no sooner had they settled down than they suffered the unwanted attentions of later aggressive raiders and invaders. The Vikings and Norsemen were doughty mariners who took their tiny vessels as far as the Mediterranean and across the Atlantic to North America. When they came to the

Anglian shores, they employed a kind of *blitzkrieg*; They appeared over the horizon, swiftly ran their ships onto the beach or sometimes penetrated far up navigable rivers, homed in on any places that looked as if they had worthwhile spoils, grabbed what looked valuable and was portable, set fire to anything easily flammable, attacked anyone who got in their way, left them for dead and then, groaning under the weight of their booty, disappeared from whence they had come. Both they and their vessels looked terrifying and the speed with which they conducted these attacks gave the natives very little time in which to secrete themselves and their valuables. The raiders seem to have had an understandable penchant for seizing and carrying off toothsome Saxon wenches.

Over time what started as purely raiding sorties evolved into permanent settlement. At first the newcomers would tend to find an easily defensible site near navigable water, fortify it and then use it as a base from which to plunder the surrounding countryside, and to either kill or browbeat and cow the inhabitants. Over generations, such hostile settlers themselves became part of the ethnic mix which was the population of the eastern counties. The invasions of Britain by the Romans, Anglo-Saxons, Danes and others all served to build trading links with the countries of the Continent. One commodity which in medieval times headed the list of exports from England to the Continent was English woollen cloth, particularly raw wool. Other items featuring largely in exports were grain and animal hides. Lynn, Yarmouth and Ipswich were the major ports dealing with these commodities.

The development of amicable and beneficial trading relations inevitably meant that people from the countries involved settled in this country and especially in Colchester, Norwich, Ipswich and Lynn. They were not generally accorded a friendly reception. On occasions they were subjected to official discrimination. Some of them were already, and others quickly became, very wealthy. This meant that sometimes they found themselves regarded as something of a milch cow, being required from time to time to stump up extra taxation. This discrimination usually lasted only for a generation or two after which time social and cultural assimilation took place. An exception was often Jewish immigrants. They were an easily identified minority and there were various reasons arising from the specific historic conditions of the time explaining why they were disliked. The history of their lives in medieval England is, at best, a mixed one. Certainly it was not one that natives of longer standing should necessarily be proud of.

In the fourteenth century, the Hanseatic League or 'Hansa' had a profound effect on the ports of East Anglia. The Hansa was a confederation of north German and Baltic seaports partly formed to cut out wasteful competition but mainly to enjoy a mutual strength within the League which enabled them to dominate and almost monopolise international trade and commerce around the seas, coasts and ports of the then German Ocean. The Hansa became powerful enough to operate economic sanctions and even to take naval action on those occasions when its position was challenged. It had substantial influence over the commercial activity of the major East Anglian ports. The Hansa only went into decline during the reign of Elizabeth in the second half of the sixteenth century. England began enriching herself through exploring far parts of the planet and opening up a hitherto undreamt-of range of trading possibilities in other parts of the

world, which tended to make the Hansa increasingly irrelevant. As the Hansa waned, so the Merchant Adventurers of London took on some of its role. This was a grouping of merchants based in London and it received various privileges through royal charters in 1486 and 1505. It became England's main overseas trading body, possessing, rather like the Hanseatic League, a number of overseas headquarters known in this case as 'staples'. Notable among these staples were Antwerp and Hamburg. The main thrust of the Merchant Adventurers activity was the cloth trade to Germany and the Netherlands. They went into decline in the seventeenth century as monopolies became unfashionable because of the rise of capitalism and its associated theories and practices of political economy.

Even in the Middle Ages, the East Anglian coast remained extremely vulnerable to seaborne malefactors. Pirates from the Low Countries, from the German states, Spain, Scotland and also elsewhere in England, operated with almost total impunity. They frequently captured ocean-going and coastal shipping and hauled them away as prizes or seized their cargoes, often burning their hulls if they were considered useless because they had no commercial value. They sailed into ports, causing havoc not only with shipping but often in the towns around the ports as well, looting and burning as they went. During periods of officially declared war, enemies employed privateers. These were basically pirates but they carried a licence issued by the government of the belligerent country involved which allowed them to plunder enemy shipping at random so long as they turned an agreed percentage of their profits over to the government. A Royal Navy did not exist in the Middle Ages, nor was there a standing army, and therefore England with its long coastline was very vulnerable to attack of these sorts.

It is hard for us to have any conception of how important herrings and cod were to our medieval ancestors. Both fish existed in quantities to baffle the human imagination, but despite the availability of so much fish, English fisherfolk were frequently on very poor terms with their Dutch counterparts. The latter always seemed to exceed the English in the quality and durability of their fishing boats and in the skill with which they salted and pickled the fish they caught. The Dutch were the people that the English loved to hate and their presence fishing off the coast was greatly resented. Occasionally, Dutch ships, fishermen or their catches would be seized by the English and then the Dutch would strike back in a kind of rehearsal of the so-called 'Cod Wars' of more recent years.

Until the second half of the nineteenth century, East Anglia's fishing industry was largely inshore and small-scale, working out of innumerable tiny coastal communities and just supplying local demand. Fish were caught by gill nets and hook-and-line. However, from the 1830s larger boats called fishing smacks came into use and the industry began to be transformed as much greater capital needed to be invested in more expensive boats and equipment. Now trawl-gear was dragged along the sea bed and this provided the opportunity to secure far larger catches. It was the coming of the railways which provided the incentive for an even greater capitalisation and the transformation of the industry along modern lines. Fish is, of course, highly perishable unless preserved by smoking or salting. The railways enabled huge catches of fresh fish to be placed in ice and swiftly moved from the fishing port to the large urban markets. In East Anglia, Lowestoft benefited most. Trains carrying fish ran at express

speeds, particularly to London. The availability of cheap, fresh fish in London and other urban areas effected a huge improvement in the diet of the working classes. It was also a major factor in the spread of that British culinary marvel, fish and chips. The efficient industrial scale of operations at Lowestoft meant that fishing based at places like Harwich or Southwold remained largely inshore and small-scale, catering mostly for local demand and the holiday trade.

A well-known feature of the herring industry was the migration of the shoals down the east coast. The preparation of the herring for salting was carried out by a small army of Scottish fisher-girls. They stayed at and worked in the various ports along the East Coast at which the herring was landed. The words that come to mind to describe these women could include 'feisty' and 'robust'. When several hundred took up temporary residence in Lowestoft, for example, they must have had an electrifying effect in the pubs and clubs when they went out on the town. Those girls worked hard and played hard.

The herring industry is all but defunct. Culinary fashions change and herrings are no longer as prized as they were despite their growing rarity. Oily fish like herrings and mackerel do have certain health benefits and while they are strong on taste, cooking them takes time, can be messy and creates smells; however, they knock gastronomically illiterate concoctions like fish fingers into a cocked hat. There is still a lot of herring in the North Sea but most of it is caught by Dutch and German vessels. They process it for fish meal and various oil extracts. For the table, mature fish are needed. Most of the herring caught these days are small but size does not matter so far as processing is concerned.

Fishing still takes place off the coast of East Anglia, as it has done since time immemorial, of herrings, various white fish including demersal varieties, and shellfish. Cromer is rightly renowned for its crabs. However, the East Anglian fishing industry is now small-scale and sustainable, the people who work in it mostly do so part-time and the equipment needed is not prohibitively expensive.

Before the building of the canals and the railways, rivers and the open sea provided the easiest way of transporting goods over long distances and, for that reason, the coastal trade has a very long history. In the seventeenth century, it was reckoned to be up to twenty times cheaper to send goods by water than by road. The East Anglian coast had few large rivers but it was often possible to navigate small seagoing vessels upstream to places like Colchester, Ipswich and Woodbridge.

The men in the coasting trade were engaged in a particularly hazardous occupation. They were exposed to the attentions of pirates at all times, along with privateers and enemy vessels during wartime. The North Sea has innumerable navigational hazards and these were doubly threatening for those vessels whose business meant that they hugged the coastline. The North Sea is notorious for its tidal ranges, hidden shoals, and its extreme and sudden changes of mood. The east winds which are such a feature of East Anglia turn the coast into an exposed lee shore. These hazards were such that the sturdy little collier ships which passed down the coast carrying coal from Northumberland and Durham to London often stayed in harbour during December, January and February. When they did so, there might be a crisis caused by coal shortage in London. Of course many ships paid the price of defying the North Sea and a sailor in

1676 left a diary in which he stated that 'the sea is so full of wrecks on these coasts that those at sea are forced to look sharp to steer clear of them'. Many mariners preferred the more predictable hazards of a long haul to the East Indies, for example, to a winter voyage down the East Coast of England.

Over the centuries, navigation became somewhat safer. In early times, however, ships hugged the coast because of their almost total lack of navigational aids. We must admire the courage and skill of the men on board tiny medieval coastal vessels feeling their way down the coast on a dark and stormy night, visibility almost zero. Sometimes the only way to try and establish the ship's whereabouts was by heaving the lead and then examining what was brought up from the sea bed in the tallow on the bottom of the lead. Early charts were notoriously inaccurate but heaving or swinging the lead as a method of establishing the ship's whereabouts required an extremely intimate knowledge of the sea bed.

Contrary to a facile model often put forward, history does not move in cycles. When something superficially similar occurs again, the circumstances and conditions have moved on, and so the event, despite appearances, is necessarily different. What is basic to the historical process is change. Nothing is ever static. We can see this with the volatile state of the coast, being eaten away here and growing somewhere else, often quite close by. Change can also be seen so far as the trade, the shipping, the passenger traffic, the fishing and the naval activity along the coast are concerned. In the Middle Ages, East Anglian ports thrived on the busy trade with Scandinavia, the Baltic and north German states. Later on the major thrust was the development of colonies and trading relations, many of which were in the western hemisphere and this meant that ports like Bristol, Liverpool, Glasgow and Whitehaven enjoyed a heyday while those in East Anglia were relatively in the doldrums. Since the 1990s and with the move towards European unity, the surviving ports of East Anglia have been on a roll, blessing their geographical location.

Even phenomena that appear to be constant are actually in a continuous process of change. For four centuries ferries have crossed the North Sea to the Low Countries but the size and the technology of the ships concerned have changed out of all recognition. Spritsail barges once plied the coast in huge numbers, a workaday, mundane and largely unnoticed sight. Anyone could have been excused for thinking that they would remain in use forever. They had broad, shallow-draft hulls which made them ideal for negotiating the shallow coastal waters and the creeks and rivers where trade took them. They carried such unglamorous cargoes as bricks, hay and foodstuffs down to London and returned with, among other things, a load even less glamorous; horse dung, to be used as fertiliser on East Anglian fields. Advancing technology has rendered these barges obsolete for commercial purposes but who on earth, in the days of their prime, would have imagined that dozens of these vessels would survive, lovingly preserved? It would have seemed even more fantastic that these barges which are now regarded as cherished relics of the past should be involved in races for fun, manned by enthusiastic amateur sailors. Is the author alone in thinking that craft like spritsail barges were actually more interesting when they were engaged in the seemingly mundane commercial tasks for which they were so effectively designed?

The Norfolk Coast

Our journey starts at The Wash which is a great, roughly u-shaped, shallow inlet separating the marshland of Lincolnshire from the shingle banks and sand, dunes and salt marshes of north-west and north-east Norfolk. The saltings, creeks and marshes attract a wealth of wild life and there are many nature reserves. The generally flat littoral gives way to low cliffs at Hunstanton, Sheringham, Cromer and beyond, but the cliffs are crumbling under the North Sea's relentless assault as this is a highly vulnerable stretch of coastline which is eroding and retreating rapidly. In many places the dunes are held together by marram grass but it is very clear that it would only require one or two great storms to effect major changes in the configuration of the coast. The shoreline now becomes a distinctly more southerly one as it approaches the sizeable urban settlement consisting of Great Yarmouth and Gorleston-on-Sea.

North-east Norfolk has become very fashionable as a place where rich Londoners, in particular, buy up second homes or where they sometimes retire. The spending power they generate is reflected in house prices and the kind of cuisine available in local eating-places as well as in many shops in places like Holt, for example. North-east Norfolk is now 'sought-after'.

King's Lynn

King's Lynn has in the past been called 'Lynn Episcopi' and 'Lynn Regis' but for much of the time it has simply been called 'Lynn' and is still known as such locally. The origin of the town probably lies with a small fishing settlement on the bank of the River Ouse close to where it enters the sea. At the end of the eleventh century, St Margaret's church and the priory had been founded by the Bishop of Norwich (hence 'Lynn Episcopi') and a Saturday market had been established. In 1204 King John granted the town a charter. The population was growing and a suburb was developing just to the north of the main settlement around what was then the chapel of St Nicholas. A second marketplace was laid out with rights to do business on a Tuesday. The presence of these markets was crucial to Lynn's growth and assisted it to grow into a regional centre, a function it still performs. In 1536 the Crown appropriated Lynn which then became Lynn Regis or King's Lynn.

The major source of Lynn's prosperity, apart from its function as a market town, lay in its role as a seaport trading in large quantities of wool and cloth; particularly with the north German states and the countries around the Baltic. In 1271 the Hanseatic League established a base at Lynn. The sheep were reared on rich pastures nearby that

had been reclaimed from the sea. The cloth was manufactured in East Anglian villages and towns. Other exports included salt and grain. Corn exports were of particular importance in the eighteenth century when Lynn enjoyed what was probably its heyday. Imports coming through the town included Baltic timber, wine from France and coal from pits around the River Tyne. Lynn benefited from the network of waterways which enabled these products to be carried deep into its hinterland. In the nineteenth century, Lynn was a significant whaling port. Old imports died away to be replaced by timber and also phosphates and potash. These provided raw material for the manufacture of artificial fertilisers. Coal brought to Lynn by rail became another export. Glass-making was a significant local industry.

Modern King's Lynn is the third largest town in Norfolk and the natural regional and trading centre for much of the Fens and north Norfolk. It is also still a port of some significance handling continental and coastal shipping. In order to create a port, the course of the River Ouse had to be straightened in 1850 and two wet docks were built. The first was Alexandra Dock in 1869 and then Bentinck Dock in 1883. These works were expensive but they have proved to be an excellent investment. Before this work was done, ships tied up at open wharves along the river bank. Evidence of this practice can be seen is the fine Custom House on Purfleet Quay, built in 1683 with stone brought down the River Nene from Northamptonshire. The architect of this well-known building, Henry Bell, is a figure of some significance in Lynn's history. He was the mayor on two occasions and an amateur architect of some virtuosity as this delightful little building shows very clearly. For some time its future was in doubt but now, happily, it acts quite appropriately as the Tourist Information Centre.

Lynn has some of the very worst 1960s to 1980s types of town centre architecture: ugly, banal and insensitive to its historical surroundings. It has all the usual tediously drab high street chain stores and shops which reduce town centres across the country to

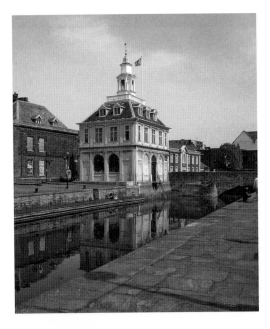

The Custom House.

uniform mediocrity. It also has some very shabby streets close to the centre; but for all that the town is extremely rewarding for the investigator prepared to make the effort and to take time to walk the alleys and streets away from the modern retail area. Lynn has impressive medieval churches and various monastic remains and also street after street containing, among others, superb merchants' houses and humbler buildings indicative of the town's purpose and prosperity in late medieval and early modern times.

One of the choicest of Lynn's buildings is the Duke's Head in the Tuesday Market Place. This originated as a townhouse built by the aforementioned Henry Bell for John Turner who was a prosperous local businessman and patron of the arts. The building is of brick covered with high quality plaster. It is a pleasantly atmospheric old town inn and hotel which exudes a comfortable sense that it knows it has played an important role as a centre of social activity in King's Lynn for very many years. Close by is the imposing Corn Exchange.

Leading off the Tuesday Market is St Nicholas Street which contains many medieval houses and takes the walker to the church of St Nicholas. This was originally a chapel-of-ease to St Margaret's, the main church. A chapel-of-ease was essentially a subordinate place of worship acting as an outstation for a parish church and performing many of the same functions but on a reduced scale. The fabric of St Nicholas's dates mainly from the fifteenth century. It possesses a richly ornamented south porch, an angel roof and fine east and west windows. It acts as a venue for musical events during the annual Lynn Festival, held in July.

South-west from the Tuesday Market Place, running parallel to the river, is King Street which contains St George's Guildhall. This was probably built in the fourteenth century. It was once a theatre in which William Shakespeare may have acted. Subsequently it went through other uses but happily it became a theatre once more and is the centre for the important Lynn Festival. Queen Street is the continuation of King Street and it also possesses many fine domestic buildings including Thoresby Hall, a brick house with Gothic doors built in 1500 for the thirteen priests of the Trinity Guild. Queen Street contains a connected complex of buildings including the Town Hall, the Guildhall, the former gaol and also the former Assembly Rooms. The

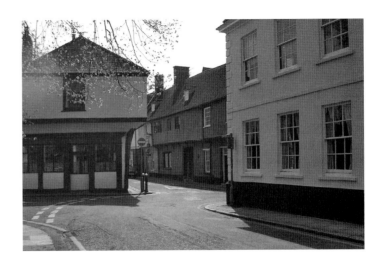

A corner of old King's Lynn.

Guildhall, which is a reconstruction of 1421, is particularly striking with its superb use of flint and freestone to produce an effect like a chequer board.

The earlier importance of the town is clearly indicated by the scanty remains of no fewer than four monastic establishments. There is the Lantern Tower of the Greyfriars, the gateways of the Whitefriars and the Austin Friars and a street named after the Blackfriars. The old South Gate to the town survives in London Road. Lynn was a walled town. This gate is close to a former pub, The Honest Lawyer, the sign of which portrayed a man with his head tucked under his arm and showing some legal accoutrements. This sign is indicative of a healthy scepticism and belief that the only honest lawyer is a dead one. There are a few traces of the old town walls. The town was stormed by Parliamentary forces in 1643 during the Civil War and, after a fierce defensive effort and equally violent bombardment, it eventually had to surrender. In St James's Park, or the Walks, is the Red Mount Chapel. It was built in 1485 as a stopping-off point for pilgrims passing through the port of Lynn on their way to or from Walsingham. The building is small, octagonal and has three floors. Its upper floor has fine fan-vaulting resembling a smaller version of King's College, Cambridge.

The Saturday Market Place is dominated by the bulk of St Margaret's church with its two eye-catching towers, visible in many distant views of Lynn. This was founded in the twelfth century and contains work from all periods since, including a nave, much of which had to be rebuilt in the 1740s after a storm caused the old steeple to collapse and fall down onto it. Two of the finest and most important memorial brasses in England can be found in this church. They are those to Adam de Walsoken and his wife, 1349, and Robert Braunche and his two wives (he was not married to them at the same time) in 1364. They are represented life-size and are of superb Flemish or German workmanship. There are some good misericords including, for fans of the genre, one depicting a Green Man. There is a seventeenth-century moon clock which tells the time of the tides.

Across the square from St Margaret's is the old Town Hall, originally the Hall of the Trinity Guild. It was built in 1423 on the site of a previous building which had burned down. Some very fine civic regalia may be seen. Nelson Street is another street with excellent old houses, including the fifteenth-century Hampton Court in the entry to which hangs a cannon ball which is thought to be the very one which crashed through the roof of St Margaret's when Lynn, almost single-handedly in West Norfolk, was holding out for Charles I and was being besieged by Parliamentary forces.

On the north side of Tuesday Market Place, about 12 feet from the ground and just above a window, is a small diamond cut into the brickwork and enclosing the carving of a heart. In 1590 Margaret Read was burnt as a witch in the marketplace. She was believed to have murdered her mistress, although the latter probably died of severe food poisoning. In those days they liked to make the punishment fit the crime and so Margaret was suspended above a cauldron of water placed over a huge fire. At the precise moment that the water started to boil, the terrified woman was lowered into the water, raised out of it, lowered in once more and so on, several times. She was so traumatised by this ordeal that her heart is supposed to have burst out of her body with such force that it was propelled across the marketplace to strike the wall where the diamond shape can now be seen. As if that story is not sufficiently fantastic, the

heart is supposed to have been moving with such a momentum that, not content with striking the wall with considerable force, it then rolled off at high speed down a nearby street and plunged into the River Ouse. This tale, although admittedly not without its interesting aspects, does stretch the bounds of credulity.

Among famous people associated with King's Lynn was Sir Robert Walpole (1646–1745), who was the town's MP and went on to become Britain's first Prime Minister, and the navigator George Vancouver (1757–98). He was born in Lynn and sailed with Captain Cook on his second and third voyages of exploration, picking up invaluable skills in surveying and the making of nautical charts. A favourite daughter of the town is Fanny Burney (1752–1840). She was born in the town and taught herself to write novels. Her best-known work was *Evelina*, published in 1778, which describes how a young and innocent girl from the provinces deals with both the social gaieties and the pitfalls of life in London. She shows an affectionate but quite waspish wit which foreshadowed and influenced the much more successful and better-known Jane Austen.

Another daughter of the town was Margery Kempe. She was born *c.* 1364 and her father was the mayor. She married at the age of twenty and proceeded to give birth to fourteen children after which, or perhaps because of which, she became deranged. She claimed to be in personal touch with Jesus. She decided that she was a sinner and that she had to go on a pilgrimage to shrive these sins. She wandered all over England and Europe and even to the Holy Land, weeping, lamenting loudly, groaning and beating her breast as she went. She attended public worship and upset everyone by constant screaming. It is hardly surprising that she got on the nerves of just about everybody she met. People tried to avoid her or gave her money to go away. Eventually coming back to England she decided to crawl from London to Canterbury dressed only in a sackcloth apron and wailing as she went. These activities, which can be seen as either displays of rare deeply felt devotion or as the rantings of a lunatic, are less important than *The Book of Margery Kempe*. This work is regarded by some historians as the first autobiography in English. In it she described her extensive pilgrimages and provided valuable insights into the life of a middle-class woman of her time, albeit one who by any criterion was much out of the ordinary. Margery may have been a mystic but she clearly also had a practical bent. In 1421 the Town Hall caught fire and the conflagration threatened to spread to the church of St Margaret. She persuaded the priest to take the Blessed Sacrament out of the church and then she re-entered the building, praying as hard as she possibly could for a miracle. One was urgently needed because sparks were already finding their way in. The miracle occurred. The heavens opened, down came the rain and out went the fire.

Lynn is still a busy port and smallish ocean-going vessels enter its dock or load and unload their cargoes at numerous quays and staithes along the river. The vessels concerned are mostly from German, Dutch and Baltic ports, this practice showing an interesting historical continuity.

A small museum in Old Market Street displays items of local maritime history including the eighteenth- and nineteenth-century whaling industry. This was always small-scale and it petered out in 1821. There are many reminders of just exactly what a completely unsavoury industry whaling was, with the gruesome implements used to extract the valuable parts of the monster mammal always referred to by its hunters

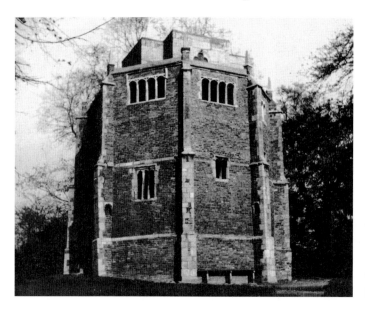

The Red Chapel, King's Lynn.

as a 'fish'. Visitors to Lynn described the appalling smell created as the blubber was boiled but the locals stood up for their industry and said that the smell had many health benefits. At Trues Yard, North Street, another museum contains reminders of Lynn's fishing industry and the proud and independent fisherfolk. The Wash has never attracted many fish but it was full of shellfish and the particularly prized and succulent pink and brown shrimps.

Castle Rising

At first sight, the inclusion of the village of Castle Rising in a book considering the history of the East Anglian coast might seem anomalous until the old ditty is rendered:

> Rising was a sea-port
> When Lynn was but a marsh
> Now Lynn is the sea-port
> And Rising fares the worse.

This piece of doggerel is a reminder that Castle Rising was indeed once a significant port, even though it is now several miles inland and the small tidal river which was previously navigable silted up, probably finally doing so in the late seventeenth century. It is now a very peaceful place, an attractive village with a palpable sense of departed glories. It had a fair and a chartered market and retains its marketplace. However, what brings the visitors to Rising is the castle which was started in 1150. There were earthworks dating from Roman and Anglo-Saxon times on this site and so the Normans made good use of these. What catches the eye now is Norman architecture on its most ponderous scale, the keep being one of the largest in Britain. The building

of this castle was initiated by the first Earl of Arundel. He was known as 'William of the Strong Hand' from a story which alleged that he once put his hand into the mouth of a lion and pulled its tongue out. A toothless lion?

For many years in the fourteenth century, Queen Isabella was imprisoned in the castle by her son, Edward III. She had connived with her lover, Roger Mortimer the Earl of March, to murder her husband, Edward II. Her son could never forgive his mother for this action, and although some of his advisors thought he should put her to death, instead he incarcered her at Castle Rising and left her to grow old and lonely. Some idea of the character of Queen Isabella is suggested by her nickname, 'The She-Wolf of France'. Legend has it that she went mad during her time at Rising and that her ghostly agonised screams can sometimes be heard echoing eerily through the cold stone chambers and staircases of the castle. The castle went into decline in the fourteenth century and had become ruinous by the sixteenth.

A delight of the village is the Howard Hospital or Hospital of the Holy and Undivided Trinity which is almost unchanged from when it was built in 1614 for twenty 'needy spinsters'. It is a low brick building with little towers round a quadrangle with an immaculately mown lawn. The resident pensioners still go to church wearing long red cloaks bearing the badge of the Howards and topped by pointed black hats. The hospital was founded by Henry Howard, Earl of Northampton. The chapel contains many fine Jacobean fittings. The church of St Lawrence is basically Norman. There is a well-preserved fifteenth-century cross on the Green.

The name 'Rising' probably means 'settlement of Risa's people'. On one of the lanes out of the village is the delightfully named 'Onion Corner', because at the right time of the year the air is permeated by the pungent smell of ramsons or wild garlic when its white flowers are in bloom.

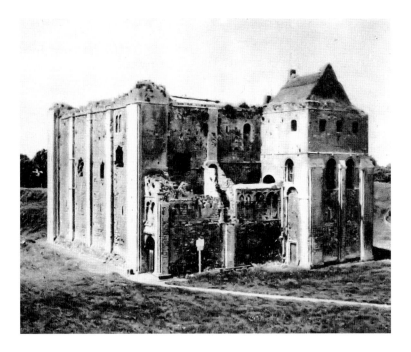

Castle Rising.

Heacham

The church, much of which dates from the thirteenth century, contains an interesting alabaster monument to Pocahontas, the daughter of a Native American chieftain who in 1614 married John Rolfe who brought her back to England. Although she was happily married to Rolfe, Pocahontas understandably pined for her homeland and died just before she was due to embark on a ship to return to America. Pocahontas is portrayed as a contemporary English lady of wealth and fashion. The Rolfe family owned much land around Heacham. An oddity in the church is an inscription recording nine local people who decided to go boating on a Sunday. This was the day for public worship and peaceful recreation and these hedonists paid the ultimate price for their levity. They never returned, doubtless much to the glee of some of local Christian fraternity.

It is hard to envisage now, but Heacham once had a market and a harbour as befitted a minor port. The latter increasingly suffered from silting and, after decades of decline, finally went out of use in the 1930s. At low tide, a huge expanse of sand is revealed which attracts families in considerable numbers but another newer attraction is 'Norfolk Lavender'. At the right time of the year, the lavender fields are a fine sight.

Hunstanton

Hunstanton is the largest of the west Norfolk resorts and notable as the only East Anglian seaside town facing west. There are great stretches of sand, attractive and colourful striated cliffs about 60 feet high and rewarding rock pools at low tide. The cliffs have bands of red and white chalk and also of carr-stone which is rusty brown-coloured sandstone. The latter is used extensively for building purposes in this part of Norfolk, especially in Hunstanton itself. Palaeontologists have found many interesting fossils in these measures. Although these cliffs are far more stable than the volatile clays further down the coast, these are also under continuous attack as can be seen by the sometimes very sizeable fragments that have fallen and lie scattered at the bottom, only for them to gradually be worn down into tiny pieces by the erosive power of the sea and then carried to be deposited elsewhere.

A small part on the sea front of Hunstanton is unashamedly loud and brash but this is not the atmosphere of most of the town which is predominantly sedate and Victorian or Edwardian-feeling. Many of the buildings were designed by the well-known architect William Butterfield acting on the instructions of the Le Strange Family, the local landowners who invested in developing Hunstanton as a quietly fashionable resort. Previously, Hunstanton had been no more than a hamlet a little further along the coast. It is still there and is now usually called 'Old Hunstanton'. The new community grew very rapidly in late Victorian times although it never became more than a small town. It was well laid-out and spacious and at first was known as 'Hunstanton St Edmunds' although that name never caught on. It was always intended that the new Hunstanton would cater for well-off 'gentlefolk' and the Le Strange family always very carefully controlled the town's development.

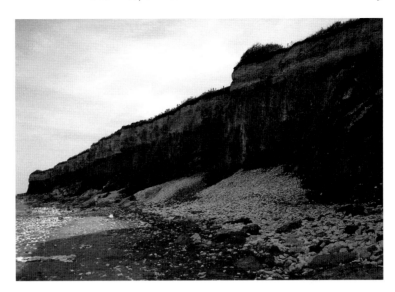

The cliffs at
Hunstanton.

The person responsible for Hunstanton's development as a resort was the eccentrically named Henry L'Estrange Styleman Le Strange, who started by restoring Hunstanton Hall which had been semi-derelict for fifty years or more. He drew up a comprehensive plan for a select seaside watering place and he was quickly at work building a large and plush hotel located in the middle of fields. It remained in glorious isolation long enough to earn it the nickname 'Le Strange's Folly'. He was every bit as quirky as his name and he went off to paint the visible part of the wooden ceiling of Ely Cathedral. It took him four years to complete just the first six bays. By no means deterred, in the best eccentric traditions, he painted on and died in harness, as they say. His son, Hamon, took over and was largely responsible for building what came to be called 'New Hunstanton'. There were, and maybe still are, some decrepit old signs around the town which announce that the Le Strange family had the right to all oysters and mussels taken off the foreshore. Apparently an ancient document states that they also have the right to anything found on the foreshore or as far out to sea as a man on horseback could throw a spear. To back up this quaint right, the head of the Le Strange family had the title 'Hereditary Lord High Admiral of the Wash'. The church of St Mary in Old Hunstanton boats a fine brass to Sir Roger Le Strange, made in 1506.

It was the coming of the first railway in 1862 which kick-started Hunstanton's growth as a resort but the town was on the end of a long branch line and a journey to it by rail was time-consuming and tortuous even from Peterborough, Cambridge or Norwich, the nearest places of any size. Steamers brought visitors from Skegness.

Before the age of the motor car a day-trip to Hunstanton was not something to be undertaken lightly unless by it was by special excursion train. Hunstanton therefore has remained smaller than Great Yarmouth or Southend, for example and it still seems to be in something of a time warp.

Hunstanton gained the reputation of being a place with healthy air, a good beach and clean water and this was endorsed in bricks and mortar when the Hunstanton Convalescent Home for Men, Women and Children opened in 1872. Before that,

the purchase of nearby Sandringham House and Estate by the Prince of Wales had stimulated interest in the area and brought many visitors.

On top of the cliffs are the remains of St Edmund's chapel, where Edmund, King of the East Angles, is said to have landed in AD 850. This saintly man is supposed to have had a wolf as his best friend and when Edmund was martyred and decapitated for his Christian beliefs, this wolf is said to have guarded the severed head. A few yards from this ruin is a sturdy white-painted lighthouse, which was decommissioned in 1921. There has been a lighthouse at this point since 1665 and that which can be seen today dates from 1838 by which time it had the distinction of being the last privately run lighthouse in operation. In that year it passed into the hands of Trinity House.

The name 'Hunstanton' is from the Old English 'Hunstan's farmstead' and it is still sometimes pronounced 'Hunston' by older local people. Thirty-two people died in Hunstanton in the great storm of 1953. Stationed in the town were American servicemen, one of whom, although himself a non-swimmer, plunged into the turbulent and icy waters again and again and succeeded in rescuing nearly thirty people, an action for which he was rightly awarded the George Medal, as was another of his comrades.

A pier was opened in 1870–71 and it was 830 feet long. It prospered over the years until 1939 when the far end caught fire after which the pier was reduced to 675 feet. In 1957 the pier came to public attention because it was at the centre of a film called *Barnacle Bill*. This was an Ealing Studios production and it starred, *inter alia*, Alec Guinness. Extensive renovations took place in 1958 but in 1978 fatal damage was inflicted in a major storm. Now all that is left of the pier is the main building at the landward end, acting as an amusement centre.

There is fishing from the beach for tope, dab and flounder. Boat trips go out to a sandbank in The Wash where large numbers of seals may be seen basking and doing all the various things that seals do when the tide is out. The town centre has shops largely oriented to the visitor trade and one of them is claimed to be the largest joke shop in the UK, or even possibly in the entire known universe.

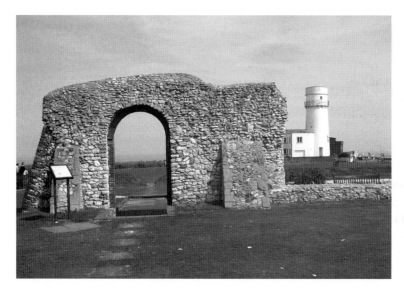

The ruins of St Edmund's chapel and the disused lighthouse, Hunstanton.

Along the coast is Old Hunstanton, a village with red-roofed cottages which once housed fisher-folk, an attractive church and Old Hunstanton Hall, a moated mansion dating back to Tudor times. In the churchyard headstones mark the resting places of William Webb and William Green who were soldiers working with the preventive men. They were killed by smugglers in 1784. The epitaph for William Webb reads as follows:

In memory of William Webb, late of the 15th D'ns,
Who was shot from his horse by a party of Smugglers on the 26 of Sepr. 1784
I am not dead but sleepeth here,
And when the Trumpet Sounds I will appear
Four bullets thro' me Pearced there [sic] way:
Hard it was, I had no time to pray
This stone that here you Do see
My Comrades Erected for the sake of me.

Pedants might criticise the scanning or various grammatical solecisms but events of this sort were all too common. The revenue men had few friends in the community and were always short-staffed and under-resourced. Occasionally they were able to co-opt dragoons to assist them but the latter hated these duties because they made them extremely unpopular with their friends and families and because they were also intrinsically hazardous. As smuggling became a heavily capitalised industry from which huge profits could be made, so more was at stake, and gangs of smugglers were prepared to murder informants or anyone who tried to intervene as they were carrying out their operations.

The author L. P. Hartley gave a sensitive description of Hunstanton in his first full-length novel, *The Shrimp and the Anemone*, published in 1944.

Just along the coast from Hunstanton is Holme-next-the-Sea. In 1999 a great storm battered the salt marshes and revealed what was quickly called 'Seahenge', a circle of timber stumps planted in the sand around 4,000 years earlier. Somehow or other, the builders of Seahenge had inverted a huge oak tree and pushed it deep into the sand. Its base, which now became its top, was acting as a kind of altar. When the discovery of these ancient and hallowed timbers was announced, all manner of tree-worshippers, Druids, mystics, conservationists, and even oddballs of every sort descended on the place. Very quickly this extraordinary archaeological relic became endangered on two main counts. First of all the timber had been under peat which had been stripped off by the action of the sea but it was in excellent condition because it was waterlogged in an anaerobic state. As soon as it was exposed to the atmosphere the timber began to dry out. The other problem was created by the heterogeneous hoard of people that descended on Holme with such avid reverence and inevitably caused considerable damage to the site. The authorities decided, very controversially as it turned out, that to ensure the conservation of a monument of such importance, it was necessary to remove it and place it in the care of experts in handling ancient timber. It went first to the Flag Fen site at Peterborough and then on to Portsmouth. Since that time a replica has been put on display at the Museum in King's Lynn and a second older ring has been discovered which has been left *in situ* because it is only rarely exposed to the elements.

Brancaster

As its name suggests, this place was once occupied by the Romans. However, nothing remains of the Roman fortress known as 'Branodunum'. It was built around AD 300 as one of several forts designed to defend the coast against attackers coming by sea from Northern Europe. In the churchyard a stone tells the melancholy story of Alexander and Susan Roche who were drowned in 1833 during a fierce storm at sea. Twenty-first-century Jeremiahs with gloomy relish make much of the supposed recent decline of public behaviour and mores. They should come and view this stone. This makes it clear that not only was absolutely no attempt made to rescue them but when they were washed up on the shore, any valuables on their persons were stolen and their home was broken into and plundered.

Brancaster Staithe, a mile or two to the east, was used by the Romans as a place for harvesting shellfish, of which they seem to have been extremely fond. The district is still associated with mussels. Like so many other places along this coast, Brancaster was once a prosperous small port.

Reachable by boat from Brancaster Staithe is Scolt Head Island. This is a paradise for the natural historian because it consists of sand and mudflats, marshland, shingle ridges and dunes, all in close proximity. Naturally these attract an exceptionally wide range of birds, some of which are resident but others are just passing through as it were and occasionally these birds of passage throw up very rare visitors. When this happens the 'birders' descend in such numbers to catch a sight of the poor unsuspecting creatures that they must wish they had chosen somewhere else to pass the time or that they were less exotic and merely belonged to one of the more commonplace breeds that the birders take for granted. An equally exotic range of plants specialised to cope with salty conditions can be found. They in turn act as a magnet for a wide range of insects. No fewer than eighty-six species of beetle have been recorded. Fortunately, these less spectacular fauna and flora attract far less frenzied activity. Scolt Head Island can be visited with permission.

The Burnhams

There are seven small settlements with 'Burnham' in their names. Some are just a short distance inland and they from a tight cluster. Burnham Thorpe no longer has the rectory where Nelson was born. It was demolished in 1802 but the church possesses the font in which he was baptised. A bust of Nelson can also be seen as well as a mass of Nelson memorabilia.

Burnham Deepdale, which is more-or-less contiguous with Brancaster, has a parish church with a characteristic Norfolk round tower. This one is older than most, dating from Anglo-Saxon times. Flint, of which the tower is composed, is an intractable material defying the stonemason's best efforts, but other types of stone suitable for building are scarce in this part of Norfolk; this meant that the masons had to use what was at hand, hence the circular towers to be found in considerable numbers in Norfolk, especially in those places where there was not enough money to bring good building

stone in from afar. The church possesses a 'Labours of the Months' font. These are fairly uncommon. They shed interesting light on medieval life by depicting the various agricultural tasks associated with each month.

Burnham Overy Staithe is a resort of leisure-time sailors and has good views towards Scolt Head Island Nature Reserve. It is likely that Nelson gained early experience in handling small boats around the saltings and creeks on this part of the coast.

North Norfolk between Hunstanton and Cromer possesses large stretches of fine dunes and marshes, 17,000 acres of which have been designated National Nature Reserves or Sites of Special Scientific Interest. Brancaster and Burnham Overy Staithe are sheltered from the open sea by Scolt Head Island which came into the public domain in 1923. The attraction it has for bird life has already been mentioned. The island is about 4 miles long and half a mile wide and was formed by wave action as a result of which sand and shingle ridges developed. A plant that has played an important part in assisting the formation of places like Scolt Head is marram grass. Marram establishes itself in the shingle and then sand blown up from the water's edge becomes trapped in the pebbles and dunes start to develop on the top of the shingle. Initially, the sand, shingle and mud of places like Scolt Head would seem to be an inhospitable habitat given that they are also subjected to blistering winds and salt spray. However, the contrary is often the case. A multiplicity of wild flowers, shrubs, insects, sea and land animals and sea birds can be found, many of them highly specialised, some of them very rare elsewhere. The difficulty obviously lies with conserving such natural resources while allowing controlled human access. The more the marram grass binds the sand dunes, the more they shelter the shore in their lee and encourage the deposition of silt in streams running down to the sea which turn into marshy saltings with their own interesting fauna and flora. On the northern shore of Scolt Head Island, semi-precious stones such as cornelian, onyx, amber and jet are often thrown up and provide fun for beachcombers.

Wells-next-the-Sea

This is something of a misnomer because drifting sand along the coast means that Wells is no longer on the open sea, the sandy beach being about a mile away. At this point bathing can be dangerous. A lagoon can be used for boating and it has the strange name of 'Abraham's Bosom'. Close by is a memorial showing a mast, anchor and lifebuoy. It commemorates eleven members of the crew of the local lifeboat which capsized in a storm in 1880, after they had saved the crew of one stricken ship and were going to the assistance of a second. The lifeboat station at Wells is unique as being the only place where an attempt has been made to steal the actual lifeboat. This was just at the end of the Second World War. Some German prisoners of war were impatient to get back home and so, under cover of darkness, they showed some initiative and seized the Wells lifeboat. However, they could not get it started. Nice try.

Wells has an engaging quayside where small commercial coastal vessels continued to tie up at least until around 1990. Wells had existed as a minor port trading especially with the Netherlands since medieval times and was developed by the Great Eastern

Railway, which built two branch lines to the town, both long since closed. A few small fishing boats operate from Wells and catch sprats while others look for whelks. The proud boast of Wells is that most of the whelks eaten in England are landed here. The whelk is an edible marine snail. It rejoices in the scientific name *Buccinum undatum* and is usually consumed sprinkled with vinegar. It is traditionally very popular at seaside resorts and in London's East End. Whelks can be found in vast quantities about 10 miles offshore. Some uncharitable people liken their consistency and taste to that of salty rubber bands. Stalls sell freshly caught local seafood and marsh samphire (*Salicornia europea*) in season. This is a much sought-after local delicacy. It is a succulent which grows close to the sea in muddy, marshy tidal waters in many parts of the neighbouring coast. The north Norfolk coast from Brancaster to Cley and Salthouse is the richest source of samphire in the UK and there is also much to be found around the River Blyth near Southwold and Walberswick in Suffolk. Samphire is at its most tender on hot days in July and August. It can be eaten crisp and raw when it is very young or boiled briskly for five minutes in unsalted water. It is then drained and eaten with melted butter, drawing the tough stems between the teeth. Traditionally it is eaten with mutton or lamb.

The quay at Wells is a pleasant enough mixture of eating places, amusements and ship's chandlers. The town consists of a number of narrow streets of a more common or down-to-earth feel than many of the more affluent settlements around the north-east coast of Norfolk. The parish church of St Nicholas, the patron saint of sailors, had to be entirely rebuilt in 1875. It had been hit by a massive bolt of lightning which started such a fire that even the bells melted. The Buttlands is an open green surrounded by many dignified Georgian houses. It takes its unusual name from being the place where the archery butts were located in medieval times when it was a requirement for men to practice on the longbow. This weapon was medieval England's ultimate deterrent.

The best-known local story is that of a travelling fiddler and his dog. They supposedly came to Wells sometime in the Middle Ages. The fiddler was told that there was an underground tunnel connecting two local monasteries, these being at Binham and Walsingham. The fiddler was something of a braggart and he boasted that he and his dog would go down into the tunnel and find out whether the tunnel, which was known to exist, did actually link the two monasteries. A sizeable crowd gathered, probably keen to witness the discomfiture of the fiddler who told them that he would go down with his dog and would play the fiddle as he went. They would be able to catch snatches of his sawing as he made his way along underground. Followed by the dog, which may have had private misgivings, the fiddler descended into the tunnel and was soon lost to sight. However, occasional bursts of distant music seemed to indicate that all was well. However, when they got to a place subsequently called Fiddler's Hill, the sound of music ceased. The crowd became concerned when the fiddler and his dog failed to reappear or emerge where the end of the tunnel was supposed to be. They were never seen alive again. However, those of you enjoying this white-knuckle ride will probably not be astonished to hear that workmen doing various excavations at Fiddler's Hill in 1933 found the skeleton of a man and his dog.

The quay at Wells-next-the-Sea.

Stiffkey

This is a small village spread out along the winding coastal A149 road. It has long been known for the sea lavender which blooms profusely in the summer and for the shellfish obtained from the marsh saltings close by. In particular, 'Stewkey Blues' have an excellent reputation. They are reckoned to be among the very best cockles to be found on the East Coast. Records going back before 1800 mention the women of the village making useful money by scouring the cockle beds in the marsh below Stewkey. These cockles, which are indeed blue, can be steamed and used in soups and pies and local restaurants serve them with samphire during the season. 'Stewkey' is the old dialect name for the village.

Stiffkey became internationally famous in the 1930s as a result of the scandal surrounding the local vicar, the Revd Harold Davidson. He annoyed his bishop because of the amount of time he spent out of the parish engaged in pastoral duties with young prostitutes, wannabe actresses and good-time girls in London's West End. He seemed to have been unduly tactile and attentive when ministering to their spiritual needs. Questions were asked when, for example, he accompanied young ladies of this sort to the fleshpots of Paris for the weekend, engaged in a search, so he said, for jobs for the girls. His care for these young women extended to bringing some back to Stiffkey where they were put up in the great rambling vicarage for 'rest and recuperation' from the rigours of their profession. Many of these girls had probably never been in the countryside before and to keep their hand in, as it were, they quickly got to know the local youths who couldn't believe their luck. Soon anguished grunts and impassioned squeals of delight emanated from the barns and thickets around the village as the girls put their well-honed skills at the disposal of the village's young swains. Complaints were made by some of the parishioners and Davidson ended up in a Consistory Court where his dirty linen was washed under the spotlight of a delighted and salacious international media. His conduct in the court was extraordinarily naïve and frivolous and he did nothing to help himself. He clearly revelled in being the centre of attention and did not seem to realise

the seriousness of the situation in which he found himself. Statements like, 'Yes, I did sleep with some of the girls but only on the outside of the sheets,' or admissions that one good-time girl had lanced a boil on his buttock, were not helpful in presenting a case for the defence. It was hopeless and he was defrocked, losing his job and his home in one fell swoop. He claimed that he had been victimised and he spent several years trying to raise the money to launch a legal appeal. He never really had a chance and he was reduced to performing stunts with a geriatric lion in a cage at Skegness. The lion, whose name was Freddy, was normally of a docile disposition but it must have got out of bed the wrong side one particular morning because instead of performing various tricks at Davidson's behest, it tried to eat him. He was rescued, bizarrely, by a scantily clad young female trainee lion-tamer, but his injuries proved fatal. It is now generally considered that Davidson, while naïve and indiscreet, was unfairly made an example of and that the evidence produced would not stand up in a court of law today or at an employment tribunal. The author visited Stiffkey some years ago and spoke to older residents who remembered the vicar. They had nothing but good to say about Davidson as a man and priest and the way in which he carried out his parochial duties. He is buried in the churchyard. Perhaps Davidson was like his mentor – more sinned against than sinning!

Blakeney

This was a small but flourishing port on the River Glaven but it is now a smart and select but small seaside resort which attracts the sailing fraternity and bird watchers and those who like the seaside but not with the bright lights. The large church of St Nicholas stands on a rise above the village and has an imposing tower and an odd little turret which may have been used as a beacon for mariners out at sea. The chancel is unusual. It was part of a Carmelite friary founded in 1296 and has a ribbed vault and unusual stepped seven-lancet east window, both of these seemingly having little to do with the rest of the church. The village was formerly much closer to the sea but when the tide is out at the harbour only a trickle of water is now to be seen. For all that, the tide comes in with formidable speed and unwary motorists who have parked in the wrong places often find their cars surrounded by water. A house in the High Street has a plaque marking how high the water reached during the floods of 1953, more than 6 feet above street level.

Wiveton

This is now little more than a hamlet a short distance from the sea but was once a port of some significance on the estuary of the River Glaven. The large church of St Mary contains some particularly good brasses commemorating members of the Brigge and Greneway families.

An incumbent of the parish, albeit only for a brief time, was James Hackman (1751–79), a native of Gosport in Hampshire; his parents bought him a commission in an infantry regiment. It was while he was engaged in recruitment duties in 1774 that he met Martha Reay and plunged deeply in love with her. Despite the fact that

she was older than him and was the long-term mistress of the Earl of Sandwich by whom she had borne nine children, he commenced an affair with her and soon proposed that she should go away with him. At first she seemed agreeable but when she decided to turn his proposal down, his response was to renounce the world. He resigned his commission, took holy orders and became the curate at Wiveton which meant that he was as poor as the proverbial church mouse. It seems that he had harboured some hope that Martha would be favourably impressed by this gesture. She wasn't. She was content with the affluent lifestyle she was enjoying courtesy of the Earl. One evening Hackman saw Martha in all her finery stepping out of her patron's coach to attend the opera in Covent Garden. Smitten with insane jealousy, he shot and fatally injured her and then tried unsuccessfully to shoot himself. He was hanged at Tyburn on 19 April 1779. Some wag penned a piece of doggerel to commemorate this sorry chain of events:

> O clergyman! O wicked one!
> In Covent Garden shot her
> No time to cry upon her God –
> It's hoped he's not forgot her.

The best distant view of the Church at Cley-next-the-Sea is from Wiveton's churchyard.

Clay-next-the-Sea

Cley is yet another former minor port now left stranded some way inland. Insidious silting of the River Glaven and the increasing size of seagoing ships put paid to Cley as a port. Its most notable feature is probably its fine windmill which has featured in innumerable

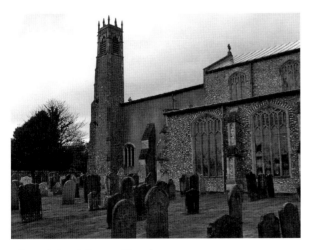

Above left: Blakeney Church.

Above right: A road sign near Wiveton.

paintings while the size of the church is evidence of prosperity in the days when wool and later made-up cloth were being exported. Evidence of its earlier operations as a port is the red-brick Custom House. There is a slightly Flemish feel about the place. Wool-buyers from Flanders were frequent visitors in earlier times. Cley (pronounced Cly) is a seemly little place popular with visitors, although the present centre of the village is rather difficult to walk around as it stretches along the narrow and twisty A149.

The church of St Margaret is large and very striking. It contains some good ancient misericords and carved bench-ends, some with grotesque or humorous human figures and imaginary beasts. The clerestory is unusual for containing round windows with cinquefoils. There is a rare font with carved depictions of the Seven Sacraments. These were Baptism, Confirmation, Eucharist, Penance, Extreme Unction, Orders and Matrimony. The south transept has been in ruins since about 1600.

Sheringham

Upper Sheringham is a village with an old church on what constitutes a significant hill by local standards. Sheringham Hall and gardens were completed in 1817 to the design of the eminent Humphrey Repton and his less well-known son. The latter probably did most of the work on the house and father certainly was largely responsible for the gardens which he described as the commission he enjoyed most of all in his career. When the rhododendrons are in bloom they make a magnificent sight. An odd feature is the Repton Temple. This was designed in 1812 but not built because the owner of the estate died suddenly and very prematurely and his wife was so heartbroken that she could not bear to finish off all the work associated with the gardens. After a gap of 163 years, work started on the planned temple. Better late than never...

Lower Sheringham, once known as 'Sheringham Hythe', was an old coastal fishing village which was transformed in the nineteenth century into a fairly sedate seaside resort. What started the rise of Sheringham as a watering place was the arrival in 1887 of the Midland & Great Northern Railway, satirised by its initials as the 'Muddle and Go Nowhere'. This provided connections from places like Leicester, Derby and Nottingham in the East Midlands for people who came to stay on the Norfolk Coast. Sheringham set out to attract those who wanted fresh air and seemly attractions without the razzmatazz which came to be associated with, for example, Great Yarmouth. A couple of palatial hotels were opened, of which the doyen was the huge Grand Hotel, but such establishments were usually doomed by economic, social, cultural and other changes that took place from the 1960s onwards; sometimes earlier. The district was promoted as 'Poppyland' from the 1880s because of the masses of these bright flowers that bloomed close to the coast in this neighbourhood. After the First World War poppies took on emotional connotations and the district benefited even more by the references to the poignant flowers of this plant.

For buffs of old trains, a truncated section of this route, formerly promoted as the 'Poppy Line' and now known as the North Norfolk Railway, joins Sheringham to Holt. This is an attractive run to a town which is itself well worth looking round, especially if the visitor is into so-called 'retail therapy' and has a bottomless wallet. North-east

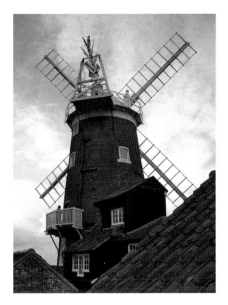

Above left: The windmill, Cley-next-the-Sea.

Above right: The font at Cley, depicting Extreme Unction as well as the other Sacraments. This ritual was carried out by the priest as death approached.

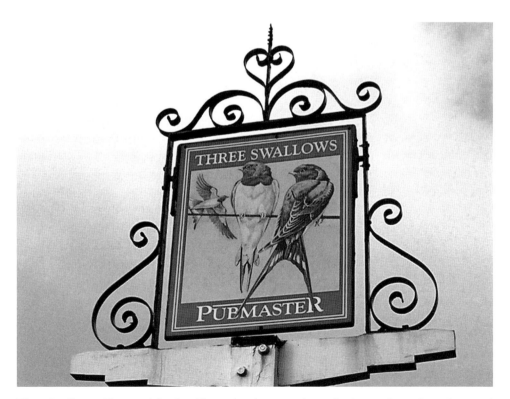

Three Swallows, Cley-next-the-Sea. The author has a weakness for interesting pubs and unusual pub signs. The name may be unique. The pub's pretty good, too!

Norfolk attracts many affluent residents and weekenders with second homes and this is very evident in a place like Holt.

There is a ridge of pebbles at high tide but plenty of good sand at Sheringham when the tide is out. Coastal erosion has required the building of large reinforced concrete defences and these are an ugly, if vital, feature of the front. A characteristic of the town is the use of smooth beach pebbles as decorations for the front of some of the older houses. The town still has some streets of small vernacular cottages, built of flint with pantile roofs, giving some sense of its past as a fishing village.

There is a busy high street with a neat clock tower at one end and the seafront at the other. There is still a small fleet of inshore fishing boats which go out after crabs and lobsters. Uniquely, Sheringham possesses no fewer than four lifeboats. The veteran *Henry Ramsey Upchurch* of 1894 has a little shed of its own while the others are in the local museum in Station Road.

Nearby, at a gap in the cliffs, is a place where twelve drowned sailors were washed ashore in the eighteenth century after their ship was wrecked. The locals, not standing on ceremony, dug a deep hole and threw them in, one on top of the other, without even giving them a Christian burial. The site was marked by a cairn of stones. The souls of the departed mariners seem to have resented this cavalier treatment because, for decades afterwards, anyone foolhardy enough to go there on a stormy night would report hearing an uncanny and disturbing sound. This was said to be like shingle being dropped slowly, pebble by pebble, onto a large boulder. This is not the kind of sound normally associated with paranormal activity.

The name 'Sheringham' means something like 'the place of Scira's people', and a long-standing inhabitant of Sheringham is known as a 'Shannock'.

Cromer

This is one of the larger of the East Anglian seaside resorts, although even then it is not a sizeable town; however, it has a bustling atmosphere and plenty to attract families for holidays. Cromer is an ancient settlement mentioned in Domesday with narrow streets crowding round the large fifteenth-century church of Saints Peter and Paul. This possesses, at 160 feet, the tallest church tower in Norfolk and it forms a spectacular landmark on this part of the coast. The church displays a very fine Burne-Jones window in the south aisle and is spectacular in terms of style.

Perhaps this place should be called 'New Cromer' because when the tides are particularly low, not only are the remains of a forest dating back to Pliocene times revealed, but also a coastal settlement called Shipden-juxta-Mare which was destroyed by the sea in the Middle Ages. This had a church and it is inevitable that the more fanciful (or drunk) of the locals claim that the bells of this lost church can be heard ringing when the tide is out. They are said to portend storms. Part of this church lies just below the waves and many ships have been damaged by it, some seriously. This 'Church Rock' is about 400 yards offshore. The coast is being eroded quite rapidly in the vicinity and the present town of Cromer, perched on the cliff, was once considerably further inland. It is a replacement for another settlement called Shipden-juxta-Felbrigge.

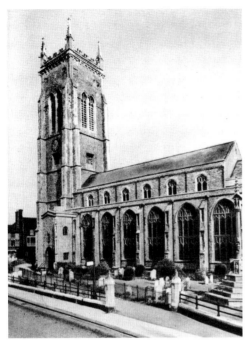

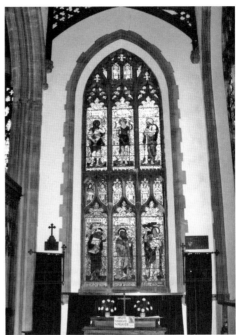

Above left: Cromer Church.

Above right: The Burne-Jones window in Cromer Church.

Daniel Defoe, while perambulating the coastline in the 1720s, does not seem to have been greatly impressed by Cromer. He wrote of the town: 'I know of nothing it is famous for – except good lobsters which are taken off the coast in great numbers and carried to Norwich, and in such numbers as to be carried to London too.' Today it is almost obligatory for a visitor to Cromer to buy a fresh crab or at least a crab salad in a pub. Experts in such things say that Cromer crabs are markedly sweeter than crabs caught elsewhere but are not sure why. The crab boats are to be seen on the pebbly beach. They are sturdy, clinker-built, double-ended and of a design which has scarcely changed over the centuries.

Cromer unquestionably benefits from being perched on one of the few cliffs of significant size on the East Anglian shore. It has extensive sands, sea-bathing, lots of fresh air, many good walks in the neighbourhood, interesting places to visit nearby and a not unpleasant, slightly old-fashioned seaside resort feel about it. Who knows? With the global warming we are constantly been warned about, perhaps a slightly faded resort like Cromer might come into its own again. Who would need to go to the Costal del Sol when they could go to a place like Cromer which enjoyed an equatorial climate?

The first mentions of people coming to Cromer to enjoy its seaside location and its waters occur in the 1790s. These were wealthy people – the only sort who had the time and the money to enjoy leisure. Although they would have come in small numbers, their spending power would have ensured that they were made welcome and the facilities they wanted would have been laid on for their delectation. The railways were

quite late in arriving at Cromer and so until the 1870s the town managed to maintain its reputation as being quiet and select. The first station, opened by the Great Eastern Railway Company, was appropriately known as 'Cromer High' and was perched well above the town and, being a mile from the town centre, extremely inconvenient for it. This situation was remedied in 1887 with the opening of Cromer (Beach) which was far more central. While the railways opened up access to Cromer, the town never took on the character of a seaside resort unashamedly aiming its delights and amenities at working-class visitors. A generally rather better-off clientele continued to be attracted to Cromer and this was borne out by the building of several large and surprisingly palatial and luxurious hotels. These included the Grand, the Metropole, the Cliftonville and the Hotel de Paris; of these only the last two survive. The Hotel de Paris was opened in 1895 and it exudes a tantalising sense of faded grandeur, of being a survival from a very different age, of being a kind of time warp. It traces its origins back to the 1830s and was the brainchild of an aristocratic French *émigré* called Pierre le Francoise. Many such people fled to England to avoid what they thought of as the horrors of the revolutionary events in France. Not a few of them were worthless fops quite incapable of doing anything useful but others drew on their experience in culinary matters or in what would now be called the 'hospitality industry' to set themselves successfully with a new life in Britain. The hotel continued to prosper after his death in 1841, so much so that the brave decision was taken to rebuild and subsume the properties on either side, and the result can be seen today. There is still a Lady's Powder Room at the Hotel de Paris. Not many of those about these days. The Cliftonville has a similar but different air of being congenially and comfortably old-fashioned. Outside the town, another large hotel called The Links burnt down in 1936.

Cromer has a pier opened in 1901 replacing a jetty damaged by storms. The pier is 450 feet long and since 1932 has housed the slipway for the local lifeboat, actually extending the length to 500 feet. In 1948 the pier came under the ownership of the local authority. Severe damage was caused by the huge storms of 1953. In 1976 the pier was given listed building status. There were a number of occasions in the 1990s when storms seriously damaged the pier and in November 1994 a construction rig, of all things, managed to crash into it, making a breach which isolated the theatre and the lifeboat station. The end of the pier theatre continues to stage successful shows. At the time of writing (June 2010), it has just been announced that a large sum of money is needed to ensure the long-term survival of the pier.

There are treacherous sandbanks offshore and the local lifeboat is one of the busiest in England. The lifeboat station contains a bronze memorial to Henry Blogg, the lifeboat coxswain from 1909 to 1947 who deservedly won the George Cross and the British Empire Medal for his selfless bravery in saving lives at sea. They handed out gongs more sparingly in those days. During the Second World War the Cromer lifeboat saved no fewer than 450 lives. Over his entire time in the lifeboat service, Blogg took part in operations that are thought to have saved 873 lives. Blogg shunned the limelight and was always modest and very reluctant to talk about his experiences or to be lauded as a hero. He never learned to swim.

In 1932 Blogg was involved in the heroic rescue of the crew of an Italian vessel, *Monte Nevoso*, which had gone aground on Happisburgh Sands and was breaking up.

The crew was all rescued by the Cromer lifeboat and another vessel but just to check, Blogg and his men climbed on board. They heard a scratching noise and opened a door only to find a Pyrenean Mountain Dog and a canary that had been abandoned by the crew. He recovered them both. The author cannot speak for the canary but Blogg and the dog soon became inseparable mates. He gave the dog the name 'Monte'.

Just to the east of the town is the lighthouse. Built in 1833, it is 58 feet high and its light has a range of 23 miles. The previous lighthouse fell into the sea.

A delightful museum containing items of local history interest can be found in Tucker Street. Among its proud possessions are a number of fishermen's ganseys. These knitted navy-blue jumpers were worn by fishermen all round Britain's coasts but those made lovingly by the women of Sheringham and Cromer were reckoned to be the finest.

One of Cromer's least likely former inhabitants was Albert Einstein who lived in the town briefly in the early 1930s as a refugee from Jewish persecution in Germany before he moved on to the USA.

The name 'Cromer' is derived from the Old English 'lake frequented by crows'. The town is old-fashioned and unpretentious but for the author, that's an essential part of its charm. No one could use the word 'precious' to describe Cromer although that word could certainly be used to describe some coastal towns further south.

Overstrand

This is a fairly unremarkable place but it contains two interesting houses by Sir Edward Lutyens: one called 'The Pleasaunce', with a garden designed by Gertrude Jekyll; the other 'The Hall'. They are both strange-looking buildings. They date from the last decade of the nineteenth century which was the fairly short-lived heyday of the village because several extremely well-to-do families came and settled, attracted by the atmosphere created in Clement Scott's then very popular writings about 'Poppyland'. A characteristic of the area is lanes leading straight towards the clifftop and then ending abruptly on the edge of crumbling cliffs containing good fossils. The clay, of which much of the cliffs hereabouts is composed, turns when saturated into an oozy mass seeking to make its way downwards. When it is particularly dry, it shrinks and large cracks and crevices appear forming a natural route for heavy rainfall. The result is that these cliffs are highly volatile, being destroyed by the action of terrestrial water as well as wave action by the sea.

High hopes were once entertained that this settlement would develop into a resort to rank with Cromer. The Overstrand Hotel was a massive and wildly optimistic venture looking altogether too grandiose for its surroundings but it quickly became evident that it was not going to be a rewarding in investment and little further development took place.

Mundesley

Pronounced 'Munsley', the name means 'the glade of someone called Mun or Mundel'. It stands where the small River Mund enters the sea.

Cromer Pier.

Above left: Inside Cromer Lifeboat Station. This is unusual for its position at the end of the pier.

Above right: A Cromer Villa. In the Cliff Avenue of Cromer are some very fine Victorian villas, indicative of the affluent residents that were attracted to the town at that time.

Mundesley is a spacious small resort having associations with the poet William Cowper. He is said to have been inspired to write the hymn 'God moves in mysterious ways' after watching a fearsome storm visibly gathering over the sea and then breaking over Happisburgh just down the coast. The fairly lofty cliffs here are particularly prone to coastal erosion. Attempts were made to develop a substantial seaside resort here to rival Cromer. Two big hotels were put up in 1892 and 1900 but their attractions did not really catch on and Mundesley never developed beyond being a minor seaside watering place. The former coastguard station contains the Mundesley Maritime Museum whose boast is that it is probably the smallest museum in Britain.

An amusing incident occurred during the Second World War when the coastguards observed a lifeboat approaching the coast and apparently containing a boatload of German officers! It was clear they intended to land. Was this the start of the feared German invasion? If so, why was the first vessel on the scene a lifeboat? The Home Guard was alerted and they mustered on the beach, rifles at the ready, determined to give the enemy a good drubbing. It turned out that the men in the boat were Russian prisoners of war who had appropriated the lifeboat from Texel in Holland and set off pointing towards England, but not before they had purloined a job lot of German officers' uniforms.

In the nineteenth century, reports began to come in about an apparition known as 'The Long Coastguardsman'. This supposedly started walking along the coastal path every night from nearby Bacton to Mundesley just as the clock struck midnight. This spectre was a bit of a deviant in supernatural terms because unlike the rest of its kind, it never appeared on moonlit nights. It loved nothing better than a stormy night when it could be heard shouting and singing gleefully and with great gusto above the sound of the waves.

To the south-east of Mundesley and about a mile inland stand the extensive ruins of Broomholm Priory, founded in 1113. This establishment, which in 1195 came under the Cluniac Order, prospered greatly in the thirteenth century owing to its claim to possess a piece of the cross on which Christ was put to death. This relic attracted large numbers of pilgrims. In reality there were enough pieces of the True Cross venerated as relics to have got them together and made several crosses.

Happisburgh

The prominent tower of St Mary's church acts as a landmark for mariners while the unique red-and-white striped lighthouse warns them of the presence of treacherous shifting sandbanks a few miles out to sea. This has become Britain's only privately operated lighthouse and is supported entirely by voluntary contributions. Pieces of shrapnel from bombs dropped by German aircraft in the Second World War can still be found embedded in the fabric of the church. The churchyard contains many memorials to the victims of shipwreck as well as their mortal remains. The large green mound north of the church is believed to be the mass grave of the ship-of-the-line HMS *Invincible*, which was wrecked on an offshore sandbank in 1801 when sailing to join Nelson's fleet at Copenhagen.

A curiosity in the churchyard is the grave of a man rejoicing in the name of Jonathan Balls. The inscription tells us that he was an incorrigible rogue who, for some strange reason, was buried with a piece of cake in one hand and a poker in the other. He supposedly made a habit of spiking people's drinks with arsenic until one day he made the fatal mistake of drinking from the wrong glass.

Smallish numbers of visitors are attracted to the simple pleasures offered by this part of the Norfolk coast. The beach is excellent, the air brisk but Happisburgh (pronounced 'Hazeborough') never really grew up. The name of the village means 'stronghold of Haep', whoever he was.

For many years in the late eighteenth century, regular sightings of a ghost were reported in the vicinity of Happisburgh. The apparition was known as the 'Pump Hill Ghost'. Farmers coming home late at night were badly shaken when they sighted a figure coming up the village street from the sea. It was said to be headless and legless if that is the right description of someone whose head apparently hung down his back between his shoulders. He carried a large bundle and those who claim to have seen him say that he looked like a sailor. A natural question to ask is how it was possible to make out so much detail if it was pitch-black. Another question might be whether it was the apparition or the observer that was legless. One man who saw the figure decided to follow it and see where it went. He observed it going to the village well whereupon it flung its bundle down the well and then disappeared down the well as if in hot pursuit of the bundle. The next day he told his story to the other villagers and they decided, albeit with some misgivings, to investigate the well. A volunteer was found, perhaps surprisingly, to descend the well-shaft in a bucket. At the bottom of the well he found a wet bundle containing a pair of bloody legs hacked off at the thigh. Then he found the legs' owner: a corpse whose head was held on only by a flap of skin at the back. They came to the conclusion that the head and the legs had belonged to a smuggler murdered by his colleagues for reasons unknown. This rather facile explanation fails to answer very many questions, including the obvious one of how the murdered man managed to walk up from the sea through the streets and to the well on so many occasions with his legs detached.

Palling

This small settlement, often referred to as Sea Palling, suffered severely in the storm of 1953 and continues to be extremely vulnerable to attacks from the sea.

Winterton

The church has an extremely lofty tower visible from far away. Many ships have come to grief on what often seems to be a deceptively innocuous sea. Daniel Defoe, when he visited in the late seventeenth century, declared that the main building material in the village's houses was timber from ships wrecked nearby. He referred to an appalling storm which had occurred in 1692 when 200 ships foundered and were wrecked and over 1,000 lives were lost.

Winterton stands just outside the long and ugly stretch of camp and caravan sites, shanties and bungalows that characterises, if that is the right word, the coast north of Great Yarmouth.

Just inland from Winterton is Somerton whose claim to fame is that here once lived and now lies Robert Hales, the Norfolk Giant. He weighed in at 32 stone and stood 7 feet 8 inches tall in his stockinged feet. Wonderful expression that. He took to the road as a member of a troupe of travelling human oddities or 'freaks' as they were less politely known. Many people would part with good money to see mountainously fat people, skeletally thin people, people with more than the usual number of limbs or people with none at all; freaks of all sorts including 'caterpillar men' and 'elastic-skinned men'. Hales made enough to retire and buy a pub in London. His size attracted the punters and he could economise by never having to employ a bouncer on the door. His sister was something of an anti-climax at only just over 7 feet. Hales died in 1863 and his grave is marked by an imposing memorial. The taste for looking at freaks is as popular as ever. Now we can do it in the comfort of our own homes while we watch 'reality' television. Whoever termed the description 'reality' for programmes so full of vacuous nonsense deserves to be put in the pillory.

Caister

The name correctly suggests that the Romans were active in the neighbourhood and there was indeed a sizeable Roman town on the west side of the village. Some physical remains are still visible including part of the walls of a town called 'Venta Icenorum' founded in the second century AD, and a section of cobbled road.

Two miles west stands Caister Castle. It was built in the 1430s and 1440s and is rather more a fortified manor house than a castle in the true sense. It was the property of the powerful Sir John Fastolf who commanded the English archers at the Battle of Agincourt in 1415. It is commonly believed that he provided the model for Shakespeare's Falstaff. This castle had a comparatively short life. When Fastolf died, the castle passed into the hands of the Paston Family but the Duke of Norfolk coveted it and so in 1469 he besieged it with a powerful force and battered it into submission. When the Duke died, the Pastons reoccupied it but perhaps the damage that had been done to it meant that it was too far gone and so they abandoned it in 1599 and built a new mansion nearby. Caister Castle became even more ruinous as it suffered the fate of similar abandoned castles and was used as a quarry for building materials by the locals. Today its most striking features are first that it is brick-built and secondly the very tall, slim cylindrical great tower which is 90 feet high and possessed five storeys of residential accommodation. The castle is open to the public and there is a vintage car museum in the grounds.

Out to sea from this part of the coast are Scroby Sands. A curious incident occurred in December 1952. In fog and heavy seas, a Danish naval motor torpedo boat ran aground on the sandbank. Twenty-four men were on board. Nine of them were rescued by lifeboats and four by naval helicopter. The others spent Christmas aboard enjoying Christmas fare courtesy of the Royal Navy and eventually after six weeks, the boat was

floated clear of the sands, still in a seaworthy condition. This gave the crew members involved a story to tell their grandchildren.

Great Yarmouth

Great Yarmouth is a substantial and ancient town engaged in fishing (albeit to a far smaller extent than previously), food processing, a minor port and a seaside resort rolled into one and this gives it considerable character. It is fairly quiet in winter but heaving in summer when the brash and glitzy resort aspects of the town come into their own.

For many years, Yarmouth was provided with defensive walls because the town was seen as a place of strategic importance in defending the East Coast from attack by Northern Europe. The building of these walls started in 1261 and was completed in 1346. The last time these walls were called upon for military purposes was in the English Civil War when the town declared for Parliament, after which they were allowed to decay. Three of the towers survive as do stretches of the walls. Originally the walls were 23 feet high and 2,200 yards long.

The Rows were a unique collection of narrow courts and alleys with an extraordinary mixture of medieval, sixteenth century and later buildings which survived until the Second World War when they received the bombing attentions of the Germans. They constituted one of the most remarkable built-up areas in Britain. There were no fewer than 145 of these passages and some were a mere 30 inches wide. The narrowness of these lanes led to the design of a unique narrow horse-drawn vehicle known as a troll

A tower in Yarmouth's medieval walls.

cart, for carrying goods around the town. By placing the wheels below the body, the troll cart saved on width. It is not surprising that the Rows were huddled together because old Yarmouth was built on the constricted, narrow strip of sand between the river, made up of the confluence of the Bure, the Waveney and the Yare, struggling to find a way to the sea, and the sea itself. One of the few remaining Rows (No. 111) is cared for by English Heritage. The names of these alleys were a fascinating study in themselves. Here is a sample: Split Gutter Row; Lacon's Brewery Row; Doughty the Leather Cutter's Row; Worship the Attorney's South Row; Kitty Witches Row; Fulcher the Pawnbroker's Row; 3 Herrings Row and Chambers the Sailmakers Row. What made the names of the Rows complicated is that they had a tendency to change their names when the person, business or feature after which they were named, moved out or moved on.

The church of St Nicholas was largely destroyed by enemy action in the Second World War but it has been rebuilt and is one of the very largest of England's parish churches. It has a modern stained-glass window depicting aspects of the fishing trade. In the early nineteenth century, the townsfolk were astonished to see a small boy on the top of the tower clutching two pillows. For reasons best known to himself, he then proceeded to take the feathers out of the pillows and throw them to the four winds. The boy was Astley Cooper and he went on to greater fame as one of the leading physicians of Queen Victoria's time and sometimes attending the Queen herself. He became notorious as one of the most persistent buyers of human cadavers supplied by the 'Resurrection Men' or 'Sack-'em-Up Men'. These were the criminal lowlifes who exhumed freshly buried bodies from burial places at night and sold them to members of the medical profession and teachers in anatomy. The cadavers were then dissected as object lessons by those learning anatomy and physiology. The progress of scientific medicine ironically owes a considerable debt to these particularly repulsive criminals. However, their activity would not have been possible were it not for the members of the medical profession who wanted as many bodies as they could buy and were not too fussy about enquiring into their provenance.

The town dates back at least to Roman times. The settlement then was located on a sandbank which had become habitable because of a fall in sea level. This is the long and narrow spur separating the sea from the River Yare which is so much a feature of the town today. In Saxon times an annual fair was held at which freshly caught herrings were pickled for consumption over the winter months. In Domesday, Yarmouth is recorded as having seventy burgesses and it continued to grow in prosperity, particularly as a seaport, which explains the sumptuousness of its parish church and the complex medieval street pattern as well as various other remaining ancient buildings. It was noted in medieval times as a shipbuilding centre and England's premier herring fishing port. The annual fair, known the 'Free Herring Fair' was one of the greatest of all medieval trade fairs.

One of the focal points of the town is the marketplace, lively enough when the market draws attention away from the unsightly redevelopment that surrounds much of it. Definitely worth seeing is the delightfully-named Hospital for Decayed Seamen which are almshouses dating from 1702. This was founded by the town corporation. The almshouses open out into a charming little courtyard flanked by Dutch gables,

the central cupola being topped by a chilly looking statue of St Peter, the fisherman's friend. In the courtyard is a figure of Charity. Given that so many of Yarmouth's ancient buildings were destroyed by bombing in the Second World War, it is good that this attractive ensemble has survived.

In the nineteenth century the town moved forward again very rapidly as a result of the Industrial Revolution, the massive rise in the urban population, and the development of the railways. These factors allowed places like Yarmouth and Lowestoft to develop from being ports where fish was landed largely for consumption in the immediate locality and its hinterland. Instead, fishing was transformed into an industry and they became industrial towns in their own right using the railways to provide quick transport of the highly perishable fish to the large developing concentrations of urban population where fish was sold to the urban masses that had hitherto been denied fresh sea fish. This effected a significant improvement in the diet and therefore in the health of the urban masses. Much of the white fish caught was consumed in the form of fish and chips.

Yarmouth became the centre of Britain's herring fishing industry and catches peaked in the years leading up to the First World War when the maximum number of fishing boats registered stood at 367. The largest catch of herrings was made in 1913. When the herrings were being landed and processed at the peak of the season, up to 1,000 drifters would be temporarily based at Yarmouth. As is well-known, the Scottish fisher-girls moved down the East Coast in the autumn following the regular movement of herring shoals and they descended on Yarmouth in such numbers that special trains were laid on exclusively for them. These girls were enormously skilled, working at an extraordinary speed, and there is a record of one who managed to gut fifty-seven herrings in one minute. There was never a dull moment when these girls were in town. However, these boom days could not could not last and even the natural bounty of the sea could not withstand exploitation on such a massive scale. While things were going well, the speciality of Yarmouth was bloaters, rarely seen these days, being whole herrings that had been lightly cured and smoked. Bloater paste was a popular Victorian delicacy. The last herring drifter was decommissioned in 1963 but North Sea gas and oil exploration has helped Yarmouth to stave off economic decline. One door closes and another opens. Whither Yarmouth when the oil and gas runs out?

The first seawater baths were opened at Yarmouth in 1759 and the town was well established as a resort by the time it was visited by Charles Dickens around the time that *David Copperfield* was published in serial form in 1849. The virtues of Yarmouth's bracing fresh air had been vigorously extolled in a book on resorts written by a Dr Spencer Thompson but what for him made Yarmouth special was that great lungs-full of beneficial North Sea air could be taken in laced with different but equally beneficial inhalations from the many establishments preparing bloaters and kippers by smoking them over burning oak chips. A few lungs-full of that smoke was thought to work wonders to those who were a bit 'chesty'.

As evidence of the growth of what later came to be called the leisure industry, Yarmouth expanded rapidly in the later Victorian and Edwardian period, which explains the neat rows of terraced houses, the parks and wide promenades built at that time, particularly on what was then called the Denes, some distance away from the

old town within its walls. Parts of these survive cheek-by-jowl with the urban bustle of a sizeable town and the noisy razzmatazz expected of a popular and large seaside resort. The railways that served the town had much to do with the subsequent growth. In the 1871 season, well over 80,000 day trippers arrived by train. However, not everyone was impressed with Great Yarmouth's development as a resort. One visitor was brutally frank: 'the buildings on the sea front, by and large, are a hotch-potch of conflicting styles guaranteed to instil a slight feeling of nausea into the aesthetically-inclined.' In 1886 a writer recorded his opinion that a visitor 'Will not find here fashionable promenades or a very select society … this is the one, and possibly the only watering place that has no select or fashionable quarter'. Modern Yarmouth still has few buildings with visual dignity or aesthetic attraction.

The large Burton-on-Trent brewery of Bass, Ratcliff & Gretton in the last years of the nineteenth century and up to the First World War used to organise a free annual excursion for its employees, their families and friends. Usually the destination was a seaside resort and Bass worked with the railway companies over whose tracks the trains would run and with the local authority at the destination concerned to ensure everything went smoothly in what was a complex major operation.

In 1893 the chosen destination was Great Yarmouth. No fewer than fifteen trains ran on this occasion, the first leaving Burton at 3.50 a.m., reaching Yarmouth at 8.30 and the fifteenth leaving at 6.10 to reach Yarmouth at 10.50. The first to arrive at Yarmouth was also the first to leave (at 7.30 p.m.). The fifteenth and last train left Yarmouth at 9.50 p.m. to arrive back at Burton at the witching hour of 2.35 a.m. It was back to work for some next day! All the trains in both directions stopped at Peterborough for what was euphemistically called a refreshment break. The authorities at Yarmouth certainly pushed the boat out to cater for all tastes – it was worth their while – fifteen full trains brought a huge number of people and considerable spending power into the town, if only for a day. The sprat to catch the mackerel was, of course, the hope that they might be so impressed that they would return to Yarmouth for a longer holiday in the future. The attractions that were laid on give a good idea of what was expected of a popular seaside resort of the time. There were organ recitals in the parish church, brass band concerts, military tattoos, circus performances and daylight fireworks. Production of a ticket rendered many facilities free to the trippers. Bathing machines were available – the programme coyly directed female bathers to that part of the beach south of Britannia Pier which was reserved for them – as well as steamer trips, donkey rides, the aquarium, the piers, the museums, tennis courts and bowling greens, trams and cabs. In addition Bass arranged a full dinner for all, offered in a variety of venues across the town. The whole event was a highly complex and expensive logistical exercise on the part of Messrs Bass & Co. who reckoned that they gained more than they spent because it encouraged loyalty to the company and engendered good industrial relations.

Great Yarmouth has 5 miles of glorious sandy beaches. It also has two piers. The first was the Wellington Pier opened in 1853, followed hotfoot by the Britannia Pier in 1857/58. The present Britannia Pier is the second on the site. The pier as originally built was 700 feet long and was constructed of wood. It contained a jetty for serving steamers and space for the presentation of open-air entertainment. This suffered various

vicissitudes and was demolished in 1900 to be replaced by an entirely new structure of 810 feet, opened in 1902. It contained an impressive pavilion built by the Norwich form of Boulton & Paul, who were later famed as aircraft builders. This burned down in 1909 and its replacement was also burned down in 1914, seemingly the work of militant suffragettes. There were further fires but happily the Britannia is still trading. One marked oddity is the existence at nearby Potter Heigham of an extremely curious house composed of part of a helter-skelter that used to stand on the Britannia Pier.

When the Wellington Pier opened, it consisted of a timber platform 100 feet long with a landing stage and it was, of course, named after the Duke of Wellington. The pier passed into the hands of the local authority in 1900 and was rebuilt with a pavilion that is a flamboyant exercise in Art Deco.

In 1974 this building gained listed status. One oddity of Great Yarmouth was that its amenities at one time included a structure of iron and glass called the Winter Gardens bought second-hand from Torquay. This was opened in 1904.

In Admiralty Road in the South Denes stands the Norfolk Pillar. This has a figure of Britannia atop a 144-foot column built in honour of Nelson in 1819. Nelson landed at Yarmouth after his victories at the Nile in 1798 and Copenhagen in 1801. The column was open to the public in July and August and if the visitor was prepared to climb 217 steps, the view, at least on a clear day, was a rewarding one. At least it was but the public are no longer admitted. On the base of the column are the names of Nelson's most significant victories: Aboukir (also known as the Battle of the Nile), Copenhagen, St Vincent and Trafalgar. The pillar is surmounted by a figure of Britannia holding a trident in one hand and in the other a laurel wreath symbolising Nelson as the victor. The architect of the Norfolk Pillar, William Wilkins the Younger, is supposed to have committed suicide by throwing himself from its upper reaches upon discovering that the pillar he designed faced inland rather than towards the sea. Some say that Britannia is actually facing towards Nelson's birthplace. In 1863, a professional acrobat climbed the 217 steps but, not content with reaching the observation platform, he then clambered up the figure of Britannia. A large crowd, eagerly appreciative of this derring-do, gave him an encouraging burst of applause. Marsh, for that was the

The Wellington Pier, Great Yarmouth.

acrobat's name, decided to play up to his audience and do various ever-more-daredevil stunts for the crowd's delectation and entertainment. The bit the spectators enjoyed most of all was when he attempted to get up on the trident, missed his foothold and fell headlong to his death at the bottom of the pillar. Unfortunately, the Pillar stands in rather rundown surroundings and is itself rather shabby and unsafe.

The Town Hall contains a fine portrait of Britain's greatest naval hero. The Norfolk Nelson Museum is dedicated to memorabilia associated with Nelson. It stands on South Quay. The story is told that in 1800 it was decided to confer the freedom of Yarmouth on the diminutive naval hero. At the ceremony, he was asked to take the oath with his right hand but Nelson did so with his left hand, quipping that his right hand was at Tenerife. One local landlady wanted to change the name of her hostelry and asked Nelson what he thought about calling it the 'Nelson Arms'. Very politely he intimated that he was flattered but not keen on the idea because by that time he only had one arm.

The Maritime Museum for East Anglia in Marine Parade is housed in the former Home and Refuge for the Shipwrecked. The museum does what is suggested by its title. The refuge was opened largely as a result of the dedicated campaigning of the unsung Captain George Manby. An odd man who derived great pleasure from duelling and was once shot in the head while engaging in the habit; he was also quite incapable of preventing his numerous wives from leaving him shortly after the nuptials had been celebrated. However, he is guaranteed a place in nautical history by those in the know as the inventor of a shore-to-ship rocket which fired a line to vessels in distress offshore. It enabled them to bring off their crews and saved huge numbers of lives over the years.

The town has a museum dedicated to Anna Sewell (1824–97), authoress of that children's classic, *Black Beauty*. It is located in her birthplace, which displays some half-timbering (rare in Yarmouth), dates from 1641 and doubles as a tearoom. This novel, for which she received just £20, was published three months before her death and although it was an immediate success, she obviously did not have much time in which to enjoy her acclaim. It was her only novel. The Time and Tide Museum which commemorates the herring industry is housed in an old smoke house and still evocatively reeks of its everyday working smells which have presumably permeated its fabric.

In the early 1840s a suspension bridge was opened across the River Bure at Yarmouth. In 1845 a stuntman was giving a show which consisted of him being towed up the Bure in a washtub, of all things, pulled, even more bizarrely, by four geese. This absurd spectacle had attracted a large crowd who used the bridge to give them a grandstand view. As the entertainer in his tub passed under the bridge, the crowd moved to the other side to get a further view of him. The pressure created by this surge of humanity caused the chains of the suspension bridge to break and the bridge decking and the spectators plummeted into the river below. Although many were rescued, eighty people, mostly women and children, died that day. They were mostly buried in a mass grave in the churchyard of the parish church of St Nicholas. One who was buried in an individual grave has a headstone bearing the following inscription: 'Sacred to the memory of George H. J. Beloe, the beloved son of Louisa Beloe, who was unfortunately drowned by the fall of the suspension bridge on 2 May 1845, aged 9 years.'

There was a twentieth-century Royal Navy expression, 'to go Yarmouth' which basically meant to be hospitalised for being 'bomb-happy' or so stressed or traumatised as to be incapable of useful front-line service. The Royal Navy had a hospital at Great Yarmouth for such victims of the war.

Talking of war, Great Yarmouth was the first place in Britain to be bombed during the First World War. The aggressor was Zeppelin L3 and the date was 19 January 1915. A little while later, L4 attacked random targets in Norfolk including King's Lynn. Total fatalities on this occasion stood at four with some destruction of buildings. The damage to morale, however, was far greater. Within a few minutes the moat, which had always surrounded Britain and been such a decisive factor in the country's history and collective psyche, had been breached. If the country could be effectively attacked from the air, the moat, and the country's island position, no longer counted for much. Aerial bombardment brought the war to the civilian population. Things could never be the same.

Going back briefly to the matter of the town walls. The building of these walls started in 1285 and dragged on for many years but when completed they were over a mile in length. The face of the town towards the river was left without a wall because it was thought unlikely that an attack would be launched from that direction. Of the mural towers eleven survive but all the ten gatehouses have been demolished. There was a castle but no trace of this survives.

Offshore from the Norfolk Column and visible only when the tides are exceptionally low, are the remains of a barque, the *Sarah,* which was wrecked in a storm in 1897. Another barque, the *Erna,* was driven ashore in a terrible storm in November 1905. The pitiful plight of the ship as it was battered by the waves attracted large crowds of spectators. Fortunately, the crew was rescued but the crowds were then witness to an extraordinary sight bearing out the truth of the old adage of the rats leaving the sinking ship. The creatures, obviously instinctively aware that their cosy home was in the process of being destroyed, flung themselves into the sea in vast numbers and many made it through the waves. They did not stop when they reached the sand but proceeded to scurry up the beach looking for safe havens and there were enough of them to scatter all but the bravest members of the crowd.

In December 1927 a merchant vessel named *Oscar* caught fire off the town. The fire went out of control, although fortunately the crew members were all safely taken off. The abandoned hulk was literally incandescent such was the inferno aboard and it eventually broke up, spilling what was left of its cargo into the sea. This was composed of timber products and they came ashore in such quantities that vast and high piles of wood lined the high-tide mark. Not for long, though; this bonanza of free fuel was greatly appreciated by the locals who descended on it and carried off all they could handle before the unsympathetic authorities put an end to the fun. Roaring fires burnt in many a local hearth that Christmas. Doubtless some of the *Oscar's* timber went into homemade garden sheds and perhaps pigeon lofts. Some of it may still be serving a useful purpose.

Gorleston-on-Sea

Gorleston-on-Sea on the opposite bank of the River Yare is often regarded as nothing but an appendage to Great Yarmouth and it greatly resents the fact. In the late nineteenth century Forbes Philipps was a clergyman in the town and he wrote *The Romance of Smuggling* in the 1900s. In it he wryly comments that the vicarage he lived in had been designed by a previous incumbent. It contained large cellars for the storage of contraband and had once had a tunnel to a landing stage. This vicar had always been an eager participant in all the smuggling runs.

Gorleston is actually an older community than Yarmouth and continues to attract pleasure-seekers to its sandy beach. A couple of miles to the west stands Burgh Castle overlooking Breydon Water. This was built by the Romans around AD 275 and it is still an impressive military installation with its walls consisting of alternate layers of flint and brick. Strictly speaking, Burgh Castle is in Suffolk.

 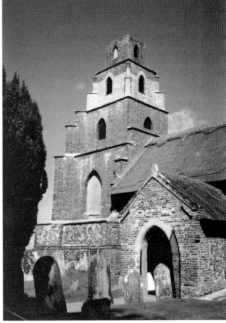

Above left: Lacon's brewery sign on a pub at Great Yarmouth. The brewery dated back to 1640 and was acquired by Lacon's in 1760. It was acquired by a London-based brewer in 1965 and the brewery was closed in 1968 and demolished. With the closure went a little bit of local tradition and character. Few industries can equal brewing for the rapacious way in which the bigger companies have swallowed up the weaker ones and destroyed choice for the consumer. Of course large numbers of small heritage and craft breweries have started up in the last twenty-five years but they do nothing to change the industry's domination by multinational corporations.

Above right: Burgh St Peter, the church tower. This church stands, isolated from its village, in a watery spot to the west of Lowestoft. The base is of the tower is medieval but then it is as if some child has come along and built the tower up with building blocks. It is not easy on the eye but the tower is regarded as a curiosity and is visited by those who like follies and 'rogue architecture'.

The Suffolk Coast

The Suffolk coast has, at Lowestoft, the most easterly part of the mainland of the United Kingdom. South from Lowestoft the story is once again of an embattled coast, much of which here consists of low, crumbling cliffs and some sizeable stretches of shingle. Few places offer such spectacular evidence of erosion as Dunwich or Orford Ness for coastal deposition. A stretch of unspectacular and largely unvisited coast, punctuated by Martello towers, runs south-west from Orford Ness to the mouth of the River Deben at Bawdsey. Felixstowe stands on a low cliff and then Suffolk peters out at Landguard Point where there are impressive views of the seemingly continuous procession of ships operating to and from Harwich and Felixstowe. A look at a map will show that Suffolk, unlike Norfolk, has a number of broad and deep estuaries penetrating some distance inland and some, such as the Orwell, can take large ocean-going ships.

Lowestoft

Lowestoft is a substantial town of ancient origin with a character very much of its own, although what can be seen today largely dates from the 1840s. The town seems to have started growing in importance in the fifteenth and sixteenth centuries as a fishing village with a huddle of huts around Lowestoft Ness and constituting a rival to nearby Great Yarmouth. It clearly became a place of some importance, if the parish church of St Margaret with its lofty spire is anything to go by. It was mostly built in 1480 and the situation of this sizeable building well away from the sea is something of a puzzle because there is no indication that there were many contemporary buildings nearby. Its size is evidence of the importance and wealth of the town at that time. The church contains many tablets commemorating naval officers and ships' masters who were born locally. The earliest of these date back to the seventeenth century.

Lowestoft seems to have sprung into fame in the eighteenth century when George II chose to return to his kingdom from one of his many trips to his beloved Hanover by landing at the town. It is said that as his party approached the shore in a small boat, a group of sailors waded into the sea and lifted the boat and its occupants onto their shoulders. The King was probably expecting to be tipped into the water because rarely has there been a sovereign who elicited less affection in his subjects. However, the King, his party and the boat on this occasion were carried onto the beach to the accompaniment of much cheering.

Exploiting the Dogger Bank and other North Sea fishing grounds, Lowestoft became one of Britain's major fishing ports, associated particularly with the catching of herring;

it expanded very rapidly after the development of the railway system with associated canning and food processing industries. It had also become a significant seaside resort with a good beach and its location made it a useful base for visiting the nearby Broads. Herrings cured at Lowestoft were exported to all parts of what became the British Empire. Now the largest numbers of fish landed at Lowestoft are plaice.

An old expression in that cornucopia of riches which constitutes idiomatic English language is 'A Red Herring'. Someone introducing a red herring into a conversation is trying to create a diversion away from the main point of what is being discussed. Why 'red herring'? In earlier times kippers were known as red herrings and they had a considerably redder colouration then than they do now. They have always, of course, had a strong and distinctive smell. When young foxhounds were being trained, one of the hunt workers would set off ahead of the hounds trailing something smelling of fox behind his horse. The hounds would then follow the scent but another worker would confuse the issue by riding across the path of the approaching hounds hauling a sack containing red herrings. The rookie foxhounds then had a choice. Those that were quick on the uptake would continue to follow the foxy trail but there would always be some who would find the red herring scent too good to resist. It was back to the schoolroom for them.

One feature of the town which gives it character are the numerous 'scores' or narrow lanes that connect the High Street of Old Lowestoft up on the cliff with the foreshore which contained an old fishing settlement with cottages, boat building sheds and net-drying areas. This part of the town became woefully neglected before traces of what was left gained Conservation Status. The scores have fascinating names. Among them are Herring Fishery Score and Lighthouse Score.

The town has a noble history of rescuing shipwrecked mariners and indeed set up its first lifeboat station in 1801, twenty-three years before the Royal National Lifeboat Institution came into being. Its lighthouses were among the earliest anywhere on Britain's shores. There is an excellent Maritime Museum in Hapload Road containing the history of the fishing industry in these parts. A curious feature of the town is the way in which it is divided in two by Lake Lothing, a stretch of water which connects with the Broads and is really part of Oulton Broad. Shipbuilding continues in this area as does much commercial shipping activity.

Above left: Malsters Score, Lowestoft.

Above right: Herring Fishery Score, Lowestoft.

Lowestoft's modern development however owes much to far-sighted entrepreneur Samuel Morton Peto. Among other things, he was largely responsible for the town gaining its railway links, the creation of the docks and harbour and also for the building of a Marine Parade and Esplanade and the launching of Lowestoft as a seaside resort.

Lowestoft was also very prominent in the Second World War as a base for small naval vessels such as converted tugs, trawlers, drifters and small pleasure steamers whose dangerous job it was to patrol the offshore waters. Near the lighthouse stands a war memorial to the men of the Royal Navy Patrol Service who, so the inscription goes, 'have no grave but the sea'. Not surprisingly, Lowestoft received a lot of damage from enemy bombers in the war. A total of 178 raids were made on Lowestoft and 266 lives were lost as a result, as well as much structural damage and destruction around the town. There is a Royal Naval Patrol Service Museum commemorating the host of small, hard-working and unglamorous ships engaged in coastal patrolling, minesweeping and other exceptionally hazardous duties. In Belle Vue Park stands a memorial to the Royal Naval Patrol Service. It is close to the Lowestoft High Lighthouse and was built to be the same height. This meant that the gilded sailing vessel atop the memorial is illuminated by the passing beam of the lighthouse.

Lowestoft Ness is the most easterly point in Britain. It is perhaps not surprising that it had the first lighthouse in this country – built in 1609. While pondering over these weighty facts, note that the Lowestoft & East Suffolk Maritime History Society has an excellent museum in Sparrows Nest Park, Whapload Road. Two large reminders of the town's fishing heritage have been preserved: a superbly restored sailing fishing smack called *Excelsior* and the steam drifter *Lydia Eva*. There are many other items to gladden the heart of any old salt. Unique is a photograph taken in 1925 of a sturgeon 11 feet 8 inches long and weighing well over 5 cwt. It was caught locally and it is difficult to tell who was more surprised, the monster fish or the bemused fishermen and his audience of admirers.

The town has a dual character because south of the bridge and the harbour is South Town, the resort part of Lowestoft which benefits from very fine sands. The Claremont Pier was completed in 1903 and later gained a substantial pier head. It was a project carried out by the Coast Development Company, which also built the piers at Southwold and Felixstowe with the intention that they should primarily be used as landing stages for pleasure steamers. This particular pier stands in water which becomes deep very quickly and so it is fairly short and had the advantage that ships could serve the pier irrespective of the tide. Extensive renovation was carried out in 1980 but the seaward end is currently closed to the public. Lowestoft South Pier was built in association with harbour works and opened in 1846. It was 1320 feet long. It has been updated as part of the work involved in creating the marina.

The North Quay is supposed to be haunted by a ghost which has allegedly been seen on several occasions by a number of different people. It is said to be the ghost of Edward Rollahide who had an argument with a fellow labourer when they were doing building work in the vicinity in 1921. It is possible that the argument started over a game of cards but witnesses stated that Rollahide was so incensed that he picked up an axe and started chasing Turner, the other man, with it. He swung the axe with such force that he lost his balance and fell into a pit of wet cement, suffocating before anyone could get him out.

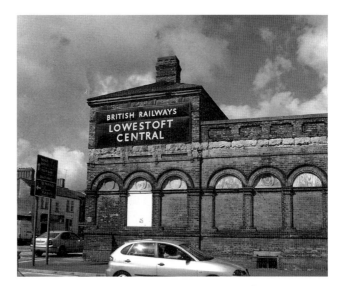

Lowestoft Station; this old Eastern Region of British Railways sign is at least fifty years old and has somehow survived to become a piece of living railway memorabilia.

This much seems fact – concrete evidence, if you like – but what supposedly happened next is a bit more unlikely. A few nights later, Turner was rolling back from the pub when Rollahide's ghost appeared, brandishing an axe and dripping wet cement in all directions. However, before the axe could fall and cleave Turner's head in two, the ghost disappeared through a wall. Turner, chastened by these events, went straight to bed and promptly died.

Benjamin Britten was born at Lowestoft. So were the four members of the rock group The Darkness.

Covehithe

This isolated spot is notable for the large ruined medieval church of St Andrew, containing in its gaunt and roofless nave a much smaller church with a thatched roof built in 1672. By this time the original church, which had been built in the heady days of the fifteenth century, had become too costly for the parishioners to repair after it sustained serious damage during the Civil War so they came up with this odd way of cutting costs while still glorifying God.

The coast hereabouts is retreating very rapidly – possibly as much as 10 feet in some years. Anyone thinking of buying a nice retirement home with a sea view around Covehithe should think very carefully. Insurance companies will not cover the risk of coastal erosion and there is no government compensation for anyone whose house tumbles into the sea, it's worth remembering the old Latin phrase, *caveat emptor*.

Southwold

This is a most elegant little town located on a low clifftop overlooking a beach with colourful huts giving something of an Edwardian feel to the foreshore while the town

itself gives off a largely Georgian and Victorian air mixed with elements of the Jacobean and Dutch. A feature of the town is a sense of spaciousness provided by a number of open greens. These are mute reminders of a devastating fire which razed 250 buildings to the ground in 1659. After the fire, the authorities decided to leave these areas open to act as firebreaks in the event of any future conflagrations.

Southwold is an ancient place. Its name means 'south forest' and it seems likely that the site where the town now stands was once an island, sheltered from the North Sea by Easton Ness to the north and Dunwich to the south. It is just possible that the Romans settled here because a hoard of Roman coins was found near Gun Hill on the edge of the town. The finding of such a hoard is not, of course, conclusive evidence of Roman occupation in the vicinity. Such is the extent of coastal erosion in the area that it is probable that any such settlement dating from that time is now under the sea.

Southwold is mentioned as a minor fishing community in Domesday and for many decades it was required to pay an annual tribute of 25,000 herrings to the Abbey of St Edmund at Bury St Edmunds. The abbey owned the manor of Southwold. The next period is something of a mystery but we do know that a chapel was built in 1200 by Cluniac monks from nearby Wangford Priory. It was dedicated to St Edmund. By 1220 Southwold had become a place of sufficient gravity to be awarded a charter for a weekly market to be held on Thursdays. In 1227 it won the additional valuable right to hold an annual fair. Such events, although they provided the opportunity for jollifications of various sorts, were primarily for trading, commercial and retail purposes and even just an annual event could bring considerable prosperity to the town as people converged on it from a wide hinterland, to buy and sell, and often socialise as well. The chapel was destroyed by fire and its replacement was the present parish church. In 1259 the manor of Southwold was exchanged by the Abbey of St Edmundsbury for land at Mildenhall. This meant that Southwold passed into the ownership of Richarde de Clare, Earl of Gloucester, who obtained a licence from Henry III to build a castle. It seems that work on this commenced but never got very far. Archaeologists think that they have found some traces of this at Skilman's Hill.

With Easton Ness to the north and Dunwich to the south being steadily eroded by the incursions of the sea, Southwold benefited most of all because this erosion and the associated deposition had the effect of silting up the estuary of the River Blyth at Dunwich. There was enormous enmity between the people of Southwold and those of Dunwich, both wanting to have a monopoly of the commercial trade by sea along this stretch of coast. One of the bones of contention was that ships from Southwold and also, incidentally, Blythburgh, had to pass through Dunwich Haven and many of them refused to pay the dues that Dunwich was entitled to levy, vitally important to the Dunwickers as their town gradually slid into the sea. Interestingly, given recent events when local authorities have demanded government assistance after having been hit particularly hard by natural, or in some cases man-made, disasters, the townsfolk of Dunwich petitioned the kings of the time for resources to enable them to enforce the levies on ships coming down the Blyth. They also petitioned for financial assistance to help them erect coastal defence works to keep the port open and stop or at least arrest coastal erosion. The submissions by the men of Dunwich do not seem to have had much success and sometimes the Dunwickers took the law into their own hands.

For example, in 1299, the Earl of Gloucester's ships all mysteriously sank while they lay in Southwold Harbour and this was widely believed to be the work of men from Dunwich. Nothing was ever proven. It is known that Dunwickers attacked men from Southwold when they were attempting to build a channel to the sea which would have obviated the need to take their ships out via Dunwich and paying the hated tolls.

Alas for Dunwich folk, a massive storm in 1328 suddenly and violently rearranged the coastline in this area and rendered the port facilities at Dunwich almost unusable. From them then on, Dunwich, which had been the premier seaport in East Anglia, went into steep decline. Dunwich's misfortunes were to Southwold's benefit; the town became increasingly prosperous and the church is evidence of Southwold's rise. It seems that Henry VII had a soft spot for Southwold because he gave it a charter of incorporation as a town in 1490, granted it the right to a second annual fair and also sanctioned a second weekly market, to be held on Mondays.

That indefatigable traveller Daniel Defoe (1660–1731) came to Southwold in the 1720s and found a town that was thriving on sprat catching and curing, with a busy commercial port. However, even then they were having trouble keeping the River Blythe from silting up as it approached the sea. They were also plagued by pirates, mostly French and Dutch, who seized many merchant and fishing vessels operating into and out of Southwold. On one occasion they stole a local ship lying just a couple of hundred yards from the mouth of the river. They even stole the ferry that plied across the river between Southwold and Walberswick. They didn't seem to know what to do with it because it was found some time later at Margate of all places. After vociferous protestations about the pirates, the government increased the town's two guns to eight and provided a man-of-war as an escort for the fishing fleet.

The great fire of 1659 has been mentioned very briefly. It occurred on an exceptionally windy night which aided the rapid and uncontrollable spread of the fire and it engulfed the entire town, almost totally destroying it. Around 300 families lost everything they had and the damage was assessed at £40,000 – a huge sum by the standards of the time. An appeal for help, material and monetary, was launched and it raised a considerable amount but it took over a century for the town's previous level of prosperity to be regained.

In 1672 the indecisive Battle of Sole Bay was fought off Southwold. This was between a fleet under the then Duke of York who later became the ill-starred James II and a Dutch fleet under their great naval commander, De Ruyter. This was in the days that Sole Bay really was a bay. It is still marked as such but coastal erosion has largely put paid to the bay which at one time provided a sheltered anchorage. Indeed the reason why the battle took place off Southwold was because the sheltered roads there provided a base for naval operations at the time, the English seeing the Dutch as their main enemy and Sole Bay being particularly useful in that respect. The fleet that took action against the Dutch consisted of 101 vessels and was a joint operation between the English and the French, a recipe for confusion, incompetence and ineptitude given the history of relations between the two countries. The battle was a classic case of English lack of preparation. When the Dutch fleet was sighted, the English mariners were hung-over from a great carousal they had been having the previous night and it took the town bailiffs four hours to round them all up and get them, bleary-eyed and sore-headed, into boats and out to their ships. Poor communication between the two

elements in the allied fleet meant that most of it was completely unprepared when the Dutch sent in several fireships. However, the Earl of Sandwich, second-in-command, who had reason to believe that he was generally regarded as a coward, had earlier set sail with his squadron of ships and came up unexpectedly on the Dutch from the rear, causing them great consternation. Sandwich was determined to expunge any suggestion that he was craven-hearted and he fought as though possessed, personally running his sword through one of the Dutch admirals. He and his men were, however, completely outnumbered and when his flagship caught fire, he realised he was fighting a losing cause. He assisted many of the officers and men in taking to the boats and then leapt from the burning deck into the sea dressed in his full admiral's uniform complete with the insignia of the Order of the Garter and all his other decorations. He sank like a stone. Nobody ever called him a coward after that.

There is a story that the night before the battle, the Earl stayed in Sunderland House, still to be seen in the town centre, and managed to lure a servant girl to share his bed for the night. He must have made a good impression because the girl was distraught when she learned of his death. Her ghost is said to haunt Sunderland House, perhaps unable to deal with the tragedy and hoping upon hope that her lover will come back to resume where he left off. In the High Street, Montague House was the home of the parents of Eric Blair, better-known as George Orwell. Apparently he always disliked Southwold, thinking it snobbish and pretentious.

The seagoing trade of Southwold was thriving again by the 1750s and in 1757 work was done to open up the Blyth for wherry traffic as far inland as Halesworth. A trade directory dated 1844 gives the trades of Southwold as a salt manufactory, two breweries, two maltings and several fish curing houses. When the herring industry experienced a particularly good year, Southwold sometimes acted as an overspill for Lowestoft and many Scottish herring craft were based temporarily in the port. Numbers of the rough-and-ready Scottish women who followed the fleet down the east coast and were occupied in gutting, salting and otherwise processing the fish would also have been in town. Quite what they made of Southwold's genteel charms, goodness only knows; or equally, what Southwold made of them.

The town was sporadically bombarded by German cruisers in the First World War. In the Second World War naval and anti-aircraft guns were installed, a hole was made in the pier to prevent it being used for invasion purposes (was this really likely?) and the harbour was blocked by a boom. Tank traps were built along the seafront and mines were laid down except in one small section where bathing was still possible. The little wooden chalets along the front were removed and scattered fairly randomly on the marshes nearby to prevent enemy planes landing but again that possibility seems rather a remote one given that the Germans were unlikely knowingly to try to land their planes in such terrain. The town suffered from frequent aerial hit-and-run raids and occasionally from bombers returning to Germany jettisoning their unused bombs.

Southwold is still prosperous, although mainly as a quiet watering-place, residential and retirement centre. It was ignored by the Industrial Revolution partly perhaps because it never became possible to put the river to significant commercial use and also on account of the town being effectively left off the railway map. It also stands relatively isolated on what in effect is a peninsular between the River Blythe to the south

and Buss Creek to the north. The main coast road runs some miles inland. Motorists can go into Southwold but not through it. It has a predominantly shingle beach which although pleasant is very exposed to the prevailing easterly winds.

The town is famous for many things. It perhaps has three particular icons. One is the jolly white lighthouse built around 1890 which from a distance appears to protrude right from the centre of the town. Closer, it appears to be in the back yard of the Sole Bay Inn. It certainly has more urban surroundings than the majority of British lighthouses. It also has 'Southwold Jack', the splendid parish church and, dearest of the three to the author's heart, it is the fountainhead of Adnams excellent beers. The author believes that these fine traditional ales are at their very best when sampled within sniffing distance of the brewery. Small family brewers are now largely a thing of the past but Adnams have been very astute in their business strategies and marketing techniques. They have a strong brand and their products are sold across the whole of the UK and extensively abroad. Long may they continue! The author is not sure whether the practice continues but he does remember when the spent malt was taken away in a lorry bearing the immortal legend, 'Adnams pigs are happy pigs'. You bet they were!

It would be positively churlish not to say a little more about Adnams Brewery. Brewing in Southwold was first recorded in 1345. The origins of this famous company go back to the eighteenth century, but the actual Adnams family connection dates only to 1872. In that year George and Ernest Adnam acquired the brewery and embarked on a programme of expansion. This was quite successful but George lost interest and decided to leave for greener pastures. He immigrated to Africa where he was last heard of being swallowed by a crocodile. He did not survive the experience. Despite this setback the company has gone from strength to strength. They have fought off a number of takeover bids which would almost certainly have led to closure of the brewery and the loss of many local jobs. There are still family members on the board of directors.

The parish church of St Edmund is enormous, being one of the largest in a county with many large and fine churches. The tower is a powerful composition in flint and there is attractive external stone and flint flushwork. It has a superb pre-Reformation wooden rood-screen with wonderful original paintings which somehow at least partially managed to avoid the destructive seal of the puritan iconoclasts of the sixteenth and seventeenth centuries. Angels gaze down from the hammer-beam roof. 'Southwold Jack' is a fifteenth-century oak figure of a man-at-arms, carrying a sword and a battle-axe. When the cord is pulled, the axe strikes a bell to signal the start of a service or the entry into the church of a bride for her wedding ceremony. For many years, Southwold Jack was the trademark for Adnams Brewery.

Just south of the town centre are the green slopes of Gun Hill where there are six ancient cannons, pointing out to sea. Their predecessors were given to the town in 1630 by Charles I to defend it against privateers mostly sailing out of Dunkirk. The present guns were given to the town by George II in 1745 because the locals complained that their existing guns were too small and decrepit to be of any use for defensive purposes. The new guns were duly installed. They were 18-pounders and the townsfolk were immensely proud of them. Now they were safe! What they had not been told was that these guns were actually 150 years old and therefore even older than those about which

they had been complaining! Strangely, these guns were hidden away by the authorities during both World Wars. Perhaps they were frightened about what might happen if the Germans landed and commandeered them – an unlikely scenario.

About a mile down the coast from the town is Southwold Harbour. It stands at the mouth of the River Blyth and is an idyllic spot, by no means beautiful but redolent of the pleasures of simply messing about in boats. There are innumerable small pleasure craft, coastal fishing boats, drying nets, floats and all manner of working and redundant nautical paraphernalia. Fresh fish such as plaice, flounder and whiting can be bought. There is a rickety jetty for the ferry across to Walberswick. The pub (Adnams of course), serves excellent fish and chips. Marks on the wall of the pub show how high the water has reached during some of the floods that are experienced here from time to time.

The track of the long-abandoned narrow-gauge Southwold Railway, closed in 1929, provides an attractive pathway through stretches of gorse and blackberry and across the River Blyth to Walberswick. The Southwold Railway was a quaint and quirky line which continued across the marshes to Halesworth where there was a station on the East Suffolk Line between Lowestoft and Ipswich. It was generally reckoned that it didn't matter if you just missed a train from Southwold because a reasonably fit person could stroll along the track and catch it up, so leisurely was its progress. It was said that the engine driver sometimes stopped the train to pick groundsel for his budgie. Rumours circulated that the firemen on the engine would bake potatoes or chestnuts in the firebox if requested or that the train would draw gently to a halt in the middle of nowhere if a passenger had told the driver that he wanted to do a spot of bird-nesting or black-berrying. Small wonder then that a visitor in the 1900s said, 'Southwold without a doubt is the least obtrusive of all the East Coast watering places that are accessible by rail'.

The Southwold Railway with its little blue locomotives and maroon coaches was built on a narrow gauge and everybody who used it found it endearing. The company got quite angry, however, when it was described in one guide book as a 'quaint toy railway' because it took itself very seriously even if no one else did. A railway historian described it as having 'an apparent unconcern for the timetable'. A service of five trains in each direction was the usual provision, perhaps generous under the circumstances. However, you can tell that the railway company had pretensions because it worked with Adnams to build one or two hotels in the town with the intention of accommodating the hordes that they hoped would arrive in the town by rail. They never did. The formation of the line can be used for a pleasant walk through the gorse to Walberswick. A branch off this branch line (a twig?) served Southwold Harbour.

Southwold began to develop as a seaside resort in the 1820s and 1830s. Although the town has never made any real concessions to popular tourism, it has had a pier but as is the way with piers, it has proved vulnerable to damage and for many years it consisted of little more than a stump at the landward end. The pier had opened for business in 1900. Steamers stopped calling after a storm which damaged the pier in December 1933. The pier was breached early in the Second World War and later damaged by a drifting mine. Repairs were affected in 1948 but this structure was already in a dire state and succumbed to storm damage as well as being hit by a drifting vessel in 1979. Little was left apart from an amusement centre at the landward end. It is very gratifying to note that Southwold's neglected pier was rebuilt, upgraded and reopened in 2002

 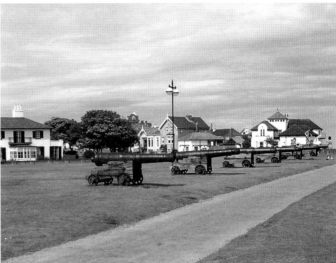

Above left: Southwold Jack.

Above right: The cannon on the South Cliff, Southwold.

Southwold Harbour from the Walberswick side of the River Blyth.

when on 21 June the MV *Balmoral*, laden with passengers and television crews, docked at its outer end at 16.15 hours, the first ship to have called since 1928. Later the same vessel left with 510 passengers to do a trip round the bay and to return to the pier to the accompaniment of a spectacular firework display. The pier is currently 620 feet in length. One or two very substantial large hotels were opened in the early twentieth century. One of these was the Grand, just up the cliff from the pier. They have gone the way that such establishments in small resorts have tended to go.

Southwold has a very fine example of a dying breed. This is a museum established by the local Archaeological & Natural History Society. What makes this one unusual is that it has not faded away, been closed down or taken over by the local authority. It is still run by volunteers and it really captures the history and character of the town. It stands in Victoria Street. Another little gem is the Southwold Sailor's Reading Room on East Cliff. A variety of interesting marine paraphernalia is on view. A definite oddity is the Alfred Corry Museum in Ferry Road. This is the building which stood at the end of Cromer Pier and housed the local lifeboat. It was removed from Cromer and installed close to the town to house the *Alfred Corry* which served as Southwold's lifeboat for many years.

However, part of the charm of Southwold is that it has never gone out of its way to attract visitors. It has never had to.

Blythburgh

This village, situated on a brackish creek, part of the River Blyth, possesses a huge parish church sometimes called the 'Cathedral of the Marshes'. Both the size and the opulence of this church are reminders that Blythburgh was once a seaport of substance and prosperity engaged in weaving and trading particularly in wool. It could not last.

Picture Palace, Southwold; still alive and kicking.

Ships got bigger, the Blyth silted up and the town went into decline. Before that, there had been a priory, two chartered fairs a year, a jail and even a mint.

The church combines a fourteenth-century tower (it once had a spire) with a copybook nave and chancel of the Perpendicular style of the mid-fifteenth century. The overall impression created is one of space, grace and light. Medieval Suffolk produced some wood carvers capable of very high-quality work. One of the delights of their handiwork is that it was 'people's art' rather than fine art, the carvers being humble craftsmen. While they clearly displayed their devotion in their handiwork, they were not po-faced and consequently vitality, a range of emotions and a strong sense of humour are very evident in their work. In an age of generalised illiteracy, universally recognised symbols were used to convey concepts. All the best-known saints had a story concerning their good works and virtues or sometimes the manner in which they were put to death for their beliefs and a symbol was used to encapsulate these. In the choir stalls may be seen; among others, Bartholomew with a knife, Matthias with an axe and Matthew with a purse or money bag. In the ancient benches in the nave, the journeyman carvers combined piety, artistic skill and robust peasant humour to provide the modern observer with priceless insights into the popular culture of the Middle Ages. For example, carvings depict the Seven Deadly Sins and visitors today can discern Gluttony looking as if he has bellyache and Pride strutting around in his finery, while Slander can be seen with a slit tongue and Sloth lies on his bed.

The church was badly treated by Parliamentary soldiers billeted in the area during the English Civil War. They amused themselves by using the gilded angels that decorate the timber roof as targets for musket practice. They used the church for stabling their horses.

An odd feature of the church is the 'Jack-o'-the-Clock'. This is a painted wooden figure holding a hatchet and it strikes a bell with the hatchet and turns its head when a string is pulled. There is an alms box with the very early date of 1473. This was originally installed to receive 'Peter's Pence', yet another fundraising enterprise on the part of the Vatican in Rome. This meant that gullible, sin-ridden ordinary folk felt that they ought to shell out their groats and farthings which, instead of going to help even needier people in England, went instead to boost the bulging papal coffers in Rome. There were many benefits resulting from Henry's Reformation of the Church some years later. One of them was an end to the tomfoolery of Peter's Pence.

The spire referred to earlier fell during an appalling storm in August 1577. It came down during a service killing three worshippers. Of course some people eagerly opined that this was down to divine retribution. Others said that the fall was caused by Black Shuck, the monstrous Black Dog that haunts the eastern counties. It is likely that both these explanations are somewhat wide of the mark and that the spire was actually struck by lightning.

It is worth saying something more about Black Shuck, the Demon Dog. A persistent story in several parts of England but most particularly in East Anglia is that of a very large, lone dog which lopes along the lanes or leaps over walls and has luminous jowls looking as though they are alight. Alliteration apart, it patrols at night. In Suffolk folk believe he is harmless, if terrifying, and problems only arise when he is challenged. The death of the challenger usually follows swiftly. The Norfolk Shuck is more formidable, as black as Newgate Knocker and equipped with an eerie, heart-stopping shriek.

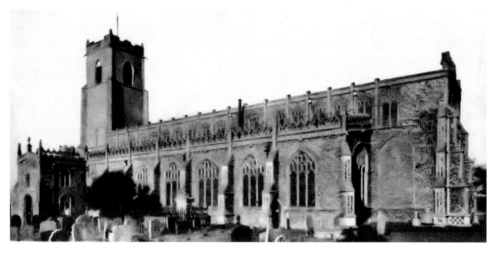

Blythburgh Church.

This hellhound has a habit of following belated walkers. First they hear his pads clicking on the pavement and then his breathing down their necks. What he exhales is ice-cold. No one can look at Black Shuck and live. Curiously enough, the Essex Shuck is altogether different, being of a benevolent nature and even guarding benighted travellers. However the fact that he lurks around burial places means that he cannot completely cast off his diabolical antecedents. It is thought that Arthur Conan Doyle, when on a visit to East Anglia and hearing about the Shuck, gained the inspiration for the spine-chilling Sherlock Holmes story *The Hound of the Baskervilles*.

Blythburgh is now little more than a hamlet but it still boasts an excellent old inn, the White Hart. The River Blyth made a handy route to bring contraband some little way inland and the pub has a window in which a light would be displayed giving guidance to smuggling vessels in the vicinity.

Walberswick

Just across the mouth of the Blythe from Southwold, and more easily reachable from that town by footpath or ferry than by road, is the village of Walberswick. This is another place of ghosts, once a flourishing fishing, commercial port and boat-building centre where the keels of large numbers of wooden vessels first tasted saltwater. The present village is widely dispersed, partly the result of devastating fires in the seventeenth century. The gaunt remains of the huge church somehow epitomise Walberswick's decline. As the fortunes of the community ebbed from the mid-sixteenth century, there were insufficient resources to maintain the church. In 1695 the decision was taken to remove the roof from most of the building, except for one aisle which was retained for worship by the shrunken community. The rest became ruinous with the exception of the lofty tower, serving as a seamark. Walberswick's great days were between the middle of the thirteenth century and the first quarter of the seventeenth.

Walberswick has pleasure boats, fishermen's huts and picturesque nooks and crannies. It has traditionally housed a colony of artists, greatly attracted by the quality of the light on this highly atmospheric part of the coast. Perhaps the best-known of these artists was the Impressionist Phillip Wilson Steer (1860–1942). Another eminent man from the world of arts associated with the village was Charles Rennie Mackintosh (1868–1928), the innovative architect, designer and water-colourist. By the late 1900s, he had become an embittered and disillusioned man, frustrated by the fact that despite achieving great respect and admiration in Europe, he failed to receive similar recognition in his beloved Glasgow. In 1914 he moved to Walberswick and stayed for around a year. He roamed the lanes painting a series of delightful watercolours of hedgerow plants and flowers. However, the horrors of the First World War were hanging over Britain. Mackintosh, brooding and self-absorbed, had a strange habit, especially when the weather was bad, of marching some distance into the sea where he would then stand motionless for long periods. This attracted the attention of vigilant local busybodies. He also had a penchant for rather outlandish headwear and voluminous capes, was unfriendly and when forced to speak, did so in broad Glaswegian which was virtually incomprehensible to the locals. Soon rumours started to circulate that he was a German spy. He was actually detained by the authorities and was extremely angry that he had to prove to them that he was a harmless patriot, albeit one who behaved oddly.

A local story goes that back in the eighteenth century, a soldier of African origin serving with a regiment of dragoons was supposed to have raped and murdered a local girl at a lonely spot among the lanes nearby. He paid for the crime with his life. Ever since that time, so the story goes, there have been sightings of a coach drawn by headless horses, careering down the local lanes, the horses spurred on to frantic efforts by a black coachman wielding a whip. Without wanting to pour too much cold water on these sightings, it has to be said that variations of this story, admittedly usually without coachmen from ethnic minorities, can be found across England.

Like Southwold, Walberswick is a wonderful place for pottering about doing absolutely nothing at all but enjoying a sense of relaxing timelessness. Walberswick, it can truly be said that it is soporific. It is none the worse for that.

Dunwich

Although there are traces of Roman activity here when Dunwich was something like 4 miles from the sea, no human hand could successfully stay the effects of the tides. Bede described Dunwich as the capital of East Anglia. We know that in medieval times this was a walled town, a port of great significance, the seat of a bishop's diocese complete with a Cathedral and with eight to twelve churches. It may have had a population of about 5,000. King John granted the borough a charter, with all rights over wrecks on its shores, for an annual payment of 5,000 eels. What on earth would you do with 5,000 eels? How could you ever count the blasted things? Actually, eels were a valuable commodity and could be readily sold but it was the nominal price that 5,000 eels would fetch that constituted the tribute to the King. Dunwich had its

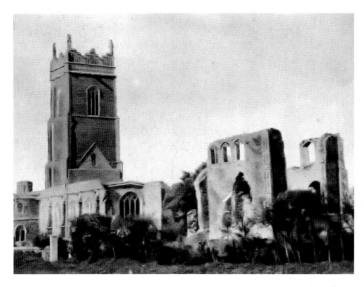

Walberswick Church.

own harbour, busy shipbuilding yards and its water gate in the twelfth and thirteenth centuries, but Man's puny efforts could not counter the effects of nature.

A huge storm in 1328 diverted the mouth of the harbour and shifted the River Blyth northwards. This then exposed the coast hereabouts to the full fury of the North Sea and the fate of Dunwich was sealed. Without its harbour, the town of Dunwich lost its *raison d'être*. Man could not control the force of the sea. By 1753, two-thirds of the town, including six churches and three chapels, had disappeared without trace into the sea. It continued to provide two MPs right through to the Great Reform Act of 1832 despite the fact that for much of the time it had no voters. It was a classic 'rotten borough'.

Now all remnants of its religious houses are beneath the waves which continue to scour away at the coast and sometimes tides wash up bones which the tides have unearthed from burial places long since gone under the sea. It is only to be expected that stories exist of the sound of bells rung from submerged steeples being heard on certain nights of the year. Equally fanciful tales are those of the lowing of herds of cattle on long-sunken pastures and even the sound of horses' hooves thudding along roads which are now far beneath the waves. Its last ancient church went over the cliff early in the last century. Other artifacts often washed up at Dunwich include objects dating from Celtic, Roman and medieval Britain. Dunwich is arguably the most spectacular example in this country of the disastrous effects of sea erosion.

There is an excellent museum of local history. It is located in a row of cottages and is suitably melancholy as befits its purpose of displaying the past of a town almost all of which has disappeared. Artefacts or fragments of them going back to Roman times are on display and there are impressive reconstructions of how the town may have looked in the Middle Ages and a wealth of visual material on its history. A collection of stuffed specimens of local wildfowl, now alas all too rare, includes common bittern, spoonbill and ruff. The front upstairs windows look out across the marsh and a possibly unique feature is a pair of binoculars in each window so that the visitor can peer through in the rather forlorn hope of catching a glimpse of a living spoonbill or other *rara avis*.

The force of the storms which still ravage the coast mean that all manner of other articles appear on the beach from time to time, washed down from the crumbling low cliffs or washed up by the waves. Many of these used to be collected by the owner of the local refreshment room. Among them were numbers of Dutch wooden sabots. The odd thing is that all those that have been recovered are for the left foot. Was there a secret cell of Roman Catholics nearby?

A man whose name became immortal was born at Dunwich. He was George Downing. His family owned the land on which a terrace of townhouses was built in Westminster around 1680. Of the original houses, only Nos 10, 11 and 12 remain. After the street was acquired by the Crown, it became the custom for the Prime Minister of the time to use No. 10 as his London residence. No. 11 is occupied by the Chancellor of the Exchequer and the Government Chief Whip has his *pied-à-terre* at No. 12. This is all very cosy and neighbourly. Do they pop into each other's to borrow a cup of sugar?

Nobody could pretend that Dunwich is a seaside resort but it is by the sea and it possesses a strange, rather melancholy atmosphere which can perhaps be put down to a sense of awareness of its own past importance and the presence of ghosts from that past. In truth there is not a lot to be seen at Dunwich. The settlement – it scarcely warrants the word 'village' – has a Victorian parish church with a medieval leper chapel beside it. There is an archway of one of the medieval monasteries still *in situ*. This establishment belonged to the Greyfriars. A big attraction so far as the author is concerned is the pub, The Ship, a convivial establishment which has an unusual and very attractive stained glass sign. It also does fish and chips to die for. Yes, it is an Adnams house.

On sunny and warm summer days, Dunwich can be quite busy with visitors and no one can begrudge those who come to enjoy themselves, most of them far more interested in the sea and the beach than in ruminating on the history of the place. When the crowds are gone, however, the ghosts happily emerge and, for the author, the place comes into its own on a grey and bleak late November afternoon when there is absolutely no one about and the spirits of the past, otherwise reticent, stalk invisibly through this place of memories and lost grandeur. It has been claimed that crowds of rather indistinct people can sometimes be seen looking out to sea. Assuming that those making the reports are not simply short-sighted or have left their glasses at home or that it is not a foggy day, we are left with the possibility that this phenomenon is nothing less than the ghosts of former citizens gazing out disconsolately over the waves which now conceal the scene of their lives, their loves, their successes and their disappointments.

There has been a proposal, apparently serious, to reproduce in sculpture just offshore in the sea the lost churches of Dunwich. Is there any point to this?

South of Dunwich is the Nature Reserve at Minsmere. About 200 different species of bird are recorded here in a normal year and exotic residents include marsh harriers and avocets.

Thorpeness

Thorpeness is no more than a village a mile or so to the north of Aldeburgh but it is unusual in that it was built entirely as a speculative development. It was planned as

a holiday centre, a kind of recreational mini garden city. Previously there had been a fishing hamlet and this was bought up by Glencairn Stuart Ogilvie, landowner, barrister, playwright and eccentric, in 1910. He proceeded to build what he thought was an idyllic residential village and seaside resort of houses available for self-catering holidays. There had been an inundation by the sea which had flooded a particularly low-lying piece of land. Ogilvie inspected it and decided that it should be made into an artificial lake just 3 feet deep called 'The Meare'. He also built a country club. Thorpeness, however, was designed to be entirely without the razzmatazz associated with Great Yarmouth or Clacton, for example. The problem was that there was no very effective water supply and Ogilvie did not want his little Shangri-La spoiled by any ugly or obtrusive water tower. The result was the well-known folly 'The House in the Clouds' originally called 'The Gazebo'. This was a five-storeyed tower underneath a brilliantly disguised 30,000-gallon water tank. The tank was concealed in a clapboarded house with pitched roof, chimneys and sham windows, perched incongruously on a narrow pedestal, also with windows. The ensemble is quite spectacular at 85 feet in height. Close by is a post mill which was formerly used to raise water into the tower.

As a speculative venture, Thorpeness proved very successful but the rental costs were high and the village was unashamedly aimed at the well-to-do. With the village growing the water tank in the clouds proved inadequate and a new larger-capacity tank was built disguised as a vaguely Norman tower called Westgate located over an arch in a parade of mock Tudor houses. 'The House in the Clouds' now belongs to the Landmark Trust and

Above left: Gateway of priory, Dunwich.

Above right: The House in the Clouds.

is let as holiday accommodation. All in all, Thorpeness is a very odd sort of a place. This is not meant as an insult. There simply is nowhere else quite like it.

There is much pleasant woodland and heath nearby but the area is somewhat dominated by the giant power-generating facilities at Sizewell. These can be visited. The authorities have laid on car parks, picnic sites, guided tours and pro-nuclear propaganda masquerading as 'facts' but the author has no wish to return.

The coast has changed considerably round here and was previously far more remote and lonely. Sizewell Gap was a favourite place for landing smuggled goods which could then be hidden if necessary in the marshes nearby. There was a network of channels large enough to be navigated by punt, for example, and these provided an easy way to move contraband around. The local smugglers were well organised. At one farm they had a heap of dung hiding a trap door down to an underground store used for secreting smuggled goods. The dung was obviously a deterrent to anybody searching the premises for illicit items. It was not without its dangers for the smugglers either. On one occasion a trio of smugglers ignored warnings to wait for the poisoned air to clear before descending into the store. They were all overcome and two of them died from the fumes.

Aldeburgh

Aldeburgh, which means 'old or disused stronghold', is a prosperous little town and watering place with a variety of mixed architectural styles. In Domesday, the place was identified as having two manors, Aldeburgh and Snape, and it belonged to the Priory of Ely. It had two parish churches. Later, the manor passed to the Benedictine House of St John of Colchester. St John's rights included that to ownership of all the flotsam and jetsam washed up on the local beaches. It grew up after a medieval town nearby was destroyed by the sea. Fishing for sprats and herrings provided a living for some in the town and others were occupied in shipbuilding. There were important salt pans. In 1547 Edward VI granted Aldeburgh a charter of incorporation as a town and also licensed it to hold a market on Wednesdays. The town had probably spent much of the medieval period in the relative economic doldrums but it now embarked on a period of growing prosperity based on the development of its fishing industry. Aldeburgh boats are known to have sailed as far as Iceland in search of cod and ling. A Saturday market was granted in 1568.

At one time the town was one of the leading east coast commercial and fishing ports and a major shipbuilding centre. Two of Sir Francis Drake's ships – one of which was *Pelican*, later renamed *Golden Hind*, in which he circumnavigated the globe – were built there. Some idea of the newly found importance of Aldeburgh is that it supplied four ships for Howard of Effingham's fleet to fight the Spanish Armada. Shipbuilding declined in the seventeenth century. This nautical activity mostly took place at the settlement of Slaughden at the southern end of the town on the River Alde. Very few traces of Slaughden survive.

The town was constantly threatened by the sea and, in 1590, an ordinance was brought in which forbade the locals from removing stones from the beach. Despite this, between 1582 and 1590, about a dozen houses were destroyed and in just one major

storm; 20 feet of land went permanently under the sea. Another hazard was shared with Southwold up the coast. This was the periodic depredations of pirates and privateers, especially from Dunkirk. The people of Aldeburgh were hardly saints. At times when the town was in the doldrums, bills were paid from the income gained by smuggling.

In 1645 and 1646, the notorious self-appointed 'Witchfinder General', Matthew Hopkins visited the town. Because he received a payment for each person who was arraigned as a witch as a result of his 'investigations', he seldom visited any settlement without homing in on one or two hapless victims. They were usually elderly widows or single women, often lonely, poor and vulnerable and therefore an easy target for the cruel and rapacious Hopkins. Men also attracted his ministrations but in fewer numbers. People of financial 'means and social status were studiously ignored even where they were denounced by malicious informants. It is known that seven 'witches' died in 1646 as a result of his second visit to the town. Contrary to popular belief, suspects were not usually physically tortured but were subjected to long and extremely hostile cross-questioning which, over a period of days, disorientated them as well as threats that something horrible would happen to them if they did not co-operate and denounce others. Some of his victims were kept awake for days on end and became so debilitated and confused that they would say just about anything just to get the ordeal over. The awful work of the wretched Hopkins reached its peak in the 1640s when the Civil War led to the breakdown of law and order and increased social tensions. East Anglia was a strongly Puritan area and in the atmosphere of fear, hysteria, bigotry and sanctimonious self-righteousness that they engendered, it was all too easy for people like Hopkins to gain credibility and to prosper. Happily, Hopkins himself was denounced as a witch, found guilty and hanged in 1647.

Little is known about the early history of Aldeburgh but flint implements and traces of an Iron Age settlement have been found nearby. Scanty Roman remains have been located just to the west. It is known that three Roman roads converged on Aldeburgh and this suggests that the place was of some importance to the Romans but the historians seem to be at a loss to explain why. The Saxons were certainly attracted here, because various burial sites have been unearthed with a variety of artefacts such as a gold ring, cloth, fragments of weapons and iron bolts from the hull of a ship. Perhaps most remarkable is some human hair of a striking auburn hue which is thought to date from this time. Some of these items are on display in the excellent museum. It is housed in the gnarled Moot Hall, a timber-framed building, the lower storey of which was built around 1530. It is a trademark building for Aldeburgh but it looks rather self-conscious, as though it is actually a modern reproduction placed there to welcome visitors to the town and to set the scene, as it were. In earlier times, it would have had more buildings around it and have been much further from the sea.

Although traces of the Roman occupation have virtually disappeared under the sea, there is abundant evidence of the continuity of human activity over the centuries at Aldeburgh in the Moot Hall of Henry VIII's reign, the church rebuilt in the same reign, the most northerly of the Martello towers and much Victorian and some later and quite seemly development. Today Aldeburgh is a town of considerable character, described by E. M. Forster as 'a bleak little place, not beautiful' although apparently he was much struck by it. A few small fishing boats stand on the pebble beach and every

so often there is high drama when the lifeboat is launched. The town is sedate, self-conscious and expensive.

There was particularly high and unfortunately tragic drama at Aldeburgh on 7 December 1899. The lifeboat, epoymously named *Aldeburgh,* was called out to an incident. She had a proud record, having saved around 152 lives during her career, but on this occasion she capsized and her entire crew drowned. A plaque in the church recalls the incident. Just as the Cromer lifeboat had its Coxswain Blogg, so Aldeburgh had a hero of equal stature in James Cable. Before the days of motorised boats, manoeuvring a sailing lifeboat in heavy seas required not just seamanship of the very highest order but strength, determination and courage. In just one storm in 1893, the lifeboat of which Cable was in command rescued fourteen men from a Russian barque and seven men from a cutter. Cable was always modest and self-effacing and his autobiography endearingly understates the difficulties and dangers he faced.

Aldeburgh is the setting for much of the poetry of the appropriately named George Crabbe (1754–1832), a native of the town. His best-known poetic work, 'The Borough', points to the harsh conditions by which the local folk made a living from the sea. Crabbe was the son of a collector of salt taxes but the house where he was born has vanished beneath the sea. He struggled to establish himself as a writer and underwent many vicissitudes before winning patrons who put him on the road to success. His writings are deeply influenced by his experience of life at Aldeburgh. Aldeburgh is the setting also of Benjamin Britten's opera *Peter Grimes*. Britten was a conscientious objector during the Second World War and he spent much of the hostilities living in the USA where, perhaps strangely, he first came across the work of Crabbe. *Peter Grimes* is based on Crabbe's work and it provides a musical pen-portrait of the eponymous tortured fisherman. Crabbe said of Aldeburgh:

...the ocean roar
Where greedy waves devour the lessening shore.

He also said:

Here samphire banks and saltwort bound the flood,
There stakes and seaweed withering in the mud;
And higher up a ridge of all things base
Which some strong tide has rolled upon the place.

Most visitors and clearly its well-heeled residents find Aldeburgh a delightful spot, but Crabbe's own son had little time for it and described it in these words: 'a poor and wretched place, with no elegance and gaiety. The town lies between a low hill or cliff, on which only the church and a few better houses are situated, and the beach of the German Ocean. It consists of two parallel and unpaved streets, running between mean and scrambling houses, the abodes of seafaring men, pilots and fishers.'

One major impression that Aldeburgh gives is of how vulnerable it is to the continuous and inexorably erosive attentions of the hungry North Sea, but hopefully it will not disappear for a while. There were once three streets between the Moot Hall and

the shingle. Most visitors these days find Aldeburgh a delightful quiet spot in which to potter. The church of St Peter and St Paul stands a little way uphill from the beach. In the churchyard lie Crabbe's parents and from its fine Jacobean pulpit Crabbe himself preached. Crabbe and Aldeburgh did not get on well. He was curate for a short time before taking himself off to another Suffolk parish, some distance away. Once there he decided to get his own back on the Aldeburgh parishioners who he described as 'a wild amphibious race, with sullen woe displayed on every face, who far from civil arts and social fly, and scowl at strangers with suspicious eye.' The church contains a memorial window to Benjamin Britten by John Piper and a memorial bust of Crabbe. Britten is buried in the churchyard with his lifelong partner, Peter Pears, close by.

A curious feature of the town are two tall watchtowers which were manned by two rival gangs, the Up-towners and the Down-towners who used them to spot ships in trouble and likely to become wrecks. When one was spotted they raced to reach the scene first so that they could establish salvage rights.

Bathing machines were early in use in a town that prided itself in being a decorous watering place. However, using these machines did not always prove an enjoyable experience if this jaundiced comment is anything to go by: 'I was ruthlessly ducked into the wave that came like a devouring monster under the awning of the bathing machine – a machine whose inside I hate to this day.' Aldeburgh set out its stall early on to cash in on the fad for bathing in and drinking sea water and accommodating and providing facilities for well-to-do visitors. For a place hitherto largely dependent on the harvest of the sea, this brought employment and a welcome diversification of the town's economic base. In keeping with Aldeburgh's desire to be a modest, select but modish seaside watering place, in 1863 legal powers were obtained for the building of a pier. In keeping with the modesty of Aldeburgh, it was to be a modest pier, just 180 yards long. Building work commenced at a point directly opposite the Moot Hall. No sooner had the first four spans been erected than a sailing barge hit the pier, damaging it beyond economic repair. The building project was immediately abandoned but the damaged and half-completed structure remained an eyesore for many years.

Fishing continued to be a major occupation. Soles, lobsters, herrings and sprats were among the main catches of a small-scale local fishing industry. The fish caught was mostly dispatched to London and some, surprisingly, sent to Holland. This may sound like a joke but sprat oil was used for burning in gas lamps in London and apparently it was Aldeburgh that supplied a lot of the sprats that ended up lighting the streets of the Metropolis. There are still about twenty-five registered fishing boats based at Aldeburgh. They are small inshore vessels and much of the catch is consumed in the towns many hotels and restaurants. There are also stalls selling the day's catch on the foreshore. It is difficult to get fish fresher than that.

The threat of invasion by Napoleon's forces seemed very real in the early years of the nineteenth century. Aldeburgh housed a large military camp and several warships were based offshore. A chain of forts known as Martello towers was erected along what were thought of as vulnerable parts of the coast of East Anglia and south-east England and the most northerly of these was at Aldeburgh. By the time the chain of forts had been completed in 1812, the threat of invasion had gone and the Martello towers never fired a shot in anger. These curious little forts, the majority of which somewhat resemble

gigantic pork pies, take their name from a fortified tower at Mortella Point on the island of Corsica, which had successfully withstood heavy naval bombardment in 1794. Armed with just two 18-pounder guns and one 6-pounder, this tower withstood an attack by a British ship-of-the-line mounting seventy-four guns and a frigate with thirty-two. This piece of derring-do so impressed the British that seventy-three forts of a similar style and three larger redoubts were built. The towers in Suffolk and Essex originally numbered just short of thirty. The tower at Aldeburgh is unique because it is larger than the rest of this chain of forts, is built on a quatrefoil plan, and was more heavily armed. It was designated Tower CC and it is let by the Landmark Trust as holiday accommodation.

A most notable mayor of Aldeburgh was Elizabeth Garrett Anderson. She fought avidly for women to be allowed to practice medicine in the UK. Her efforts met determined hostility from just about the entire medical profession and the derision of men in general but she was persistent and persuasive. With the help of her supportive husband, she founded a hospital entirely for women in London in 1872, staffed by female nurses and doctors. She also made a name for herself because when she became mayor of the town, she was the first woman to take up such an office. Her sister, who became Millicent Fawcett, was a long-term campaigner for female suffrage. Elizabeth died in 1917 and is buried in Aldeburgh churchyard.

A curiosity close to the Moot Hall is a small bronze statue of a terrier. It commemorates 'Snooks', a dog who loved nothing better than to chase and pick up pebbles thrown for him by children. Unfortunately, he sometimes swallowed them and when he started to rattle, he had to be operated on.

On the pebble beach, just north of the town towards Thorpeness is a sculpture called 'Scallop'. It was unveiled a few years ago as a tribute to Benjamin Britten and his music. As is the nature of such creations, it seems to have elicited admiration and ridicule in equal amounts.

That most elegant, understated and erudite of ghost story writers, M. R. James, is said by some of his devotees to have used Aldeburgh as the inspiration for the eerie, even spine-chilling story titled 'Oh whistle and I'll come to you, my lad'. James stayed for a while at Wyndham House, near the church but some others think he based his story on the topography of Felixstowe.

Snape

Although it is a few miles inland, Snape Maltings must be mentioned. It stands on a marshy inlet of the River Alde. The complex of buildings was originally industrial premises used for malting barley for the production of ale and beer. They closed for that purpose in 1965. In 1967 work started on converting them for use as the main venue for the Aldeburgh Festival. In 1969 there was a devastating fire would have discouraged all but the most determined but restoration took place the following year.

Benjamin Britten, a Suffolk man from Lowestoft, started composing music at the age of five and was highly competent with the piano and the viola by the age of seven. He attended Gresham's School, Holt, and then the Royal College of Music in London, where he decided to devote his life to music especially in the role of a composer. Perhaps

The memorial to Snooks, Aldeburgh.

slightly to his chagrin, he found that the real earners were the scores he wrote for documentary and feature films. *Peter Grimes* was a huge success when it was given its premiere at Sadler's Wells in 1945 and almost overnight Britten was transformed into a celebrity of worldwide fame. Britten became a rich man and moved to Aldeburgh where, in conjunction with two associates, he conceived the idea of establishing an annual music festival in the town. This festival quickly proved to be a victim of its own success because there were insufficient suitable venues in the town itself and events had to be staged in nearby village halls and suchlike which often had poor acoustics or other serious disadvantages. It became evident that a purpose-built location for the burgeoning festival was needed. As noted above, this was found at the Snape Maltings, albeit not without some vicissitudes before it became really established.

The Aldeburgh Festival never really looked back as they say while Britten went on to even greater fame and honours including the conferral of a life peerage. The concert hall at Snape in its lovely setting overlooking the marshes and the River Alde continues to attract music-lovers from across the world. With art and craft workshops, exhibition galleries and eating places, there is always something going on at Snape Maltings.

While Britten and his partner Pears were alive, the Festival had a distinctively gay tone and the robustly homophobic English composer Sir William Walton rather waspishly referred to Aldeburgh as 'Aldebugger'.

Orford

From Aldeburgh runs Orford Ness in a southerly direction forcing the River Alde to enter the sea, not where it used to, just below Aldeburgh, but a dozen or more miles

to the south at the tip of the Ness. One result of this is that the former port and small town of Orford is effectively inland and washed by the waters of the Alde rather than the sea. Thus Orford is now little more than a village and is yet another place along this part of the Suffolk coast which was once a port and now has a sense of faded grandeur. This provides a not-unpleasing slight sense of melancholia. The population in 1327 was probably about 1,000; it is less today. Orford once had three churches, a house of the Austin Friars and two hospitals. The parish church of St Bartholomew with its ruined former chancel stands on a mound.

Orford Castle is one of the most impressive pieces of military architecture in East Anglia. Its ostensible purpose was to guard the harbour. This castle was built between 1165 and 1173. The keep is the only part of the castle which is left standing and it owes its survival to being a landmark visible for navigational purposes from the sea. The keep is circular but externally it is polygonal because from it project three square towers with plinths and a fore-building. It is thought that these towers were intended to reduce the vulnerability of the keep to undermining. The real reason for the building of this castle was the determination of Henry II to establish a series of fortresses through which he could impose his rule on the recalcitrant local barons, in particular the exceptionally ambitious Hugh Bigod, Earl of Norfolk.

There is an interesting story about what is known as the Orford Merman. This creature was obviously the male version of a mermaid and sightings of mermen were reported on many occasions in the Middle Ages. There is even a misericord in Chichester Cathedral depicting one such fabulous beast. In the twelfth century, local

 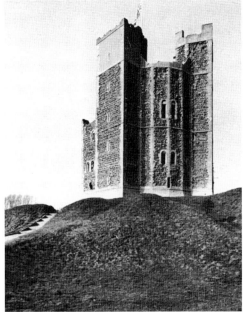

Above left: A derelict part of Snape Maltings.

Above right: Orford Castle.

fishermen caught a merman in their nets. It was described as very hairy and completely naked which is probably what you would expect if you encountered such a creature. He was taken to the castle – after all, where else would you take a merman – and the custodian tried, without success, to get it to talk. Then, because he would not talk, he was hung up by his feet and tortured. He still did not speak, not even to say 'Ow'. He ate almost everything that was offered him and would only sleep during the hours of darkness. After several days he was taken to the local church but he failed to show any reverence for the place. Perhaps they were getting bored with him so he was taken to the harbour to see whether he would perform tricks in the water. He proved so adept in the water that he swam away from the nets but returned voluntarily to his tormentors. Taking him to the sea then became quite a regular pursuit until one day he simply swam away, never to be seen again. This story has more than a hint of the apocryphal about it.

At the mouth of the River Alde stands Havergate Island. This remote spot became famous when a colony of avocets was discovered there shortly after the Second World War. These graceful black and white wading birds, with their distinctive long and slender upturned beaks, had last bred in this country in about 1825. Avocets have continued to visit and breed at Havergate in the summer and also at Minsmere, not far away.

Do not try to walk to the tip of Orford Ness. It is not that it might possibly be a rather monotonous walk. It is one of those areas where the State carries on business which is supposedly performed on our behalf but is so secret that we are not allowed to know what it is going on.

Bawdsey

Bawdsey is a fairly undistinguished place with views across the mouth of the River Deben towards Felixstowe. A foot ferry plies to Felixstowe Ferry, a small rustic, nautical outlier of Felixstowe itself with much fishing paraphernalia. Bawdsey Manor is notable for being the location of the first of the series of top-secret radar stations which were built along the East Coast and which proved so invaluable in at least partially defending the shores of Britain against aerial attack in the Second World War. A team led by Robert Watson-Watt was at the forefront of the technology involved in developing the ground-breaking technical wizardry known as radar. Bawdsey Manor is also known for being something of an architectural curiosity with much non-structural half-timbering and various faux Tudor details. It continued in use by the Ministry of Defence until 1990.

The parish church is possibly unique in that it was largely destroyed by boys celebrating Guy Fawkes and the Gunpowder Plot. On 5 November 1842 some of the local scallywags climbed up the tower thinking that they would provide the villagers with a not-to-be-forgotten pyrotechnical display. No sooner had they ignited their first fireworks than the church caught fire, whereupon the villagers were indeed treated to a bonfire of unprecedented ferocity which razed the body of the church to the ground but did at least leave the tower.

There is much evidence along the coast nearby of the archaeology of warfare. Not only is there a crop of Martello towers but also great gaunt concrete excrescences associated with the Second World War.

Woodbridge

A purist would say that Woodbridge is not a seaside town because it is several miles from the sea but it has always been a place that looks to the sea and even today it has a strongly nautical flavour about it. It is unquestionably one of the most attractive small towns in East Anglia, full of buildings that are easy on the eye. A Victorian traveller said, 'This is a delightful little town – one of the prettiest little country towns in England. Nestling on a slope of what in Suffolk must be called a hilly district, the sun always seems to shine on it...'

Woodbridge has been populated since around 2500 BC, that is, Neolithic times. Its hilly site and closeness to the River Deben made it attractive to early settlers. It is likely that there were some Roman settlements in the area and that the district was harassed by Germanic raiders who appeared up the river and eagerly raped, plundered and pillaged even before the Romans had departed in AD 410.

The Saxons became dominant in this part of Suffolk, the most powerful dynasty being known as Wuffings whose base was at nearby Rendlesham and whose royal burial ground was Sutton Hoo. In the seventh century, King Redwald, head of this clan, claimed the title 'Bretwalda' or 'chief of chiefs'. When he died he was placed in a mighty rowing vessel 82 feet long and dragged to the cemetery on a cliff overlooking Woodbridge from the east. There he was laid among his royal predecessors and surrounded by fabulous treasures. He was accorded pagan rites at a time when Christianity was rapidly making its presence felt in England. The existence of burial mounds was known but work on excavating them only began in 1939. The fourth to be opened and the biggest of these mounds contained a ship of a sort never seen before and with its accompanying artefacts, it threw much new light on that period of history once known so misleadingly as the 'Dark Ages'. The treasures unearthed were reckoned to be worth around £1 million in the prices of the time but the lady who owned the land coolly gave the cache away to the nation and the best pieces are on display in the British Museum. The name 'Woodbridge' derives from the Anglo-Saxon 'Woden's Burgh' meaning something like 'Woden's Town' or possibly 'place or bridge by the wood'.

Woodbridge was described at some length in Domesday. It had a small church at the time, possibly dating from pre-Conquest days. Shortly afterwards a small priory of Augustinian canons was founded near what is now the market square. These canons studied devoutly, performed parochial duties and conducted services locally. The foundation became rich from tithes and endowments. The canons were at the forefront in the successful fight against the strong opposition of Ipswich for Woodbridge to obtain a charter for and operate a market. Despite this, relations between priory and townsfolk were not always amicable. For example in 1296 Prior Thomas demanded that the townspeople pay to repair the priory bells and the peremptory manner in

which he did this led to a riot in the town, with stones and brickbats being hurled at the priory and any of its fraternity silly enough to show themselves. It seems that the locals must have worked off their anger because they eventually clubbed together and stumped up the sum of 5s. Whether this paid for the bells is not known but it seems to have shut the prior up so it was probably a good investment. This episode apart, we know that the priory was responsible for raising much of the money that went into the building of a new and rather grand church which as St Mary's remains clear evidence of the importance and wealth of medieval Woodbridge. There are 133 steps to the top of the tower and in 1753 a 67-year-old man went up and down those steps seven times in twenty-seven minutes. Just what was he trying to prove?

The priory was dissolved rather earlier than most in 1534 by which time it had become dilapidated. It was torn down and a large manor house erected on its site. In the reign of Queen Mary, two local people were burnt as heretics on Rushmore Heath, the woman having her ears cut off first for rather unwisely having publicly likened the Queen to Jezabel! Such a condign fate is ample evidence of the truth of the old adage, 'See all, hear all, say now't!'

Woodbridge prospered in Elizabethan times. The town expanded as a port and a customs house was built, indicative of a considerable amount of trade overseas. The town numbered amongst its industries shipbuilding, weaving, cloth-making, rope-making and salt manufacture. Among the town's celebrities was Robert Beale, a lawyer and diplomat of staunchly Protestant views who campaigned relentlessly against Catholics in the sixteenth century and was one of the signatories on the death warrant of Mary, Queen of Scots. Another local man was John Fox, a merchant and seafarer who sailed the seas in search of adventure and got more than his fair share of it! He was captured by Turks in the Mediterranean and imprisoned for fourteen years before making an audacious escape, killing several of his captors, seizing a galley and releasing 300 fellow Christians.

However, the best-known local citizen was Thomas Seckford. He was a lawyer by profession and built himself an elegant home, rather misleadingly called 'The Abbey', which still stands in Church Street. In 1587 he opened an almshouse for thirteen impoverished local men and established a charity from the income of land he owned in Clerkenwell, London where a street and a pub still recall his name. This charity has funds which still benefit Woodbridge.

Ship-building reached its height in Woodbridge in the seventeenth century. Woodbridge-built ships took Suffolk cheeses to supply Cromwell's army in Scotland; they fought against the Dutch at the Battle of Sole Bay and were active in the later Siege of Gibraltar. However, the dock in which these ships' keels were laid and construction took place silted up and by the end of the seventeenth century the shipbuilding industry was defunct. Later on the smuggling trade helped to offset the loss of shipbuilding and records show that in 1735 for example the local revenue men with the assistance of some dragoons managed to seize over 200 tons of contraband tea. In 1784 the town witnessed a battle between revenue men and a gang of smugglers that went on for an hour round and round the streets. It seems to have ended indecisively with the revenue men getting back some of the contraband and escaping. Doubtless the sympathies of the locals would have been with the smugglers. Earlier, in the English Civil War, Woodbridge had been firmly in the Parliamentarian camp but as happened elsewhere,

its citizens clearly found the heavy hand of Puritanism oppressive and they rejoiced when Charles II resumed the throne in 1660.

Daniel Defoe visited the town and this is among the comments he made about the town: 'Woodbridge has nothing remarkable but that it is a considerable market for butter and corn to be exported to London. The rich soil of Suffolk produces some of England's best butter and perhaps the worst cheese. The butter is barreled or often pickled up in small casks and sold, not in London only, but I have known a firkin of Suffolk butter sent to the West Indies and brought back to England again, and has been perfectly good and sweet as at first.'

Woodbridge sprang into importance during the French Revolutionary and Napoleonic Wars. A large barracks for around 5,000 troops was built close to the town and many fine townhouses were erected for the officers and their families. A theatre was built to cater for them. They spent money in the town and gave it an air of prosperity but not all was sweetness and light. There was drunkenness, violence and indiscipline among the troops which culminated in 1814 with a murder perpetrated by a soldier who was later hanged at Ipswich. It was therefore with mixed feelings that the townsfolk saw the barracks close in 1815 at the end of the wars. As so often happens when hostilities cease, there was an agricultural and industrial depression and crime and vagrancy became the order of the day. There was a scandal when the townsfolk decided to be charitable to a group of local beggars who the used the money they had been given to go an almighty drinking binge.

In the 1820s and 1830s the land which Thomas Seckford had owned in the Clerkenwell district of London began to be sold for building purposes and the Seckford Foundation in Woodbridge benefited to the tune of many thousands of pounds. The result was improved almshouses, the Seckford Hospital, a lending library, a public pump and drinking fountain and a drinking trough for thirsty dogs, horses and cattle. Cats apparently were not catered for.

A number of notable literary figures lived in Woodbridge in the nineteenth century. The best-known was undoubtedly Edward Fitzgerald who loosely translated the *Rubiáyát of Omar Khayyám* from the Persian in 1856 and the result achieved international acclaim. Fitzgerald was something of a rake and a regular user of opium. His activities often provoked the wrath of the town's more prudish residents. He bought a river boat which he named *Scandal* to commemorate and offend the local gossips. Not only did he use the boat as a place to write but he also entertained other dissipated intellectuals and like-minded companions on board and there were many stories locally of drunken orgies. One local story recalls that on one occasion Fitzgerald was on the deck reading a book when he somehow contrived to fall overboard. Not the least bit put out by this contretemps, Fitzgerald simply clambered back on board and resumed reading as if nothing had happened, despite being soaking wet. Fitzgerald was an eccentric and was often seen on warm days in the summer walking through the town carrying his boots around his neck. He always contrived to look like a tramp down on his luck.

In 1859 the railway line between Ipswich and Lowestoft was opened and provoked the jubilation of all the townsfolk except those involved with maritime trade in the port. They feared that the railway would destroy the town's position as a port. They need not have worried because the general increase in trade generated at least partly

by the railway benefited Woodbridge and it became extremely busy with coal inwards and cornflour and malt being taken on board. However, the prolonged agricultural depression of the 1880s dealt a severe blow to Woodbridge as a commercial port and the amount of shipping declined dramatically.

The twentieth century has generally been kind to the town, although on the night of 12 August 1915 there was a zeppelin raid. Quite why the Germans chose to bomb such a small place is not clear. Twenty-eight bombs were dropped and six people were killed. Among the six was a young married couple who had come out of their front door onto the street to see what all the commotion was about. They were killed by flying debris while their three children slept on in the house quite regardless. Such are the tragedies which war brings in its train.

One of the most notable buildings which has not yet been mentioned is the Shire Hall on Market Hill which was built in 1575 by Thomas Seckford to house the Magistrate's Court. Its appearance is of the late seventeenth century and it is a curious three-storey building with a stone-coped Dutch gable and it now houses the august proceedings of the Woodbridge Town Council. Close by is the Bull Hotel also built in the seventeenth century and a major meeting place of town and country folk ever since. In New Street is a pub with a unique name 'Ye Olde Bell and Steelyard'. It is an ancient establishment which would probably have used the steelyard to life barrels up into the cellar for storage purposes. The pub was originally the Bell in the sixteenth century and the steelyard was added about a hundred years later. The church of St Mary is large and displays some high quality flint flushwork.

On the quayside, reached by a level crossing near the railway station, is an attractive jumble of boatyards and chandleries and all kinds of maritime junk putting one in mind of Ratty's remark in the *Wind in the Willows* that there is nothing better than simply messing about in boats. Here there are yachts and pleasure craft of all shapes and sizes. Standing in the midst of this cornucopia of seafaring paraphernalia is Woodbridge's arguably best-known building, a superb white, weather-boarded Tide Mill which was built in the 1790s and is now a working museum. A mill existed on this site as early as 1170 and this particular one still operated commercially until 1957. As the tide rose, the pressure of the water opened the sluice gates and filled a 7½-acre pond behind the mill. When the tide turned, the first outflow of water closed the gates, leaving the pond full. When the tide had fallen far enough, the miller opened the sluice gates and released the water to drive the mill wheel.

In medieval times a fair was held each St Audrey's Day in the town's marketplace. St Audrey was actually Queen Etheldreda but she moonlighted as the founder and abbess of a monastery at Ely. She died in 679. Curiously, she married twice but remained a virgin. Her first husband seemed quite content with this arrangement. He died and then his successor, who was twelve years Audrey's junior, also seemed to be compliant about what was, after all, a matter of some delicacy. He had been married to her for twelve blissful albeit celibate years when he suddenly and unexpectedly demanded his conjugal rights. Audrey abruptly refused and showed that her body could not be bought when her swain, whose name was Egfrith, offered her money to have sex with him for the first time in those long twelve years of marriage. Audrey was so disgusted by Egfrith's belated concupiscence that this was when she went off to Ely to set up the monastery there.

Audrey died of plague but seventeen years later her tomb was opened and it was found that no decomposition had taken place. This was regarded as a miracle and evidence of her sanctity. It was not long before she was placed in a shrine and the gullible were making their way to Ely and stumping up money so that her spirit could effect cures for all their maladies. All this biography is by way of saying that St Audrey was celebrated at the market in Woodbridge but that she unwittingly ended up giving her name as the inspiration for the word 'tawdry'. The spivs of the day sold garments and knick-knacks at the fair which were of such poor quality that they became known as tawdry, a corruption, of course, of the worthy Audrey's name.

Felixstowe

This town is one of many on the Essex and Suffolk coasts that have a dual character. In fact it could be argued that it has a triple or even a quadruple character. What is immediately apparent is a bustling, slightly faded but curiously attractive seaside resort dating from late Victorian times with a long sea frontage and very extensive and attractive gardens situated close to a major roll-on and roll-off international cargo and container port. This is one of the largest in Europe. Felixstowe is the second-busiest passenger port in Britain and the most successful container port. It is above all a modern port. The first work done to create port facilities was not carried out until 1885. Little more than a hamlet existed at Felixstowe before the late Victorian period, but there are archaeological remains that show that the Romans had a fort called Walton Castle close by although its remains only appear at especially low tides. About a mile to the east of the current town centre is the nucleus of the original settlement around a small fourteenth-century parish church. The fourth aspect of its character is Felixstowe Ferry, a rustic settlement full of boatsheds and fishing bric-a-brac to the north at the mouth of the River Deben with a foot ferry across to Bawdsey. However, Felixstowe only really grew in the nineteenth century when it was deliberately developed as a resort with all the expected amenities of such places. These included a long pier from which steamers took trippers to Yarmouth, Walton and even London. The pier was built in 1905 and was 2,640 feet long, which necessitated the installation of an electric tramway. The pier was largely timber-built, using foreign woods which seemed more resistant to the attention of the teredo worm than British timber. Most of the pier has been demolished and it is now a mere 450 feet long. The future of the pier is very much in doubt. Although the landward end is still in use, the main body of the pier is closed and the owners want to demolish it.

Felixstowe benefited from a fine position on a low cliff overlooking the sea but with a flat expanse behind the cliff on which the town could be laid out. There is a long, gently curved beach consisting of banks of red shingle with patches of sand at low tide. The gardens and the rows of bathing huts along the promenade contribute to the Victorian and Edwardian feel of the place.

At the south end of the town a road leads to Landguard Fort. This spot has had its moments in history. The original fort was built here in the reign of Henry VIII to guard the entrance to Harwich Harbour and later improvement work was done at the time

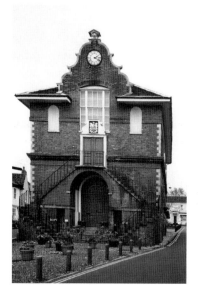 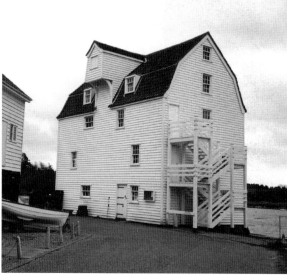

Above left: The Town Hall, Woodbridge.

Above right: Tidal Mill, Woodbridge.

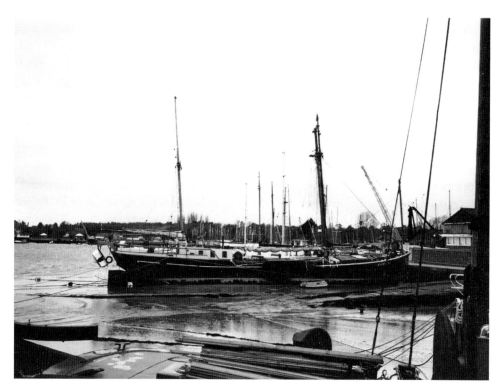

Marine clutter by the river, Woodbridge.

The Promenade, Felixstowe.

of the threat of seaborne attack by Spain. Further rebuilding took place in the 1620s but it seems that the ordnance had become neglected. The garrison was ordered to fire on a naval vessel that had failed to dip its flag in salute but apparently more damage was done to the guns in the fort by firing them than was done to the offending ship. In 1667 the Dutch invaded Felixstowe when a force of 2,000 men marched on the fort. It seems that this was more a gesture than a serious military operation but the English have always been extremely sensitive about being invaded and this was every bit as much a piece of psychological warfare as a military one. It proved that the Dutch could land on English territory if they wanted to and get away with it. The damage to English morale was immense. The present fort dates largely from 1718–20 but it was enlarged in 1875 and was operational in the First and Second World Wars. The chapel above the gateway was the scene of a notorious scandal in 1763 when the acting governor of the fort held a dance in it and used the altar as a bar. Who'd have thought that such a thing could happen in Felixstowe? Today the place provides excellent views of the shipping constantly passing to and from Harwich and Felixstowe. Landguard Fort features in one of the painter Gainsborough's few seascapes. Across a choppy sea Harwich can be seen and several ships at anchor. The fort was decommissioned in 1956 and went into limbo but in 1979 it became the Felixstowe Museum and it provides a good history of the port and town from earliest to most recent times.

Felixstowe is a positive upstart compared with the venerable port of Harwich across the estuary of the Orwell. A foot ferry plies across to Harwich. It is a smallish boat and riding the ferry can be an interesting experience when it crosses the turbulent wake of one of the large vessels passing up or down the river. Like so many East Coast resorts, Felixstowe owes much to the coming of the railway and the development of the town as a fashionable resort and of the adjacent port, these being largely the brainchild of Colonel George Tomline of nearby Orwell Park who was the Lord of the Manor. He

had originally wanted the resort to face across the estuary to Harwich but in the event the clifftop site where most of Felixstowe now stands proved to be more suitable. The story goes that Tomline had stood as a parliamentary candidate for Harwich but failed to win many votes and in fact was soundly beaten. In a fit of pique, he then decided to get his own back on the people of Harwich by developing a rival port on the opposite side of the river and a rival resort to Dovercourt. Comparison between the present-day fortunes of Harwich/Dovercourt and Felixstowe would suggest that he got his own back with a vengeance.

The earliest railway to Felixstowe was built by Colonel Tomline and it opened in 1877. It was operated with military precision and the staff wore uniforms which displayed his assumed armorial bearings. His line was so successful that the Great Eastern Railway paid hugely over the odds to buy him out. There is still a somewhat basic railway passenger service between Ipswich and Felixstowe and a heavy traffic in container trains to and from the docks.

Tomline built the Felixstowe Pier Hotel. This was later renamed the Little Ships, a unique but very appropriate name because it is a reference to the light surface fighting craft such as motor torpedo boats and gunboats that were stationed close by in the Second World War. Other entrepreneurs such as John Chevallier Cobbold of the brewing company were responsible for many of the watering place's amenities. The fact that the Empress of Germany stayed at Felixstowe was like an official stamp of approval and meant that the town began its heyday as a select watering place. The promenade was developed in 1902 and the pier was built in 1904. Soon an extensive network of pleasure steamers was calling at the pier and there were services to and from London, Southend, Walton-on-the-Naze, Clacton, Southwold and Great Yarmouth. The pier is now a vestigial stump and the grand hotels which were built to cater for an affluent clientele have been demolished, turned into offices or become care homes. One of the town's premier hotels was The Bath. On 28 April 1914 this building was destroyed by fire. This was deliberately started by a couple of militant suffragettes as part of their campaign of vandalism which they resorted to because they found that the politicians, who were all men, mostly dismissed their case for political rights as simply ridiculous. It is probable that the two women concerned had previously started a destructive fire at the Pier Pavilion at Great Yarmouth. The Bath was never rebuilt.

In view of the good relationship of the Empress of Germany and her children with Felixstowe (apparently she found the place very congenial), it is ironic that one Sunday in 1917 when divine service was taking place in St John's church – a red-brick edifice dating from 1895 and designed by the eminent Sir Arthur Blomfield – a force of German planes strafed the locality, killing and injuring many worshippers and local residents. In the Second World War, Felixstowe and Harwich were both bases for naval establishments supporting light surface vessels and they were known as HMS *Beehive* and HMS *Badger*. Despite the fact that both were land-bound, this did not prevent the German propaganda machine gleefully announcing on several occasions that these 'ships' had been sunk.

The old parish church, in the suburbs well away from the modern town centre, has some good old benches with interesting carvings. A curious relic preserved in the church is a bomb which fell through and partly demolished the roof during Communion one morning in 1917 but, miraculously, failed to explode and no one was hurt.

In 1811 a smuggling vessel ran aground close to Landguard Fort. Desperate situations require desperate remedies and it must have been with the greatest reluctance that the crew decided to throw overboard the 600 tubs of free trade spirits they were carrying in order to lighten the ship enough to float it off the sandbank. How that must have hurt. They got the ship off the sandbank and made off while the tubs came ashore on the tide. The soldiers of the garrison must have thought that all their birthdays had come at once. They set about a monster drinking binge with this largesse and four of them died as a result.

Nacton

Nacton is a village close to the Orwell estuary. The village's best-known daughter must be Margaret Catchpole, born one of six children of a local farm worker. In 1773 she stole her master's horse and galloped off pell-mell to meet her lover. She was no tyro as far as equine matters were concerned because at the age of thirteen she had galloped bareback to Ipswich to fetch a doctor for her mother who had suddenly been taken ill. She saved one of the children of her employer, who was a member of the Cobbold Family of Ipswich brewers, from drowning. The family thought highly of her and helped her to learn to read and write. However, she fell under the influence of an egregious boatman and smuggler from Felixstowe, despite warnings from all her friends. She believed he was in London and was desperate to see him and so she stole the horse from the Cobbolds and headed off to London to look for him. Stealing a horse was a capital offence and Margaret was sentenced to death only to have the sentence commuted to one of transportation for seven years.

While waiting in Ipswich Prison to be removed to a convict transport ship, she escaped. Somehow she managed to cross a high wall covered in evil spikes and have a soft landing way below. However, this audacious episode ended rather ignominiously because she was quickly recaptured. She went back to court and was sentenced to death again but once more the sentence was commuted to transportation. At the age of twenty-eight she set off across the world on her involuntary cruise to Australia. There she served her sentence followed by enjoying a happy married life with a respected settler and she brought up a family, a model of rectitude. She kept in touch with friends and relations at home and she wrote up the story of her life which a parson friend reworked as what proved to be a very successful novel based on fact. Out of respect to her, it was only published after her death in 1845. It is not certain that the novel keeps to the facts of her life because many people think that she never married.

Near Nacton is Orwell Park which was once the home of Admiral Sir Edward Vernon (1684–1757). He was rather unusual for a naval officer in having something of an intellectual bent. He was highly intelligent but had a short temper and a viperous tongue which made him enemies. He did not court favours even though obsequiousness has always been a good route to promotion but he was a highly capable leader of men and superb seaman. He was immensely popular with the public and with the men who he treated as fairly as he could. His nickname was 'Old Grogram' because his trademark boat cloak was made from this material. He could not abide drunkenness and he initiated the dilution of the daily rum ration, the resulting liquid being known as

'Grog'. While this did not necessarily endear him to all naval personnel, the replacement of neat rum by grog worked wonders for naval discipline.

A later resident at Orwell Park was Colonel George Tomline whom we have already met in connection with railway and other developments in Felixstowe. He was a typical cranky landowner of his period, autocratic and eccentric. He supervised the rebuilding of Orwell Park House along grandiose lines including the creation of an imposing observatory. He employed an astronomer who had to sweat his way up 111 stairs to the top and was on no account to use the lift which Tomline had installed for his own exclusive use. His autocratic tendencies were clear when he had the village of Nacton moved physically because he thought that it spoilt his views. The new (and much better) houses with which he replaced them had their front doors on their side elevations. It was alleged that the reasoning for this oddity was that the tenants would not be able stand gossiping to their neighbours across the road or stand and gaze at the good Colonel himself as he drove through the village in his carriage. Tomline was nothing if not a dynamic man. He used to hold shooting parties at Orwell Park which were graced by dukes and belted earls, by senior politicians and rich businessmen. They went shooting, they ate and drank of the best, they probably seduced each other's wives but, most important of all, they used these events for social networking and mutual benefit. Tomline's handsome residence is now a preparatory school.

Ipswich

On a strict definition of 'coastal', Ipswich should not be included in this book, being at least a dozen miles from the sea. However it is a thriving port and has always had close connections with seaborne trade and the nautical life. It is a town of considerable historical significance. There is evidence of human settlement from Palaeolithic times and we can be fairly sure that humans have lived here since at least 5000 BC. A number of fine Iron and Bronze Age artefacts have been found in the vicinity. The Romans seem to have had a minor settlement here but it was probably somewhat overshadowed by the important role which they gave to Colchester, close by. The discovery of the hoard of historical evidence at Sutton Hoo in 1930 made it clear that the Anglo-Saxons were a richer and far more cultured people than had previously been assumed. It may be that these sophisticated people started to create a town in the seventh century. Whatever kind of settlement there was would later have suffered from the depredations of the warlike raiders and invaders from Scandinavia. We know, for example, that the town was sacked and burnt in 990 and 993. The Orwell provided the ideal means for raiders to penetrate far inland. For reasons unknown Duke William seems to have had it in for Gipeswic and he laid waste to the town.

The curious name Ipswich has evolved from 'Gipeswic' which means something like a town at a corner of the mouth, possibly of a river. An alternative explanation is that it is the 'harbour of a man called Gip'. The River Orwell on which Ipswich stands is known in its upper reaches as the Gipping. This is the county town of East Suffolk, at least since 1974, and it has been a port since the days of the Romans. It was probably the largest port in Saxon England and it waxed extremely prosperous

in the Middle Ages because of the hugely successful woollen industry of Suffolk and Norfolk. Traces of the town's walls can be seen and are remembered in the street name 'Tower Ramparts'. There was a castle about which very little is known and four town gates. Ipswich obtained its first effective charter in 1200. It was granted by King John who was only too happy to grant such privileges in return for cash. Ipswich regards him as something of a hero although it seems that he only visited the town once, in 1216. Modern revisionist historians argue that John had considerable ability and merit and was not just the evil, duplicitous incompetent who used to be juxtaposed so unfavourably with the apparent glamour and dash of his brother, Richard the Lionheart. No English monarch has ever spent such a small part of his reign in his kingdom and it seems that Richard viewed England as little more than a treasure chest that he had the right to exploit relentlessly in order to pay for his almost incessant wars of plunder and rapine in the so-called Holy Lands.

In 1283 a large mob of townsfolk kidnapped the unpopular mayor of the time and held him prisoner until he ransomed himself by presenting his captors with a couple of enormous vats of wine. This gesture was much appreciated and we can be sure that the mayor's health was drunk many times by the grateful crowd.

In 1296 the town was *en fête* because Princess Elizabeth was marrying a foreign count in Ipswich, the Princess being one of the King's children. The King in question was Edward I and with him being a king, he put on a lavish series of junketings despite the fact that he had few funds in his treasury at the time. This did not stop him dispensing charity with reckless generosity and gaining himself immediate popularity. He blotted his copybook somewhat when, for reasons unknown, he lost his temper and threw Elizabeth's coronet into the fire. This tantrum caused damage to the coronet and involved the loss of two valuable baubles from it. I suppose that kings were allowed to do this kind of thing. No one was going to take them to task for such stupidity.

In 1404 it became one of the 'staple ports' which meant that it was licensed to export wool. It also traded in skins, leather and fish and was a major shipbuilding centre. The keels of many sturdy collier ships first tasted saltwater at Ipswich. On the town's official seal is the first known depiction of a ship with a modern rudder rather than the traditional steering oar. As international trade built up, Ipswich could not completely avoid the vagaries of economics and there were periods when the town was in the doldrums. Its status as a port also meant that it experienced more than its fair share of visitations of the dreaded plague, spread by ships' rats that came ashore carrying infected fleas.

Probably Ipswich's most famous son, although whether he is a source of pride or not is hard to say, was Cardinal Thomas Wolsey who was born around 1475. His parents were prosperous and prominent local citizens at a time when Ipswich was in its pomp. The current received wisdom about Wolsey seems to be that he was a supremely egotistical, ambitious and ruthless parvenu. Certainly he was convincing evidence of the truth of the old saying that the higher up the tree the monkey climbs, the more it shows its bottom. At one stage Wolsey's retinue was greater than that of the King. He must have thought that he was fireproof but he seriously overestimated his own importance and equally underestimated the King, who was not a man to allow anyone to steal his thunder for too long. Of the fact that he had considerable ability

there is little question but he was not as clever as he thought and definitely not as clever as his master, Henry VIII. The King used Wolsey to do much of his dirty work, which made the latter vulnerable and very unpopular, although for some time Wolsey's efforts in delicate situations were nearly always crowned with considerable success. The particularly delicate affair which proved to be his nemesis was that of attempting to persuade the Pope to grant the King a divorce from Catherine of Aragon. Wolsey built Hampton Court for himself. It was grander than any of the King's residences and when he began to realise that he was increasingly incurring the King's displeasure, he offered the mansion to the King by way of propitiation. It was perhaps fortunate for Wolsey that he died at Leicester Abbey while on the way to London to answer a summons from Henry. Had he not died of natural causes, it is highly likely that he would have been executed.

In order first of all to boost his already inflated ego and secondly to help to put Ipswich on the map, Wolsey decided to build a college in the town. As was only to be expected, there was nothing understated about this institution and it was partly paid for by closing down a number of small monasteries in East Anglia and sequestrating their assets. The college was opened in 1528 but it had not been operating long before Wolsey's career went into freefall. It did not long outlive its progenitor. A few traces of this exercise in self-aggrandisement can be seen in College Street. Other local boys who have made it good include the novelist V. S. Pritchett (1900–97) and the theatre and film director Sir Trevor Nunn.

The town contains some remaining buildings dating from the sixteenth century. They include the 'Ancient House' in the Buttermarket. It is also called 'Sparrowe's House'. This was built in 1567 and exhibits pargeting work of the very highest order. For many years it housed a bookshop and it seemed to be a particularly appropriate location for such a business. There are plasterwork reliefs of pelicans and nymphs as well as representations of the four continents known at the time. Europe is symbolised by a Gothic church, America by a tobacco pipe, Asia an Oriental dome and Africa, a trifle eccentrically, by a black native astride a crocodile. Pargeting involves the production of decorative work in wet plaster, usually on the infill in timber-framed buildings. It is usually applied to vernacular buildings and was a particular speciality of East Anglia. It can vary from simple decoration to elaborate relief work of the high quality seen in the Ancient House.

Close by was the 'Great White Horse', a fine old inn, timber framed beneath a Georgian brick façade which, unfortunately, is now closed as a hostelry. It is mentioned in an amusing incident in *The Pickwick Papers* when Mr Pickwick once accidentally found himself in the bedroom of a female guest, a lady with curlpapers. Mr Pickwick went to great pains to assure everyone that his intentions had been entirely honest and that he had made a simple mistake.

The town boasts twelve remaining medieval churches. St Clement now stands marooned in a one-way system and is noted as the burial place of Sir Thomas Slade who designed HMS *Victory* which was made immortal as Nelson's flagship at the Battle of Trafalgar. Both Slade and Nelson would have written off as entirely mad anyone who had predicted that *Victory* would be still in commission almost 200 years after the battle! St Margaret is a fine-looking and large town church. St Nicholas has

many interesting fittings. There is a delightful Unitarian chapel in Chapel Street, built by Joseph Clarke around 1700. He was a carpenter who took a few months off to supervise the erection of this meeting house. Mind you, it is timber-framed so he was working with a material he understood and it has to be said that he made a good job.

The activities of Ipswich as a port have always been threatened by the silting of the Orwell and massive amounts of work had to be done in the nineteenth century to dredge and build docks and it is from 1844–45 that the fine porticoed Old Custom House dates. We know that the town was prosperous even in early Norman times by the number of churches listed in Domesday. However, the town never had a major ecclesiastical or monastic foundation. A short section of the arcaded wall of Blackfriars Priory is the only visual reminder of the town's former monasteries. In 1524 Ipswich was ranked the sixth- or seventh-richest English town.

In 1785 a young man called Robert Ransome arrived in Ipswich having previously lived at Norwich. He was a member of the Quakers, a religious group which had that time suffered considerable discrimination and who were barred from the professions and most economic and other activities which conferred social status. Many of them consequently turned to business enterprise and they took it as evidence of God's approval if their efforts were successful. Agriculture was undergoing something of a revolution as great improvements were needed if the growing proportion of the population that lived in the towns was to be fed. One necessity was to improve the productivity of agriculture and Ransome was around at just the right time. He established an iron foundry to make improved agricultural ploughs and other implements. The company went on from there into a much wider range of mechanical engineering activity whose products could at one time be found across the world. The main factory of the company was alongside the harbour quays.

As Ipswich began to develop its industries, so the silting up of the Orwell was seen as a factor impeding the bringing in of raw materials and the transport of finished goods. An expensive and ambitious project was the building of what, when it opened in 1842, was the largest wet dock in Britain. This dock, regular dredging of the river and the coming of the railways all helped to expedite Ipswich's growth as an industrial and commercial town of some substance. Among other industries that came to be associated with the town were brewing, malting and the processing of animal feedstuffs and printing.

In 1645 Mother Lakeland was burned at the stake after confessing to having been a witch for at least twenty years. She had started by bewitching the person she hated most of all. This, some may not be surprised to know, was her husband, and her revenge was sweet. She caused him to suffer slowly and painfully until he managed to expire after a few months of growing misery. She had then supposedly started settling accounts with other people who had offended her in one way or another. This 'evidence' was not volunteered but extracted under threat of torture. In case we should mock, a residual belief in the existence of sinister witchcraft existed in the Ipswich area as late as the 1960s. A researcher in 1963 was told about a Mrs Judd who was suspected of having bewitched a pig. One way of breaking a witch's spell was to remove a small part of the creature involved and to burn it. The pig's owner removed some tiny pieces of the pig's ears and burnt them and, sure enough, not only did the pig return to full health

very quickly but Mrs Judd was seen shortly afterwards with a nasty burn. There, that proves it!

The locals enjoyed their folkways. They probably still do. Even in the early nineteenth century, they say that a white witch called 'Old Winter' used to weave his benevolent magic around the town. Hypnotism was one of the powers at his disposal and with his impelling desire to right wrongs when he came across them, he once caught a miscreant stealing vegetables from a garden. Next day the miscreant was found shivering, freezing cold and drenched in dew on the vegetable plot, after having been put into a mesmerised state by Old Winter.

Ipswich took a long time to wake up to the fact that it is one of the most interesting and most ancient towns in the land. This meant that, particularly in the holocaust of legalised vandalism which passed for town-planning in the 1950s and 1960s, many major historic buildings and indeed whole streets of secondary but still significant buildings were sacrificed on the altar of so-called modernity and the needs of the motor car. For all that, the pattern of ancient streets that made up medieval Ipswich largely survives and it actually predates the Norman Conquest. Presided over by the Victorian Town Hall, Cornhill almost certainly stands on part of the Anglo-Saxon marketplace.

Whether or not you like what can now be seen in twenty-first-century Ipswich, it is difficult to deny that in the central part of the town at least, there is considerable character much in the way that there also is in Norwich and Colchester. In other words the destruction of far too much that should have been kept and the building of much that is crass, insensitive and totally without merit, a town planning dog's breakfast which, however, has not managed totally to destroy every trace of the worthwhile old buildings and atmosphere of the town. Newer buildings do not necessarily lack merit. Ipswich has one building which excited controversy even before it was built and has continued to do so ever since. This is the former Willis, Faber & Dumas building on the west side of the town. It is now known as the Willis Corroon building. What can be seen from ground level is a black glass building certainly better than many other large offices in the town, but a helicopter is needed to appreciate what is really so unusual about it. Instead of a parapet there is a neatly cut hedge and the flat roof is covered with grass. It was designed by Norman Foster who has a penchant for striking buildings and was completed in 1975 for a firm of insurance brokers. While some drool over it, others largely ignore it because it is part of the everyday scene; others still think it looks like something the dustmen refused to take away. If you fancy a dip, there is a swimming pool on the top of this building. The Willis Corroon building is striking.

One of the great glories of Ipswich is the presence so close to the town centre of a park as spacious and magnificent as Christchurch Park and a building oozing so much historic character as Christchurch Mansion. The park has recently had much money spent on it and it is even better than it was before. In the park stands the Marian Martyrs' Memorial commemorating a number of Protestants who were burnt at the stake in Cornhill for their beliefs during the reign of Mary I. Without wanting in any way to excuse the purblind hatred and bigotry of such acts performed in God's name by Catholics, the Church of England also launched periodic deadly vendettas against Roman Catholics. As far as Christchurch Mansion is concerned, the main core of the mansion was built in 1548 to 1550 and it looks like a fine Tudor mansion house. It stands on the site of the

Christchurch Mansion, Ipswich.

Augustinian Priory of the Holy Trinity, founded in the 1170s and dissolved in the 1530s. In 1561 Queen Elizabeth stayed at the house for six days. A visit from the Queen was, quite frankly, a mixed blessing. She arrived with a huge entourage and expected the very best of everything. Her hosts were damned if they did and damned if they didn't. If they did not put on a really good show, they went in fear of official disapproval or worse. If they put a show good enough to please the Queen, there was always the likelihood that she would invite herself again with all the attendant costs and disruption for the hosts.

Much of Christchurch Mansion is now used as a museum. There are fine collections of ceramics, furniture and a number of rooms fitted out in the styles of the times. Associated with the museum is the Wolsey Art Gallery. This has a fine collection of the work of Suffolk artists. There are many seascapes and landscapes and examples of the work of the most famous local boys, Constable and Gainsborough.

In Museum Street, the town's museum can be found with strong sections on aspects of Suffolk's past. A most unusual museum is the privately run Museum of Knots and Sailor's Ropework in Wherstead Road, south of the town centre. This is of more than merely specialist interest and emphasises the vital skills in rope-work that had to be developed by mariners in the days of sail. We use the expression 'knowing the ropes'. It is probable that few people trace this idiom back to its origins. To know the ropes was an absolute necessity for a man working on the sailing ships.

Talking of ropes, Ipswich continues to prosper as a port. It is now the UK's fourth largest container port and is ranked sixth for roll-on-roll-off lorry traffic. Close to Ipswich is the Orwell Bridge. Container lorries hurtle over it at maniacal speeds but it is a marvel of modern engineering and combines utility with a certain beauty. There would be spectacular views from the bridge had the spoilsport designer not put high parapets on either side.

The Shotley Peninsula

As is the nature of peninsulas, the Shotley Peninsula is on the way to nowhere. It separates the Orwell and Stour estuaries and throughout there is a feeling that water is never far away. Shotley was long famed for being the site of the HMS *Ganges*, the training base for boys wanting to enter the Royal Navy. The original *Ganges* entered service in 1779.

She had previously belonged to the Honourable East India Company. The second ship of that name was built in India and completed in 1821. By 1861, after a distinguished career, she had become the last sailing ship at sea in the Royal Navy to carry an admiral's distinguishing pennant – in other words, to be a flagship. In 1866 she became a training ship at Falmouth. She moved to Harwich in 1899 and in 1905 she was moored at Shotley close to the shore-based training school. The Royal Naval School for Boys closed in 1976 but much about it can be learned in the excellent museum. The most spectacular annual event at HMS *Ganges* was the mast-manning ceremony. The boys climbed onto the 143-foot-high mast and one, chosen presumably on merit, because he had an excellent head for heights, was a volunteer who hadn't understood the question, or even on the grounds that he was considered expendable, was the 'button boy' who climbed to the very top, stood on the 'button' which was just 11 inches across, and saluted.

The church at Shotley is a curious although far from unlikeable little architectural dog's breakfast with work of different periods and a fine view of the estuary of the Stour to Harwich. Poignantly, large numbers of boys from HMS *Ganges* are buried in the churchyard. Many of them died of accidents while still undertaking their training. Others died as the result of an outbreak of a particularly virulent flu. Other graves are the final resting places of naval men who died on active service close by in the North Sea. All may seem tranquil enough these days but at one time children used to say: 'Shotley Church without a steeple, Drunken parson, wicked people!'

Shotley Point Marina has one or two interesting old ships usually in residence and in the summer hosts the Classic Boat Festival, but this district is perhaps most notable for its possession of four notable follies or curiosities, a remarkable concentration in such a small area. Overlooking the Orwell estuary at the western end of the peninsula is Freston Tower. This brick building, which dates from the mid-sixteenth century, is surrounded by mystery. No one is sure whether what can be seen now was erected as a freestanding belvedere tower or as part of a much larger mansion. The story goes that the tower was built for a young woman, Ellen de Freston, to assist in her education. Each floor was allocated a day in the week and a subject that she was to study on that day and in a room on that floor. On Monday, for example, she naturally started on the ground floor and devoted herself to learning about Charity. She worked her way up the tower through Tapestry, Music, Painting and Literature. By Saturday she had reached the fifth and top floor where, appropriately, Astronomy was the subject for the day. Only on Sunday did she give the tower a miss but even then her education continued because she went to church and of course studied Divinity. This all sounds pretty silly but whether or not it is true, Freston Tower is thought by some to be England's oldest folly. Anyway, it's a very fine building so good luck to it.

Very close to the Orwell estuary, is 'The Cat House' at Woolverstone. By any standards, the Cat House is a folly. It is a red brick cottage with castellations and 'Gothick' detail, built in 1793. This building is said to have been involved in the smuggling trade and a stuffed white cat was placed in a particular lighted window at night when it was safe to undertake a landing of contraband goods.

On the southern side of the peninsula is Erwarton Hall. This fine old building possesses a perfectly ludicrous gatehouse of brick which is likely to have been built at about the same time as Freston Tower. It is decorated with nine mini-towers or bartizans

somewhat resembling chimneys but having absolutely nothing to do with the building's function as a gatehouse. There is a legend that after Anne Boleyn was beheaded at the Tower of London in 1836, her heart was extracted and brought to Erwarton and buried in the wall of the church. Anne had been a frequent visitor to Erwarton Hall. In 1836 during renovation work at the hall, workmen found a lead box containing black dust. Was this Anne Boleyn's broken heart?

Further inland and not far from Alton Water is the 'Tattingstone Wonder'. This was the brainchild, if that is the right word, of the local squire, Edward White, and it was built around 1790. He lived in Tattingstone Place and was becoming extremely bored with having to look out on a vista which included two rather nondescript rustic cottages. Being a man of means he decided to perk up the view. The cottages belonged to him anyway so he decided to add a third cottage on the end of the terrace. On top he placed what looked from his house like a church tower although it only had three walls – the one on the far side was missing. He didn't need it because he couldn't have seen it anyway. To enhance the ecclesiastical optical illusion he was trying to create, he inserted two 'Gothick' style windows on the façade visible to him. He then went one better than that. On the east end of the building, he inserted the kind of large window expected of a church but topped it with a rose window. It should be added that the visual tomfoolery that made up the 'east end' of the building could not actually be seen from Tattingstone Place. Nearby Alton Water is a reservoir created in 1978 by damming the Tattingstone Valley. It provides vital water supplies for the thirsty people of Ipswich.

Located on a fine site overlooking the estuary of the Stour near Holbrook is the Royal Hospital School. The buildings are extremely imposing and date back to 1933 when the school moved to this site from Greenwich, aided by a large bequest. The RHS, as it is usually called, is a co-educational fee-paying school for boys and girls aged eleven to eighteen. The original school at Greenwich opened its doors in 1712 and was intended to supply boys for careers in the Royal and Merchant Navies. Elements of its naval traditions continue to this day. Two features are particularly interesting: one is the tall tower of the school, conspicuous and impressive when viewed from the Essex side of the Stour; the other is a monster cannon of the late eighteenth century.

Shotley Peninsula was the scene of the last outbreak of the Plague in England. A small but significant number of local people died of the disease between 1910 and 1918.

The Tattingstone Wonder.

The Essex Coast

Substantial parts of Essex are covered by what geologists term 'boulder clay' and this gives the country's rural scenery much of its character. In the west and south of the county, the London clay is predominant. It is dark blue and weathers to a brownish hue. It provides a cold, heavy soil for the gardener, the builder or the civil engineer and it stretches from the eastern end of London as far as Harwich.

The London clay is probably several million years old but the boulder clay not a lot more than about 80,000 years which makes it virtually a baby in geological terms. The presence of this clay explains the striking differences between the coast of Essex and that of Suffolk. East of the A12 the Suffolk coast is composed of light sands and gravels and these usually provide fairly steeply shelving, clean, bright, shingly beaches. The coastline of that part of Essex that we are looking at is very much one of low, muddy creeks and marshes. This is partly the alluvium deposited by the Thames and its smaller brethren such as the Crouch, Blackwater, Colne and Stour. It is also London clay, sometimes at shore level, in the river valleys or sometimes evident in the low cliffs which can be seen at Westcliff, Frinton and Walton, for example.

In the London clay can be found what is known as septaria, a kind of conglomerate composed of lumps of limestone or ironstone and it is coloured from ginger through brown to saffron. It is hard, and although not perhaps an ideal building material, was made extensive use of for lack of better options locally. It can be found in the town walls put up by the Romans at Colchester and in the later Norman castle in the town. It weathers well and was used by the people of Harwich for the building of their town wall, although all evidence of this wall has vanished.

The estuaries of Essex are different from those of Suffolk in one important respect. Due to the lessening of the shingle drift as the coastline recedes towards the Thames estuary, the rivers have tended to enter the sea very lazily over large areas of marsh and saltings which at low tides are barely covered with water and even at high tides have little depth away from the known and marked, if sometimes shifting, channels.

Strangers do not immediately think of Essex as a maritime county but it could be argued that few if any English counties have had their history moulded so firmly by the sea and the rivers that flow through it into the sea. Essex is almost surrounded by water: by the Stour to the north, the North Sea to the east, the Thames estuary in the south and the Rivers Lea and Stort in the west. Rivers and the sea provided the best form of transport. All successive waves of prehistoric invaders down to the early Iron Age landed on its coast and they and later invaders travelled by the Essex tidal estuaries and river valleys when they penetrated further into the country. It has continued to be seen as a vulnerable gateway requiring close guarding when danger threatened. For

example in 1588 the Earl of Leicester's army waited at Tilbury for the outcome of the fight with the Spanish Armada. The Essex coast remained of key strategic importance in the Napoleonic and the First and Second World Wars.

Essex, like all maritime counties, has had to fight the most remorseless raider of all, the sea. In the north-east, the frontal attack on the cliffs of Walton, Frinton and Clacton has been severe. The site of Walton Church, which disappeared in 1798, is now well out to sea and it is taking all of man's ingenuity to try to check the rate of erosion. Much of the foreshore is low-lying and it is steadily and inexorably sinking, being at least 13 feet lower than it was in Roman times. Concern about this long-term movement has been rife for centuries and, although sea defences have long been in place, they have been breached and thrust aside contemptuously when the elements have been aroused.

The most famous occasion was of course the spring tides of February 1953 when a hurricane whipped up the sea and overwhelmed the sea defences from Manningtree as far as West Ham on the Thames. Settlements like Harwich, Jaywick, Canvey Island, Tilbury and Purfleet were inundated, 100 people drowned and over 21,000 made homeless.

Until modern times, the Essex coast was remote and thinly populated, for behind the sea walls was almost continuous marshland from Bow Creek to Mersea. This made good summer pasture for sheep and produced according to Camden, the sixteenth-century antiquarian, 'cheeses of uncommon size, which are sent, not only over England, but abroad, for the use of peasants and labourers'. Camden and other historians emphasised the unhealthiness of the marshlands.

The Essex shoreline cannot be described as being of the highest scenic quality but it is unique and strangely appealing. This is a watery landscape of channels, creeks and saltings. Arms of the sea which frequently dry out completely at low tide penetrate deeply inland and have been navigated by flat-bottomed boats of shallow draught since time immemorial. Small ports, often with shipbuilding yards, grew up at the heads of the creeks or rivers at the limit of navigation, which often coincided with the lowest bridging point. Today, for the stranger to the district, it is possible apparently to be many miles from the sea in gently rolling countryside and then unexpectedly to come across an inlet oozing glutinous mud at low tide and somehow unexpectedly full of water when the tide is in. This merging of land and saltwater provides the horizontals. Verticals are few in this landscape but the masts of small sailing pleasure craft provide a counterpoint which has allured and then been captured by innumerable artists. Occasionally a church tower, often embowered, supplements the vertical. It is unsung, curiously charming scenery.

River estuaries like the Blackwater, Colne and Orwell have always proved a barrier to land communication, thus reinforcing the importance of the sea routes. They have also isolated communities in the long peninsulas so that an independence of spirit and outlook has arisen; the people of the low-lying hinterland, the marshes and saltings were looked upon as a race apart with a distinctive way of life and a probably justified suspicion of the outside world. The railway made little impact on these isolated communities and it is really only since the Second World War that their isolation has been broken down by the motor car.

Daniel Defoe in his *A Tour Through the Whole Island of Great Britain,* published in 1724, described the marshes along the Essex coast as unhealthy. He seemed to have little time for those who obtained pleasure from wildfowling and remarked that they 'often return with an Essex ague on their backs which they find a heavier load than the fowls they have shot'. He also commented on the large number of wives that many of the men of the marshes seemed to get through. Men who had married half a dozen wives were seemingly quite commonplace but he was dubious about the claims of a few that said that they had had fourteen or more wives. He explained this phenomenon of many successive marriages by the tendency of the men to go inland when searching for a potential wife. Upcountry women were markedly healthier than the females of the marshes, and prettier. Falling for the blandishments of the men of the marshes, they married them and then set up home with them along the coast. That was when their life expectancy suddenly dipped. The fogs and damps of the unhealthy littoral got to them and many swiftly succumbed to the ague or malaria. When they did, it was not long before the grieving widower was on another hunting foray inland.

Manningtree

This small town provides some evidence of its prosperous past as a minor port. The High Street, for example, has several good Georgian houses. Manningtree was the base from which Matthew Hopkins carried out the depraved activities which are mentioned in more detail under Aldeburgh. His first seven victims were all from this vicinity.

There is an annual regatta featuring, *inter alia,* punts used in the marshes hereabouts for wildfowling.

A charming corner of old Manningtree.

Mistley

Mistley has evidence of being a small working port and remains a centre of the malting industry. It stands at one end of a fine tree-lined riverside walk from Manningtree. This stretch of the Stour estuary possesses a well-populated swannery, with more swans than you could shake a stick at. The gracefulness of swans on water has attracted wordsmiths of far greater virtuosity than the author. On land they lumber along ponderously. However, here they clearly sense they are onto a good thing. They stand on the shore preening, sometimes squabbling and never far away from their next meal since feeding them is one of the local traditions.

Definitions of what constitute architectural follies are hard to make with precision. Some of them were designed to have no practical use but perhaps to catch and delight the eye. Well-known at Mistley are the twin towers which are all that are left of the eighteenth-century church of St Mary. Tuscan in style, they were added in 1776 to a church built in 1735. This building succumbed to dry rot around 1870 but, for whatever reason, the towers which were designed by none other than Robert Adam were left intact, looking altogether too metropolitan for their semi-rural and riverside surroundings. The author is happy not to try and define a folly but he does know that the Mistley towers often feature in books dealing with such quirky and lovable architectural japes.

Close by is a small planned village and port built by one Richard Rigby in the eighteenth century. He was an MP and political fixer said to have made vast amounts of money from peculating public funds. Most of the village survives, its centrepiece being a large fountain containing a carved swan which some people think looks ornamental and others think just looks rather silly.

Harwich and Dovercourt

Most of England's great seadogs of the past have come to Harwich or passed back through while engaged on their often heroic sea voyages. They include Raleigh, Drake, Frobisher and Nelson. In 1340 this was the place where Edward III's fleet assembled before setting off to defeat the French at the Battle of Sluys, the bloodiest engagement at sea in the whole of the Hundred Years War. Contrary to popular belief it was from Harwich and not from Plymouth that the *Mayflower* set off for the American colonies in 1620. She was a Harwich-registered ship and called in at Plymouth because of bad weather. The house in which her skipper, Christopher Jones, lived stands in King's Head Street. Another famous figure connected with Harwich was Samuel Pepys. He was Secretary for the Admiralty and MP for Harwich in the reign of Charles II. He is commemorated by a plaque on the Town Hall.

Old Harwich has a pattern of medieval, narrow streets and strong atmosphere of ships and sea-faring. It is located on a narrow promontory facing the confluence of the Rivers Orwell and Stour and was always regarded as a defensive stronghold. The old town which was started in 1210 had defensive walls and gates. Harwich is curiously remote and little visited perhaps because it is on the way to nowhere and

A mute stone swan, Mistley.

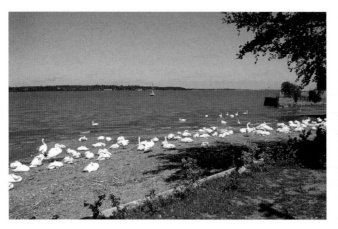

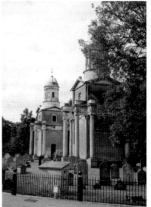

Above left: Swans galore at Mistley.

Above right: Mistley Towers.

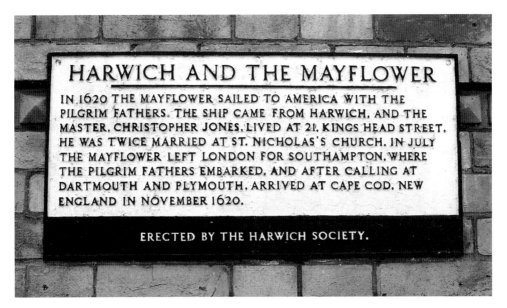

Harwich and the *Mayflower*.

most travellers get no further than Parkeston Quay, a couple of miles away, as they make for the continental ferries. For all that, Harwich is without question a town of some considerable character. Part of that character is derived from it being the base of the operations of Trinity House. All kinds of clutter associated with its activities can be seen dumped, apparently chaotically, on the quay. Trinity House was established by Parliament in 1566 and given the responsibility of looking after navigational aids for mariners, such as lights, beacons and seamarks. English seaborne commerce was increasing but too many ships were being lost and it was felt that a responsible body should take on the provision of facilities that would assist those trying to navigate tricky coastal waters.

Its position made Harwich very prone to attack from seaborne enemies. Sometimes the attacks were of the nature of 'hit and run'. For example in 1405 a French ship arrived under cover of darkness, set fire to some buildings and killed nine of the inhabitants. However, it was not just foreign raiders that the people of Harwich had to put up with. English pirates often put in an appearance and it seems that ships sailing out of Yarmouth had a particular liking for raiding Harwich and carrying off whatever they could.

One largely forgotten aspect of medieval land warfare was the frequent need to transport horses by sea. Harwich was a place where ships from other ports frequently gathered before forming up into fleets and setting off with hostile intent. It should be remembered that in medieval times there were no warships in the modern sense. Merchant ships were used and filled with soldiers who tried to board and overwhelm the enemy ships. Alternatively, the ships were used to carry, troops, horses, equipment and supplies often for amphibious operations. The feeding, stabling, embarking and disembarking of hundreds of horses was a complex specialist operation which became particularly associated with Harwich. Special gangways were constructed, 30 feet long

The Alma Inn. The back streets of Harwich are worth exploring on foot. Note the advert on the gable. These need to be maintained regularly or they turn into 'ghost adverts'.

and 5 feet wide, to enable them to board. Once there they were placed in wooden hurdles 9 feet by 6 feet to protect the timbers and planking from damage by their hooves. In order to make the animals secure, canvas had to be obtained from London and rope from Woodbridge as well as iron staples and rings. They also obviously had to be provided with the necessary quantities of oats, fodder and water. Horses cannot vomit and so they must have suffered awfully in heavy weather at sea.

Elizabeth visited Harwich and described it as 'a pretty town lacking nothing' – praise indeed. James I made it into a Parliamentary borough and, like Colchester and Maldon, it sent two members to Parliament despite having very few electors. It supplied ships and men for the desperate maritime wars against the dreaded Dutch in the middle of the seventeenth century.

Harwich was chartered in 1319 and in 1358 it received a complete set of walls. To help pay for these, the town was granted the right of murage. This allowed the town to levy a toll from every ship that passed going upriver to Ipswich. As can be imagined, the merchant community of Ipswich was less than thrilled by this development and this was only one among a number of acrimonious issues between the two towns which heartily loathed each other. In Cardinal Wolsey's time, fortification works against the action of the sea were begun and they explain why Harwich has not suffered the fate of Dunwich, for example. A Royal Dockyard was commenced in 1657 but was never actually completed. It was supplanted by Sheerness. The Royal Dockyard became a private yard. The curious old treadwheel crane which is a much-photographed feature of Harwich is a remnant of this dockyard. It was built in 1667 to lift naval stores and was worked by men walking inside in big wooden drums. Large numbers of wooden ships were built at Harwich and small ships for the merchant marine were still being built until the mid-1920s.

Harwich had centuries of experience of sending men to sea. The sea was its *raison d'être*. Not all its enterprises were successful, however. In the summer of 1553 three

The old treadmill crane.

ships – the *Bona Esperanza*, 120 tons, the *Edward Bonaventure*, 160 tons and the *Bona Confidentia*, 90 tons – set off to try to find the fabled North-East Passage to what was then called Cathay. The ships' crews perished miserably, freezing to death before they had beyond Lapland.

In 1686 a pirate ship from Algiers put in at Harwich and had the cheek to demand a refit. Harwich sailing men knew all about the Algerine pirates – after all they were frequently attacked by them and many unfortunate local men had ended up as galley slaves. Gleefully the Mayor of Harwich seized the Algerines, incarcerated them in the town gaol, confiscated their ship, released the Christian slaves on board and then triumphantly informed London about what he had done. Imagine his chagrin when instead of a pat on the back, he received a definite rap on the knuckles. Unknown to him, a peace treaty had been negotiated between England and the ruler of Algeria. The mayor was instructed in no uncertain terms to release the Algerines, give them their ship back, provide them with any supplies they wanted and to apologise. It is unclear whether or not he had to give them back their Christian slaves.

To defend the port during the Napoleonic Wars, a massive building known as the Redoubt was built in 1808. This is a low, circular building 180 feet in diameter which was placed here to complement Landguard Fort at Felixstowe. It contained ten 24-pounder guns, had a garrison of 300 and could have withstood a siege not only because of its stout construction but also because it had a well. It can be visited.

Also of interest is the Electric Palace, opened in 1911 and England's oldest working cinema. On the opening night an exciting programme of epics of the silver screen was offered. There were *The Battle of Trafalgar and the Death of Nelson*, *The Cowboy's Devotedness*, *Harry the Footballer* and some supporting comedies. The cinema closed in 1956, was locked up and quietly forgotten until someone rediscovered it with admission tickets still in the box office and, even more remarkably, films in the projection room.

The Electric Palace.

Definitely worth seeing is the Maritime Museum in the Low Lighthouse on The Green. Harwich possesses another such building, the 'High Lighthouse'. This greets people entering the town by road or railway. The former dates from 1727, the latter from 1849 and both were initiated privately at least partly because of longstanding disagreements between the local citizenry and Trinity House. They went out of use in 1863.

The dense pattern of the streets of old Harwich are well worth exploring on foot. There are many ancient timber-framed dwellings, some with oversailing upper storeys and some seemly seventeenth- and eighteenth-century houses which look as if they were designed to be lived in by retired sea dogs. The author likes Harwich.

At Harwich on the third Thursday of every year, the mayor throws gifts for the people to scramble for. Such events were quite popular across the country in the past and the gifts were usually small coins of low value. At Harwich, however, they still throw 'kichels' which are small, torpedo-shaped spiced fruit buns, specially made by a local baker. They are tasty and eagerly awaited by the children. The ceremony takes place at noon and the kichels are thrown from a window in the Guildhall. An EEC directive over twenty years ago ordered the practice to stop on the grounds that it was unhygienic and a hazard to health to have buns rolling about on the pavement and the street while people fought over them. What the namby-pamby bureaucrats can never understand is that a bit of dirt never did anyone any harm. Fortunately, the practice continues but now the buns are wrapped in heavy-duty polythene.

Harwich benefited from the eighteenth-century discovery of the virtues of seawater when saltwater baths were opened by two rival businessmen in the 1750s. These were Mr Hallsted of the 'Three Cups Inn' and Thomas Cobbold of the brewing dynasty. Little love was lost between them and they took out advertisements in local papers in which they paraded very disparaging comments about the lack of cleanliness of their rival's establishment. However, Harwich never really caught on as a watering place. A visitor in 1854 who stayed for a couple of nights grumbled, 'I was nearly devoured

by those enemies of mankind, whose names discreet people never mention aloud'. He meant fleas of course. Another visitor, this time in 1865 and to Dovercourt, complained bitterly about the jellyfish and their 'horrible stings'.

The massive yellow-brick building on the front was once the Great Eastern Hotel built by the railway company of that name in over-optimistic hopes of catering for well-to-do passengers travelling to and from the Continent. It was a white elephant almost from the start, especially when Parkeston Quay, a little distance up the Orwell estuary, was opened. The hotel closed and has seen a variety of uses including as town hall. A visitor to Harwich in the 1880s said, 'the town is mean and dull, the lighthouses superannuated, the church built in 1820, devoid of interest...' The same observer, however, waxes enthusiastically about Dovercourt: 'The principal hotels are good: there are good lodgings and an excellent esplanade, as well as a road along the cliff commanding a delightful and wide view, with the tower on Walton-on-the-Naze conspicuous to the south across the bay. Dovercourt Spa adjoins the esplanade, but is more patronised as a lounge than for the waters that are a mild tonic. There is a library and reading room.'

The same man continues: 'If you pass through a little gate at the end of the spa, you can walk along the sea wall to Harwich and will enter by its prettiest part although I am afraid that a great many people would not admit that any corner of Harwich is pretty. Harwich is such an out and out seaport that it makes no attempt to be a watering place and a mere landman like myself feels rather ashamed of himself in so nautical a town.'

Harwich has no pretensions now to being a resort and leaves this role vestigially to Dovercourt close by, which is a quiet family place with an Edwardian flavour. The seafront is its best feature and its most distinctive features are two small, six-legged iron lighthouses, built in 1863 but disused since 1917. They replaced the Harwich lighthouses. Undercliff Walk was built in 1858 as a promenade of about a mile. Nearby are eight timbered houses given by the people of Norway to rehouse victims of the great tide and floods that occurred in 1953.

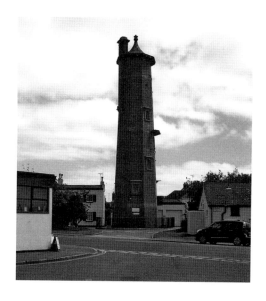

The High Lighthouse, Harwich.

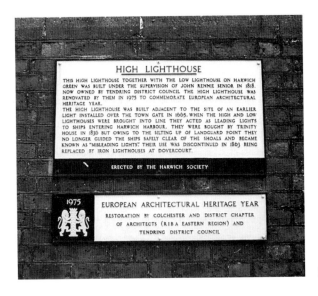

Plaque on the High Lighthouse.

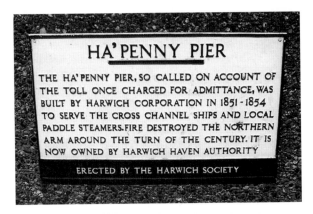

Halfpenny Pier.

A street name in Harwich.
Explanation, please!

The church of All Saints-and-St-Augustine in Upper Dovercourt contains a number of interesting fourteenth-century features and also has a strange legend attached to it. This says that until the Reformation of the Church by Henry VIII, a cross called the Rood of Dovercourt stood by the door. It was said to possess magical powers which made it impossible to close the door near to which it stood. The door therefore had to be left open. Three miscreants decided to vandalise it. They removed it and set fire to it. It burnt far more fiercely than the men could have expected and, horrified, they ran, terrified at the appalling power they seemed to have unleashed. Within six months, all had committed crimes for which they were condemned to death and judicially hanged.

Buried at Dovercourt is Captain Fryatt. When the First World War broke out he was forty-two years of age and captain of the steamer *Brussels* belonging to the Great Eastern Railway Company. Even after hostilities had broken out, this vessel continued to ply regularly between England and Holland, risking mines and submarines. In March 1915 Fryatt shook off a submarine attack and three weeks later he spotted a U-boat on the surface, steamed straight at it and rammed and sank it. He was commended for this action by the Admiralty. In 1916 he was steaming across the North Sea when his ship was stopped by a German destroyer. He was taken prisoner, court-martialled and shot on the grounds that his action as a civilian in ramming and sinking the submarine had been unlawful. This act aroused furious self-righteous indignation in the UK because Fryatt had actually been sailing under Admiralty orders. The truth is that atrocities of war were by no means the monopoly of the Germans. The Germans held a judicial review of the case after the war ended and upheld the decision. In July 1919 Captain Fryatt's body was brought home and buried with full military honours.

The idea of the motor torpedo boat had its genesis at Harwich during the First World War. It was extremely aggravating to the Royal Navy that the large German High Seas Fleet spent most of its time bottled up in port, rarely emerging to offer battle but still requiring a huge deployment of British warships to be ready for them if and when they did. The idea developed of a small, light and fast boat equipped with torpedoes which could cross the North Sea in search of its target. Then, relying on surprise and on its speed of thirty knots or more, it would literally be 'hit and run' as it launched its attack on the enemy's capital ships and other large surface units, and then disappeared before

Looking from Harwich to Felixstowe.

Second World War concrete defences between Harwich and Dovercourt. These derelict, weathered buildings look quite sinister.

retaliatory action could be taken. That was the theory. As is well-known, the motor torpedo boat has gone on to play a significant role in a number of war zones since then.

The Parkeston area of Harwich developed as a port for steamers to Northern Europe and the Great Eastern Railway Company was largely responsible for this development. The reason for shifting there was due to a lack of space at Harwich for major expansion of the port. With the constant comings and goings from Parkeston and Felixstowe, Harwich is a marvellous place for ship spotters. The town may be a trifle careworn but it has character and is well worth visiting.

Walton-on-the-Naze

Walton is a popular resort with excellent sands and a long beach, masses of bungalows, chalets, and a pier. Development here began with Barker's Marine Hotel in 1829 and the erection of the Crescent, now Marine Parade, a few years later. The pier was originally built in 1830 when Walton was becoming a select watering place. It was only the fourth pier to be erected. It was extended in 1895 and eventually reached a total of 2,600 feet, being the third longest in Britain after those at Southend and Southport. This is because deep water can only be reached a substantial distance from the shore. It had an electric tramway with a 3-foot 6-inch gauge but this was replaced in 1936 by a battery-powered car. The pier was bought by the New Walton Pier Company in 1937 and they continue to operate it to this day. During the Second World War the pier was devastated by fire and when it was rebuilt in 1948 it was with a 3-foot-gauge railway. Walton Pier has the world's oldest extant amusement park. It is still trading.

Dominating the Naze is the red-brick tower built by Trinity House in 1720 as a sea mark.

Back in the Victorian period enterprising local businessmen made money from picking sea holly (*Eryngium maritimum*) and making a candy from its roots. This they sold on the grounds that it was an aphrodisiac. Human gullibility knows few bounds

where sexual matters are concerned. Few customers who found that it did not do the job required would have the temerity to ask for their money back.

Although you would never know it to look at Walton now, the place has ancient origins, being mentioned in Domesday. Walton has an excellent situation on a Nose, Ness or Naze, nuzzling northwards into the sea which is shallow at this point. There are fossil-bearing cliffs but a visitor in 1882 was not very impressed: 'Some years ago, Walton was a favourite resort, late in the year, with quiet-loving folk, who, wanting to do nothing, could perfectly succeed. In a measure it is so still, but the place has about it rather the shabbiness than the respectability of age. Public spirit appears to be dead and buried, unless it has migrated to Clacton.' An earlier community, Old Walton, has been swallowed up by the sea. Its ancient church succumbed in 1798 and further erosion is always a threat.

Walton and Clacton were always rivals for the holiday trade and those businessmen concerned with developing Walton did not take such comments lying down. Considerable investment was made in Walton, and in 1900 a national guide described it as 'a fashionable, healthy and rapidly-rising watering place'.

The Walton Maritime Museum in the Old Life Boat House, East Terrace, tells the story of the *James Stevens No. 14,* which was Walton's second lifeboat, taken out of service in 1928 after a long and honourable career. This doughty vessel has been preserved locally and may be the oldest surviving motor boat in the world, having been fitted with an engine as early as 1900.

Frinton-on-Sea

Walton's ultra-self-conscious neighbour is Frinton, a settlement with less than 150 years' history and desperate to keep its sedateness and sense of exclusivity preserved. It has the natural advantage of an attractive low cliff and a glorious visual sweep over the sea. Frinton, which largely dates from the 1890s onwards and was the creation of Sir Richard Cooker and a land company not dissimilar to that at Clacton, developed as a town which has not yet quite, but may in the future, develop character and historical importance as an example of a certain genre of late Victorian planned seaside town. It is clean, affluent and has many handsome tree-lined avenues and a long, fine, sandy beach. It possesses an attractive open stretch of grassland on the clifftop known as the Greensward but it also has a couple of entirely inappropriate and out-of-scale blocks of private flats. Frinton has always liked to think of itself as exclusive and its residents, many of whom are elderly and affluent, fought long and hard against the opening of any pubs or fish-and-chip shops or other brash amenities in the town. Those who live in Frinton are largely the elderly and the well-to-do and this had led to the rather unkind little ditty, 'Harwich for the Continent, Frinton for the incontinent'.

Frinton's most notable building is almost certainly The Homestead, a model middle-class villa by the eminent architect C. F. A. Voysey. It is dated 1905 and is located at the Holland Road end of Second Avenue. It is L-shaped and contains a mass of fittings influenced by the Arts and Crafts movement such as shoe-scrapers and original needlework bell pulls with traceried brass ends.

Clacton

Clacton nearby is an unashamed trippers' town, bright and breezy and second only to Southend as a popular resort in Essex. It had been a small fishing village until steamers and later the railway arrived. The town takes its name from a Viking settler called Clak. Some of the earliest known flint tools have been found here dating back around 400,000 years. As late as 1860 it consisted only of the inland villages of Great and Little Clacton and three Martello towers on the coast, one of which is now a coastguard station. The town grew rapidly from a start about 1870. Originally a land company proposed a very formal planned development with avenues and open spaces but little of this ever saw the light of day. Clacton grew and grew, however, but in an unplanned way and it is now the main centre of the Tendring Peninsular which lies between the River Stour to the north and the Colne to the south.

We have an eye-witness account of the appearance of Clacton as a very newly planned seaside resort:

> In leaving the station we have at once evidence, in the wide roads laid out and planted, of how Clacton means eventually to grow. Two buildings are very prominent on the right hand, one a large Wesleyan chapel, the other the water tower of the water works. A few trees, survivors of the time when the site of Clacton was a farm, justify the name Pier Avenue given to a wide and foreign looking street at right angles to the shore and in line with the pier. Here are good shops and of course a library and, at the corner, the Royal Hotel, in more senses than one the first house in the town. At present detached and semi-detached villas and a short terrace extend for two or three hundred yards on either side of Pier Avenue. Further eastward is the little church, between which and the sea it is in contemplation to build a 'Grand Hotel'.

The pier was seen as an integral part of the whole scheme. It was opened in 1871. This was good timing, as on 5 August of that year the first-ever Bank Holiday took place. Ironically the pier was the cause of the downfall of Clacton from the originally proposed fashionable garden seaside town. The pier allowed steamers to berth and they brought the pleasure-seeking crowds of brash cockneys who had some collective spending power but were thought of as lowering the tone. Paddle steamers belonging to the Woolwich Steam Packet Company connected with London, Harwich and Ipswich and there was great excitement at Clacton when SS *Queen of the Orwell* made the first official berthing at the pier. In 1878 a lifeboat station was added to the pier. In the early twentieth century the steamer trade was going out of fashion and in the 1920s it was decided to invest in a remodelling of the pier to be less of a glorified landing stage and more what would now be called a leisure complex. Products of this enterprise included the Blue Lagoon Dance Hall, the Crystal Casino, an open-air swimming pool advertised as the only pool in the world built over the sea and later the Steel Stella roller-coaster. As a resort Clacton never quite returned to the heady interwar days. A serious fire occurred in 1973 and the pier also suffered one of the perennial hazards of such structures – storm damage. However, the pier is still in business and is a very impressive affair which its owners claim is the most extensively-used pier in Britain.

The railway arrived in the 1880s and contributed to the very rapid growth of the town, which quadrupled in size between 1881 and 1901. So headlong was the growth in fact that there was little time for the erection of buildings of architectural merit. The best part of Clacton is the seafront with the laid-out gardens on the low cliff overlooking the sea. Away on the low ground to the west stands Butlin's holiday camp, while further west is Jaywick which developed as a shanty town of bungalows in the 1930s when the land was being sold off amazingly cheaply. North-east of Clacton is the quieter, largely residential resort of Holland-on-Sea, beyond which there is a path along the sea wall to Frinton.

Clacton was the location of the second holiday camp run by Butlin's and it opened in 1938. In the late 1930s only about three million people in Britain had paid holidays. Billy Butlin's holiday camp at Skegness had opened in 1936 and been an immediate success. In 1937 it had been enlarged to take 5,000 campers. Butlin was certain that paid holidays would become the legal norm and so he expanded into Clacton. He proved correct because a week's paid holiday did indeed become law in 1938. In those days the average weekly wage was £3 10s and Butlin advertised his camps with the slogan, 'A Week's Holiday for a Week's Pay'. Everything was thrown in for that price, of course. Butlin's at Clacton opened at Christmas in 1938. There was no heating whatever and not surprisingly everyone complained of the cold. Butlin's ingenious solution was to buy a large number of metal dustbins and make them look like braziers by making holes round the bottom, with a red light bulb inside, surrounded by small balls of screwed up paper. They were then put around the dining halls and ballrooms and everyone said they felt much warmer. Butlin always had an eye to publicity and when Clacton opened, he hired a special train to bring a party of over 200 VIPs from London, and also every MP who had voted in favour of paid holidays.

In 1939 Butlin's became an internment camp for German civilians who were resident in this country and were known as 'enemy aliens'. Chalets were knocked down to allow a straight perimeter wire to be put up. Floodlights were installed every 100 yards or so. For whatever reason, few internees were brought to Clacton and the camp was soon taken over by the Royal Pioneer Corps. Bren guns were repaired in the ballroom, the tennis courts became the parade ground and commandos in full kit did their training in the swimming pool. Spud bashing took place in what in peacetime had been the Pig and Whistle Bar. Actually the takeover of the camp by the authorities represented a smart piece of business on the part of Butlin. He had experience of mass catering and accommodation for thousands of people. He knew that his facilities were ideal for the armed forces. The government agreed to pay Butlin a rent of 25 per cent of the previous year's profits and he agreed to buy them back when hostilities finished at three-fifths of their original cost, whatever condition they were in. It was also, of course, immensely helpful to Butlin in terms of goodwill and his public image.

As with most of Britain's other popular resorts, all manner of social, economic, cultural and technological changes have affected business at Clacton since the end of the Second World War. The traditional week or fortnight in a boarding house dropped out of favour as self-catering or day-tripping took over. With the arrival of cheap packaged holidays by air to places where sun can almost be guaranteed, Clacton and other resorts like it came to look old-fashioned and unglamorous. They continued to be

victims of the capriciousness of the English climate. In Clacton's case it hardly helped that the Mods decided to do battle with the Rockers over Easter 1964 and terrorise all those innocent visitors and young families who unwittingly found themselves in the centre of mayhem that received a huge amount of publicity via the pervasive new medium of television.

Great Clacton is a mile or more north of the centre of modern Clacton but it has a collection of ancient buildings which bear witness to its earlier importance. The Romans must have had some kind of settlement there because tiles from their time can be seen in the fabric of the large church. Saxon burials also took place but the church is basically Norman. Little Clacton was no more than a hamlet which has likewise become absorbed into modern Clacton. It possesses a rustic and quite charming little parish church.

Worthy of inclusion as an architectural folly is the Moot Hall. To be found in Albany Garden West, this is not some venerable meeting place of our grey-bearded ancestors but a whimsy created from fifteenth-century timbers from a demolished barn in Suffolk.

St Osyth

The village of St Osyth provides a considerable contrast to the nineteenth century and later character of Clacton, Frinton and Walton. It stands close to brackish creeks which are arms of the estuary of the River Colne.

The glory of St Osyth is the gatehouse of the priory. This was built in the 1480s and displays fine flint and stone decorative flushwork. The gateway has a stone vault with carved bosses including one featuring St Osyth herself. This building is in a poor state of repair. A nunnery was established in the seventh century and St Osyth was probably martyred in AD 653 during a raid by Danish invaders. The raiders had seized the saintly Osyth and told her to worship their gods. When she indignantly refused to do so, they were seriously irritated and they showed this by cutting off her head. She is shown here with a crown and veil. Osyth was the daughter of Frithwald and Walburga, who were the first King and Queen of East Anglia, to embrace Christianity. As might be expected, Osyth was as devout and chaste a maiden as any and was very young when she was betrothed to Sighere, heir to the kingdom of Essex. A date was set for the nuptials and a great feast was being enjoyed by the happy couple, relations and guests when Sighere happened to glance up and see a regal-looking stag trotting close by. He dropped his fork, shouted to his retinue to follow him, rushed out, leapt onto his horse and rushed off pell-mell in pursuit of the stag. This rather put the mockers on the wedding feast. It was all too obvious that the thrill of the chase was higher up the list of Sighere's priorities than the happiness of his previously radiant bride. When he returned, he found the guests had dispersed and the servants were doing the washing up. There was definitely an 'atmosphere' and Osyth herself was nowhere to be seen. He soon learned that she had rushed off in an understandable fit of pique having suddenly realised that a life dedicated to devotion and holy works had more attraction than the dubious delights of spending the rest of her life with a man for whom the pleasure of

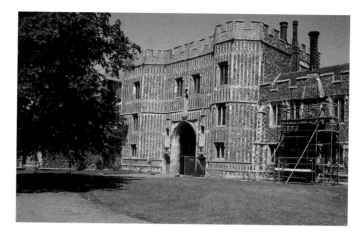

Gateway, St Osyth's
Abbey.

the chase meant more than cherishing and pleasing his bride. She joined a nunnery and probably never looked at another man again.

In 1121 a priory of Augustinian canons was established; this had become an abbey by 1261 and was dissolved in 1539. The church and most of the other buildings of what was a substantial monastic establishment have disappeared. Some, however, have been attractively incorporated into later domestic premises on the site. Nearby there are quiet and serene weatherboarded cottages which make a stark contrast to the formless modern banality which is the dominating feature of Clacton.

A gruesome discovery was made in 1921 of two female skeletons buried under a garden in the village. Their arms and legs were studded with iron bolts obviously designed to prevent them rising from the grave and 'walking'. It is thought that they are probably the remains of two local women hanged as a result of the investigative efforts of Matthew Hopkins in the mid-seventeenth century.

Brightlingsea

Brightlingsea is the archetype of the place in which to mess about in boats and this is possibly because it possesses a very fine boat-launching ramp. Fishing and boat-building have been its staple industries for centuries and the town was once famous for its oysters. In the Middle Ages, Brightlingsea was an important port and effectively an outstation of Sandwich, one of the powerful Cinque Ports of Kent and Sussex; this meant that it enjoyed certain valuable privileges. Even today there is an annual ceremony on St Andrew's Day, 30 November, when the town's officials still swear allegiance to the Mayor of Sandwich and present him with the princely sum of 50p as Ship Money. However, there is little in modern Brightlingsea that gives clues to this august past. An exception is a fine timbered house called 'Jacobes' which stands in the High Street.

The town is located on what is virtually an island, as it is surrounded by water on three sides and there is only one significant road into the town, which means that it is very much off the beaten track. It possesses a splendid parish church but this is

about 2 miles inland. It contains as many as 200 memorials commemorating local men who died at sea. There are several very fine memorial brasses. The tower of flint and flushwork is 94 feet high and was built in the 1490s.

Brightlingsea means 'Brictric's Island', and during the sixteenth century was spelt 'Brykylsey' when ships from what was then a very active little port transported Henry VIII and his entourage on several occasions. A prominent local family which owned some of these ships were the Beriffes and the house called 'Jacobes' in the High Street belonged to them. It is timber-framed with a crown-post roof and picturesque Tudor brick external stair-turret.

In the 1860s serious attempts were made to develop Brightlingsea as a commercial port with the opening of a branch railway to Wivenhoe and Colchester. Harbour works were started but abandoned when it was realised that there simply was not enough depth available for vessels of any real size. However, there was a fish-loading dock and large amounts of sprats and oysters were landed there and then taken away by train. Now there is an annual race for fishing smacks and large sailing barges. They sail to Clacton and back.

Brightlingsea Museum stands in Duke Street. In this museum is related the sad story of the *Mignonette*, a small yawl that sailed to Australia in 1884. The crew had to abandon ship and they took to the lifeboats and had to wait so long for rescue that they ate the cabin boy, Richard Parker. Whether they chose him because he was younger and likely to be more tender, because he was unpopular, because he was the least able to defend himself or simply because they had to start somewhere, is not known. A Brightlingsea man was among the crew but the court found him not guilty of cannibalism.

On the front, if it can be called that, is Bateman's Folly, a nineteenth-century building. It is a slightly leaning two-storey tower said to have been originally built by Mr Bateman himself as a freelance lighthouse. The town seems rather run-down.

Wivenhoe

This settlement on the River Colne as it approaches Colchester from the sea has a quayside which contains many remainders of past times. The main industry in Wivenhoe was shipbuilding and this began in Elizabeth's reign. It was especially busy in the nineteenth century but it continued and, in the Second World War for example, large numbers of minesweepers were built here, utilising wood for their hulls which reduced their vulnerability to several kinds of explosive mine.

The parish church has superb memorial brasses to Sir George Beaumont and Elizabeth de Vere. In East Street is Garrison House said to be named after Cromwell's troops who stayed there during the Civil War. It is decorated with some of the finest pargeting to be found in Essex. In the 1750s there was an unsuccessful attempt to turn Wivenhoe into a spa served by a regular packet boat from London. There is extensive recent housing development close to the river which has attempted with at least partial success to replicate some of the style and the feel of the old vernacular domestic buildings characteristic of this part of the country although they are, of course, equipped with all modern conveniences.

In 1884 Wivenhoe was shaken by an intense earthquake which damaged more than 200 buildings. Wivenhoe Park contained the seat of the Rebow family in the eighteenth and nineteenth centuries and the park contains a lake landscaped by Richard Woods and featuring in a painting by Constable. The house is given over to the administrative functions of the University of Essex whose campus is now located in the park. Whatever is thought of the towering blocks which dominate the campus, they are striking and take advantage of a very fine site.

The actress Joan Hickson, who many argue was the definitive Miss Marple in the televised versions of Agatha Christie's murder mysteries screened between 1984 and 1992, lived and died in the town.

Colchester

Colchester proudly boasts of being the oldest recorded town in the United Kingdom and the first major Roman settlement in Britain. It is a lively town of the present but rightly proud to show off evidence of its past. Colchester grew from a major Roman fortress established in AD 43. It replaced the nearby British capital of Camulodonum from which the pre-Roman kings ruled south-eastern England. Long stretches of the massive Roman town wall survive and the Norman castle still stands where once there was a temple dedicated to the Emperor Claudius. Inside what is left of the town walls, the street pattern still largely follows that laid down by the Romans. The walls, incidentally, constitute the most extensive Roman walls in the country. A major remnant of these walls is the Balkerne Gate which would have been the town's western entrance in Roman times.

In AD 60–61 the town was sacked by Boadicea (or Boudicca as she is now known) the warlike queen of the Iceni who, as we all know, led what ultimately proved to be an unsuccessful revolt against the Romans, although she gave them a good run for their money. Nero had previously seized Boadicea and had her publicly whipped. Her daughters were ravished, also publicly. Boadicea was determined that these brutal humiliations should not go unavenged and she raised an army, determined to put the hated Romans to the sword. One of her first actions was to sack and burn Colchester. She massacred all the inhabitants she could lay her hands on. Ashes from the destruction that she wrought have been excavated and identified by archaeologists.

Having dealt with Camulodonum, she turned her attention to Verulamium (St Albans) and then Londinium. She did the same to them. It is thought that her efforts led to the death of 70,000 native English people – rather unfairly, it could be said, but as far as she was concerned those who had submitted to the yoke of the Romans were as bad as the Romans themselves. For all that she engaged in genocide, she was clearly a military leader of remarkable ability, but ultimately the Roman war machine proved too strong for her and she was defeated. She knew the fate that awaited her if she was captured alive so she killed herself when the outcome of the last battle was obvious. Unfortunately, she chose to do this in full view of her followers which must have further sapped their morale as they stared defeat in the face. Predictably the Romans extracted a frightful toll from those English who did not die in the battle. There really

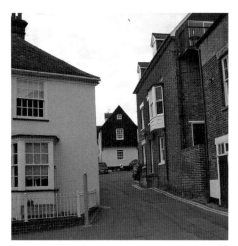

Above left: The streets of old Wivenhoe.

Above right: The Nottage Maritime Institute, Maldon. Known as the 'Nottage', this was founded in 1896 by Charles Nottage, a well-known yachtsman. It teaches a range of courses of a maritime nature and has a museum containing material of local maritime interest.

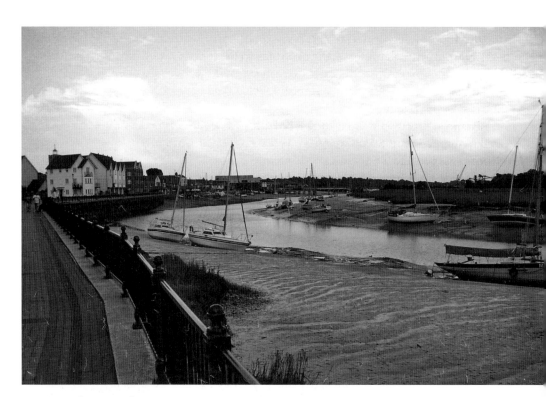

Wivenhoe waterfront.

was nothing to choose between Boadicea and the Romans so far as savagery was concerned.

The present name of the town seems to have been given to it after the Romans left and has a Saxon stem meaning something like 'The Roman fortress on the River Colne'. It was the first Roman 'colonia' which means something like a military depot which of course uncannily predicted one of the major roles of modern Colchester. However, Colchester was more than a mere military camp. It became one of England's leading cities and was surrounded by walls; many parts of which survive as do many other items that are evidence of their occupation. When the Romans left, the Saxons, who were not usually town-dwellers, broke with convention and occupied Colchester. The late Saxon tower of Holy Trinity Church and the dedication of another church to St Runwald are evidence of their presence.

Earlier, Colchester had been the city of Shakespeare's 'Cymbeline' and this 'Cymbeline of Camulodonum' was once known to every English child as 'Old King Cole'. His real name was Cunobelin. He was the foremost prince of Britain and he prospered by accommodating himself to the overall rule of the Romans. He reigned during the first century AD. Cunobelin built up strong trading relationships between Britain and Rome. His previous capital had been St Albans but he moved to Colchester in AD 3. The site of his base is under the town's bypass.

Cymbeline had two sons. The younger was Caractacus. He rebelled against the Romans and, having been captured, was taken to Rome and marched through the streets, loaded with chains. If this was meant to humiliate him, it did not work. He bore himself so proudly and addressed Caesar with such eloquence that he was allowed to go free. Later, when the Romans decided to occupy Britain on a permanent basis, it was Caractacus who led the native resistance although; as with Boadicea, his resistance ultimately proved futile because the Roman legions were simply better armed, equipped and disciplined. Cymbeline's eldest son was a turncoat. He went to Rome and persuaded them that they should return to Britain, place it under their control and settle.

The Balkerne Gate.

Colchester Castle Keep as viewed from Castle Park.

Old King Cole left off smoking his pipe long enough to father a daughter called Helena. She was apparently a great beauty and she won the undying affection of a Roman general by the name of Constantius and from their union sprang the great Constantine, famed as the first Roman emperor to embrace Christianity. The truth is that it is not known whether Helena ever went anywhere near Colchester but that hasn't stopped the town's elders from proudly incorporating her image on the coat of arms.

There is an absolutely magnificent keep or donjon from the major Norman castle that was established in the town. It was built early after the Conquest almost certainly on the foundations of a building erected by the Romans, probably a temple. It is clear evidence that William, Duke of Normandy, saw Colchester as a place of strategic importance in his plan to exert his authority over his unwilling new subjects. This building bears a considerable resemblance to the White Tower in the Tower of London but was certainly at one time considerably bigger, possibly two storeys higher. What we see now is a magnificent but truncated remnant of the largest keep ever built in Europe, or at least so it is claimed. This keep contains a museum of artefacts which very effectively evokes a sense of the town's development in Roman times. The finest exhibit of all is probably a sculpture of a Roman centurion holding his wand of office. His name was Marcus Favonius.

William of Normandy was an able, tough, ruthless and worldly man who found it expedient to trust few others. He was prepared to allow carefully chosen followers to build castles but he clipped their wings by making it abundantly clear that what he gave he could in turn take away; he was pitiless towards anyone who tried to get one over on him. Colchester Castle was occupied by one of the few men he seems at least partly to have trusted. This favoured man had the rather impressive name of Eudo Dapifer. Colchester Castle remained a royal possession and witnessed many momentous events, most of them unpleasant for someone or other. Part of it became a prison in the fourteenth century and remained as such until the middle of the nineteenth century. Among its dismal occupants were Protestants who died rather than abjure their beliefs

in the reign of Mary Tudor and also the Royalist leaders Sir Charles Lucas and Sir George Lisle who were later shot outside its walls. An obelisk marks the spot. Most of the castle was bought and demolished in 1683 by a local ironmonger and wide boy who succeeded in his business enterprise of selling the stone from the castle as first class building material, which it was.

276 people are named as residing in Colchester in the Domesday Book, and the town was extremely prosperous in the Middle Ages, with a very busy port area then known as the Hythe, and had a flourishing cloth industry. The town received its first charter in 1189. This gave the burgesses certain privileges. It had two monasteries: St John's Abbey just south of the town and St Botolph's. Of the former, only the splendid gatehouse with fine flint flushwork may be seen. The latter was the first house in this country of regular Augustinian canons. These canons were all priests but they were not tied to devotion and work within the monastery precincts. Their discipline was therefore not as tight and they performed various community and parochial duties. The ruins of St Botolph's close to the town centre are readily accessible. Other monastic buildings followed such as the Greyfriars or Franciscans and the Crutched Friars to the west of the town. By the fifteenth century the town contained sixteen parish churches. There are something like 300 buildings in Colchester scheduled as being of historical or architectural importance. It has always been a lively town and to walk a selection of its streets, preferably with a good guide is to obtain a considerable sense both of change and historical continuity. The cloth industry benefited from the fact that the water of the local streams was particularly suitable for the fulling of cloth. A fuller shrinks, beats or presses the cloth to make it heavier and more compact.

Colchester is widely known for its oysters, which have been cultivated in the lower reaches of the Colne since Roman times. We know that the Romans greatly appreciated this delectable mollusc, *Ostrea edulis*. In September the oyster season is ceremonially declared open by the mayor who sails downstream and, having dredged the first oysters, then drinks the Queen's health in gin accompanied by gingerbread. The Colchester Oyster Feast is held every year in October; it dates back many centuries. Oysters have been valued for their culinary virtues and, if truth is told, probably even more for their supposedly aphrodisiac qualities. 'Colchester Natives' as they are sometimes called, have long been highly esteemed by gourmets everywhere – or by those bent on sowing their wild oats. The season for eating oysters of course runs through those months with an 'R' in them – from September to March.

Such was the demand for oysters centuries ago that an early version of the Cod Wars took place. Other coastal areas close by had oysters but the Colchester molluscs were in a class of their own and other places were jealous. It was by no means unknown for oyster fishermen from elsewhere to sail surreptitiously up the River Colne at dead of night, determined to seize as many of the Colchester oysters as they could carry off. Sometimes the Colchester men were ready for them and desperate hand-to-hand fighting took place between those defending and the others intent on ransacking the oyster beds. This was a serious business because livelihoods were at stake. On occasions the Colchester men would decide to retaliate and, not content with their own excellent reserves of oysters, they sailed downstream to raid those belonging to other people. Of these proud Colchester men, it can truly be said that the world was their oyster.

The cloth-making industry had declined by Henry VII's time (the late fifteenth century) but it gained a new injection of life in Elizabeth's reign when around 500 Flemish refugees settled in the town around 1573. Their presence may account for Colchester's reputation for staunch Puritanism and Nonconformity at a later stage. The area they settled in is now subject to a conservation order and is known as the 'Dutch Quarter'. It has many fine old half-timbered and plastered buildings, especially in East and West Stockwell Streets. The presence of these immigrants was strongly resented at the time by the indigenous population but they were enterprising and industrious and their efforts added considerably to the wealth of the town.

The town was involved in the Civil War when it was besieged by Parliamentary forces under Sir Thomas Fairfax in 1648. A ring of earthworks, technically known as a Line of Circumvallation, was built around the town from which artillery bombarded it for ten weeks. Eventually the town was battered and starved into submission. It is said that by then all the rats had been eaten and they were down to beetles and moths. Anything made of leather had long since been gobbled down. Presumably it would have been gravel next. The garrison ran out of ammunition and was reduced to rescuing cannon balls that the Parliamentary forces had fired at them and then firing them back. Sir Charles Lucas one of the Royalist commanders was ordered to be shot and as he prayed before the firing squad took aim, he opened his doublet and declared, 'See, I am ready for you; and now rebels, do your worst.' They did. They shot him. They also shot Sir George Lisle. There was nothing forgiving about Fairfax. He sent some of the Royalist junior officers to the galleys and transported others to the West Indies where they were little better than slaves. The siege was a disaster for Colchester. The citizens had actually supported the Parliamentary cause but *force majeure*, that is, a large presence of Royalist soldiers, meant that they found themselves involved in a siege they did not believe in. The town's cloth industry never really recovered. Much of the town was reduced to rubble and even now the scars may be seen in the remnants of St Botolph's Priory and the Siege House near East Bridge which is still riddled with bullet marks. It is said that at the spot where Lucas and Lisle were shot, no grass has grown since 1648.

Buried in an unmarked spot by the church of the Holy Trinity in the town centre is William Wilbye who died in 1638. He is renowned as a composer of madrigals which have been sung by devotees ever since. Some of the best-known are 'Stay, Cordon', 'Adieu Sweet Amaryllis' and 'Flora gave me the Fairest Flowers'. In the church is an alabaster carving explaining that William Gilbert is buried close by. He was the first man to use the word 'electricity' after investigating magnetism and related phenomena. He appeared before Elizabeth I to demonstrate his knowledge and apparently she was absolutely fascinated. It is likely that this audience took place in Colchester. Gilbert realised that it was the gravitational pull of the moon that was responsible for the tides, long before such a notion was generally accepted.

Colchester has several old churches. All Saints and Holy Trinity are museums. St Giles', St Helen's chapel and St Martin's have found secular uses. Of the others it is perhaps St Peter's on North Hill which best encapsulates the history of the town. It was already in existence when the Normans arrived and it displays accretions from all subsequent periods of building and also many memorials to the great and the good of the town.

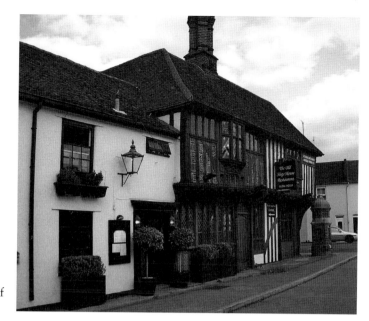

The Old Siege House Restaurant still proudly bears the scars of a bit of Civil War nastiness.

The River Colne has always played a prominent part in Colchester's history during much of which it was a prosperous and busy minor port. Agricultural produce and woollen goods were the major exports through the old part of the town known as The Hythe. 'Hythe', which is a common element in place names, simply means something like 'landing place' and it can be found in such names as Rotherhithe and Hythe in Kent. The problem with the Colne was that it was shallow and needed constant dredging and as vessels became larger the Hythe lost trade to other places with deeper approaches such as Maldon. There was at one time a scheme to build a direct ship canal from Wivenhoe to a deep-water dock at Hythe but nothing came of this scheme.

The town may be famous for oysters but other industries associated with Colchester have been engineering, ironworks and rose-growing. Among the town's residents were Jane and Anne Taylor who lived in a house still to be seen in West Stockwell Street from 1796 to 1811. They composed 'Twinkle, Twinkle, Little Star'.

East Hill is particularly rewarding for its mixture of fine Georgian townhouses nearer the town and timber-framed buildings further down. The High Street, which formerly housed a market and now constitutes the centre of town, is dominated by the Town Hall which was completed in 1902. Its architectural style could be described as 'municipal eclectic'. There is nothing understated about this building as it dominates the High Street which runs along the hill on which the old town was built. It is dominated by a figure of St Helena holding a cross which is 162 feet above street level.

One of Colchester's best-known, ugliest and apparently most popular landmarks is Jumbo, one of the few water towers to have acquired a nickname, or at least an affectionate one. It is indeed jumbo-sized, being 195 feet high, and it gained its name because it was erected in 1882 in the year when Barnum and Bailey's famous circus elephant first hit the headlines. As a water tower, it has not just size but also style, possessing a pyramidal roof capped with a lantern. It has been threatened with

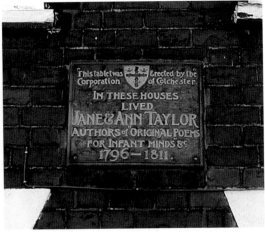

Above left: Colchester Town Hall, dominating the Dutch Quarter.

Above right: A plaque in West Stockwell Street dedicated to Jane and Ann Taylor who penned 'Twinkle, Twinkle, Little Star'. This was rudely satirised by Lewis Carroll as 'Twinkle, twinkle, little bat! How I wonder what you're at!'

demolition on many occasions and is not in the best of conditions but it manages to hang on. Colchester has another folly in the garden of The Minories, a fine eighteenth-century townhouse in East Hill. It is a summerhouse in a Gothick style, seemingly a little confused by its surroundings.

Colchester has one quality characteristic of all the best European towns from Rome to Dublin and from Warwick to Edinburgh – you can see the open country from the middle of the town. There is a wealth of old vernacular buildings, many of them timber-framed, scattered around the town, both in the centre and elsewhere. Some have been well-restored but others are in dire need of renovation. Where selective demolition has taken place, replacement buildings have often been put up in styles sympathetic to local tradition but there are substantial parts of Colchester, especially in the east and south-east of the town that are extremely depressing and run-down. As is only to be expected of a town of this size, some of the buildings put up in the 1960s and 1970s are grossly out of character and scale with their surroundings – real examples of architectural bad manners and banality.

Mersea Island

Separated from the mainland by a creek called Pyefleet and joined to it by a causeway called The Strood, which is flooded sometimes at high tide, Mersea is curiously isolated given its proximity to Colchester and other substantial centres of population – truly a world of its own. The east side of the island is predominantly rural. The tiny community of East Mersea probably has its main claim to fame in an incumbency by the impressively named Sabine Baring-Gould. He held the cure of souls from 1870 to

Above left: 'Jumbo', Colchester's trademark water tower.

Above right: The Gazebo, Colchester.

1881 and is remembered as the composer of the simple hymn 'Now the day is over'. The only settlement of any size is West Mersea, noted for its boat-building activities and a popular resort for trippers, yachters and the caravan fraternity. The Romans had a small settlement including a lighthouse in what was, and remains, a bleak spot. Goodness knows what they must have thought of it. There is still a Pharos Lane, a reference to the lighthouse. Some pieces of Roman masonry are incorporated in the tower of St Peter's church. This stands in a circular churchyard, almost always a sign that this was a place of worship before Christianity took root.

The island is largely composed on London clay, more than 100 feet deep in places and resting on a bed of sand and gravel. The north is largely alluvial mud. There are some chalk boulders to be seen, deposited by glacial action. The 'red hills' are heaps of burned soil which are the remains of salt workings dating back to Celtic times.

At West Mersea there stands a mound, 20 feet high, called Barrow Hill or Mersea Mount. According to some, when Danish raiders were marauding hereabouts, they were led by two twin brothers who loved each other dearly and were almost inseparable. Among the places they plundered was St Osyth where they killed the saintly lady of that name and carried off her sister, by all accounts a most toothsome young lady. That's when the trouble started. They both fell for her and each wanted her for himself, never mind the other brother. Mutual love turned into all-consuming jealousy and hatred. There was nothing for it but a fight to the death, the winner being the one who would then be able to enjoy her favours, he hoped. With huge swords they hacked away at each other, bodily parts flying in all directions until there was little left to hack off and they dropped down dead simultaneously. After this 'death by a thousand cuts'

their followers drew their long boat up to the top of Barrow Hill, dug a big hole and placed the ship in it. As usual the woman was blamed for the way things had turned out and so they killed her and placed her in the boat with her would-be suitors on either side. This should have been an end to it, but no such luck. According to local legend, when the new moon appears, the two brothers make a miraculous recovery and start fighting again and the clang of sword on sword and armour and screams of agony can be heard. When the moon wanes, they wane as well and they go back to their disturbed sleep. On moonless nights, the woman can be heard crying, as well she might. Probably all she wants to do is rest in peace but with monotonous regularity her slumbers are disturbed as the twins get up and resume their fight. It seems that this saga will never end because the twins are equally matched in every way and neither can gain any advantage over the other.

Baring-Gould, mentioned above, in *Mehalah, A Tale of the Salt Marshes*, gave an interesting description of the area: 'The sea is not here what it is on other coasts ... it is one tone and grey, and never tosses in waves, but creeps in like a thief over the shallow mudflats.'

Two other smaller islands – Sunken Island and Cobmarsh – can only be reached by boat.

Maldon

Maldon is a fine and ancient little town standing in a commanding position overlooking the Blackwater. Although it is a dozen miles from the sea, it possesses a strong nautical character and proud seafaring traditions. The seafaring part of Maldon lies slightly away from the town centre, downstream by the Norman St Mary's church. Here can be seen restored nineteenth-century Thames barges moored and there is a riverside promenade overlooking a beach of muddy shingle with delightful views back towards the little town.

Maldon received a charter in 1171 and the burgesses of the town grew up very jealous of their privileges. Some of the legal documents relating to the town's earlier days are preserved in the fifteenth-century brick Moot Hall. It had ancient cloth and leather industries which were later replaced by iron and timber works. Maldon-built ships fought at the siege of Calais in 1348.

In the year 991 the fierce Viking Olaf Tryggvason landed a fleet of ninety-three ships at Folkestone. He then proceeded to ravage and ransack much of the south-east of England and also East Anglia. The tactic he used was a cunning one. He used to parley with his intended victims and then see how much they were prepared to pay him to go away. Having solemnly agreed a price and received the payment, he then frequently attacked and plundered them anyway. Any brave but foolhardy attempts to resist this extortion were simply swept aside. In 991 a group of his followers arrived by water at Maldon and demanded tribute with menaces. They were extremely surprised and not a little put out when the locals told them exactly where they could stuff their battleaxes and winged helmets. There was only one possible outcome for such defiance – the local had to be put to the sword. It was a rather one-sided affair. The Anglo-Saxon leader,

Brithnoth, was soon felled by a couple of javelins and the story goes that even as his head was being joyfully hacked off by his adversaries, it was still mouthing praise to the Almighty for having enjoyed a good life. The Vikings had a habit of making drinking vessels out of the skulls of their vanquished enemies but history does not record whether or not Brithnoth's head was put to such use. He was a big man because what is supposed to be his skeleton with a lump of wax standing in for his head was found when repair work was being done at Ely Cathedral in 1769.

Maldon is a name of Saxon origin and means something like 'crosshill' which perhaps means that a cross was erected in the area on a hill and was a well-known landmark. It is the lowest point at which the Chelmer and Blackwater could be bridged. The thirteenth-century All Saints' Church has the only triangular tower in England. A wall monument inside depicts Thomas Cammocke, his two wives and his grand total of twenty-two children. He eloped on horseback with his second wife, hotly pursued by her outraged father, who was also his employer. Desperate to escape his wrath, they leapt into the river and made slow progress against a fast-running current. Somehow they managed to reach the other side out of reach of the father who was still shaking his fist and uttering outraged imprecations. Then, curiously, he relented, recognising the depth of the love that had caused them to take such desperate measures and the courage they displayed in taking to the river. Soon Cammocke and his lady love, Frances, were married and the father, who turned out to be an absolute pussycat, proudly gave his daughter away. She was in good hands. Cammocke became a wealthy man responsible for various philanthropic acts which benefited the town. Buried in an unmarked position somewhere inside the church is Edward Bright, who died in 1750. At that time he was believed to be the biggest man in the country. A special derrick had to be devised to lower him into his last resting place. St Mary's has a Norman nave.

A piece of completely inconsequential information is that in the seventeenth century the town gained its first Nonconformist minister. His name was Joseph Billio and he was such a frantically energetic man that he gave his name to an idiom of the kind with which the English language is so richly adorned. This is 'doing things like billio'.

The Moot Hall was built in the fifteenth century and is a red-brick tower which was for long used for municipal purposes. A major benefactor of the town was Thomas Plume and in the early eighteenth century he established a library of 6,000 volumes on the site of St Peter's church, all of which had been demolished with the exception of the tower.

A railway reached Maldon in 1848 and the intention was to develop the harbour especially for agricultural goods. The company that built the line soon went into receivership and was taken over by the Eastern Counties Railway who did not, however, proceed to develop the harbour or dredge the Blackwater; both projects which they had earlier indicated were part of their plans. So Maldon was left to slumber on. It is now a minor shopping and residential town with plenty of quiet attractions for visitors who did not want the bright lights. Maldon is a good place for simply pottering about lazily and doing very little.

Just north-west of the town are some remains of Beeleigh Abbey, largely incorporated into a private house. This was a substantial establishment belonging to the Premonstratensian Order. The church has gone but incorporated in the house are some of the conventual buildings such as the chapter house and undercroft.

Heybridge, just across the Blackwater, is or at least was a kind of industrial suburb of Maldon with wharves and industries as well as the entrance to the River Chelmer, canalised late in the eighteenth century. Maldon used to be renowned for its oysters and it is still celebrated for its sea salt, said to be the best there is. Salt has been extracted locally since at least the time of the Normans (Domesday mentions forty-five salt pans in the vicinity). The crystallised sea salt is a highly regarded condiment.

Maldon District Museum is in Mill Road and the Thames Sailing Barge Heritage Centre is on the river at Cook's Barge Yard. The Thames spritsail barge is a thing of beauty and also of great versatility. It has a flat bottom, is 80 feet long and weighs in at 150 tons. When in commercial use, it had a crew of two and was equally at home butting through the choppy coastal waters of the North Sea, taking on cargo at some sooty warehouse at Wapping or gliding serenely along a shallow tidal creek in Essex some miles inland from the sea. They even have an ingenious way in which the mast could be lowered to pass under bridges. In their day they were unglamorous and hard-working – and also demanding task-masters. It is good that some are preserved and are still seaworthy. Maldon will forever be associated with the 'stackie'. These were a variation on the sailing barge built flat and broad so that they could penetrate into the shallowest of inlets and load up at the water's edge with virtually a whole haystack. At the same time they were still sufficiently seaworthy to sail up the Thames estuary and offload there, helping to provide the Metropolis with the fodder so desperately needed for the vast numbers of horses that provided the main motive power in its streets.

Northey Island lies at the head of the Blackwater about 2 miles east of Maldon. It is connected to the mainland by a causeway. Much of the island is covered at high tide but in the past it was intensively farmed. Northey is a Site of Special Scientific Interest.

East of Northey Island is Osea Island. There is a good anchorage for yachts. The island has long been inhabited and for much of the time it was used largely for sheep pasture. However, in 1903, F. N. Charrington, a scion of the former London brewing company and an enthusiastic temperance reformer, bought the island. He spent a lot of money in preliminary work for his brainchild, which was to be a model town on the island, well laid-out and with every modern facility except any pubs or shops selling alcoholic drinks. This scheme did not come to fruition but he turned his own house on the island into a retreat and refuge for 'gentlefolk' who had become addicted to alcohol. This noble and well-intentioned enterprise was less successful than he had hoped for. Such is the deviance of which the human brain is capable that the well-to-do residents of the retreat developed a mutually beneficial arrangement with local boatmen. This involved the latter regularly ferrying beer and spirits across from the mainland and secreting them in an agreed hiding place, being well-paid to do so.

Bradwell-on-Sea

Those rarefied souls tempted by a hermit's way of life might be drawn to the sequestered St Peter's chapel, about 2 miles beyond Bradwell, itself a remote enough spot close to the sea. There is not even a road to this tiny building, the full name of which is St Peter's-on-the-Wall. The wall is the sea wall. This simple building is

one of the oldest places of worship in England, having been founded in AD 654 by St Cedd, a missionary from Northumbria. The Romans had been here before him and had a fort. This was manned by North African auxiliaries – goodness only knows what they must have thought of the place. St Cedd used stone from their fort for the fabric of the chapel. They called the place Ithancester and used it as a place to keep watch for raiders approaching from across the sea. This tiny building was used as a barn for centuries but was never deconsecrated and an occasional service still takes place. The presence of a former apse can be made out.

It is the loneliness and isolation of places like this that made them so attractive to the smuggling fraternity. The Essex coast was flat and had many creeks and inlets penetrating far inland. Ships would have come across from the Continent and transferred their contraband cargoes close offshore into the small, shallow punts that were so handy for moving about the dense networks of largely tidal channels. The goods would then be offloaded again and usually stored nearby until they could be taken inland for sale. What was handy about Essex was that despite its remoteness, it was actually close to London, the sheer size and accumulated wealth of which meant that it was inevitably the major and most lucrative market particularly for the highly organised and well-financed gangs of the eighteenth century. Their activities did not preclude smaller gangs of smugglers who largely sold their contraband to local people. However, woe betide smaller gangs if their operations in any way conflicted with those of the major gangs.

Bradwell had a long history of smuggling and as early as 1361 local men were accused of 'owling'. It is often overlooked that smuggling was a two-way process and that huge amounts of raw wool and later of made-up cloth was exported without paying taxes. Again Essex was well-placed for handling the woollen goods produced in the southern parts of the county. St Peter's at Bradwell was frequently used for the storage of contraband.

Bradwell Chapel.

Burnham-on-Crouch

A small town famous at one time for its coastal barges but now for its yachting associations, for oysters, smuggling yarns and long walks along the riverside wall. The Quay is a mixture of colour-washed houses of the kind one imagines being occupied by grizzled old sea-dogs and there are boat-builders' yards, clap-board cottages, old inns and an entirely appropriate aroma of ropes, tar and salt water. Burnham is actually 6 miles from the sea but like some of the other places we have mentioned, despite being away from the coast, its whole *raison d'être* is unquestionably nautical. The Museum is at The Quay.

Burnham was the natural centre of the salty marshland to the east and obtained a charter for a market in the fourteenth century. The harvesting of oysters used to be a major local industry. Unlike some of the towns we are looking at today, the coming of a railway to Burnham killed the small amount of coastal trading that the town had enjoyed for centuries. Burnham is the major settlement of the Dengie Peninsula which is the name for the low stretch of London clay which forms the land between the River Crouch and the Blackwater. The church is somewhat away from the town. A tablet records Dr Alexander Scott who was the incumbent of nearby Southminster and the chaplain aboard HMS *Victory* when Nelson was struck at the moment of what should have been his greatest triumph. He ministered to him in his dying moments.

The town attracts mild ridicule as a place where brash East-Enders from London who have risen from rags to riches without recourse to grace or style, like to go to show off their yachts and other evidence of their ability to consume conspicuously. A song called 'Billericay Dickie' has a verse which goes like this:

> Oh golly, o gosh, come and lie on the couch
> With a nice bit of posh from Burnham on Crouch.

Martello Towers

A feature of the southern part of the East Anglian coast is the Martello tower. The author felt that it was worthwhile to say something more about these curious characteristic and characterful buildings.

In its long and eventful history, England has often faced the threat of invasion but time and again, her island situation has been her saviour. One of the occasions when the threat of invasion seemed greatest was in the late eighteenth and early nineteenth centuries when England stood almost alone facing the mighty empire being created by Napoleon Bonaparte.

One response of the British Government was to strengthen its coastal fortifications. This work included a series of bombproof gun towers erected along the coast from Aldeburgh in Suffolk to Seaford in Sussex. They were built between 1805 and 1812 and were known as Martello towers. Some of these curious buildings survive, standing like upturned flower pots along the coast. In some senses their folly-like appearance is quite fitting for although they were built at an enormous cost, the towers were never

used for their intended purpose: they never fired a shot in anger against the dreaded French, or anyone else for that matter.

In 1793 France declared war on England. Nine years of fighting followed with a brief cessation of hostilities in March 1802 but the peace was short-lived. In May 1803 hostilities resumed and England faced the very real threat of invasion. Napoleon Bonaparte, the self-proclaimed Emperor of France and *de facto* ruler of half of Europe, now concentrated on plans to invade and conquer this defiant but puny country. He meticulously studied every option for crossing the Channel, and in 1803 he even ordered the Bayeux Tapestry to be brought to Paris in an effort to gain inspiration from this, the most famous representation of a successful invasion of the hated England.

By 1804 he had amassed a mighty army of over 130,000 battle-hardened troops in towns along the French coast near Calais; he then waited for the moment to strike. To transport this great army and all its equipment across the Channel, Napoleon assembled a fleet of over 2,200 flat-bottomed barges, fishing boats and other small craft. Such was his confidence – some would call it *braggadocio* – that he had a medal struck to commemorate his successful invasion of England. For all this, Napoleon was sensible enough to realise that the success of this mission depended on his gaining control of the Channel long enough and in the right weather conditions to enable his vast fleet of small vessels to make the crossing. He is purported to have said, 'Let us be masters of the straits for six hours and we shall be masters of the world.' That, of course, was the rub. Standing in his way was the wooden wall of England – the British Royal Navy – which was powerful enough to maintain a constant and effective blockade of the French ports. The British Government did not underestimate the French threat. They rightly had great respect for the hardened veteran soldiers who made up Napoleon's military elite. They knew only too well how critical the Channel was and what would happen if the hold of the Royal Navy was to be dislodged for even a few days. For this reason, the idea of strengthening the shore defences at what were thought to be the most vulnerable points seemed a good one.

Of course the British could not be certain of Napoleon's precise choice of a landing point but it was reasoned that any invasion fleet would need flat open beaches backed by flat, low countryside and to come by as short a sea route as possible. In fact, this narrowed down the possibilities considerably because much of the Channel coast consisted of cliffs which were sizeable enough to render assault extremely unlikely. Additionally, any invading army would want to land reasonably close to London because the capital would inevitably be its major goal and because an invasion force would want to minimise the distance over which it might have to fight and maintain supply lines in a hostile, aroused country. A lengthy sea-crossing was not desirable for vessels of shallow draught not designed for deep-sea operations nor for the troops themselves who would probably be suffering from seasickness. Therefore the quickest and shortest routes were the most likely. Again a quick crossing was imperative because that would reduce the time the Royal Navy had to muster its forces against the invasion fleet.

As early as 1793 some extra fortifications had been built such as additional gun batteries at Dover Castle and extra fortifications at Romney Marsh but it was now decided that some more robust and permanent form of coastal fortification was

needed. It was considered that the most vulnerable areas were along the South Coast between Folkestone and Beachy Head and to the north-east along the coasts of Essex and Suffolk.

In the summer of 1803 Captain William Ford, a young officer of the Royal Engineers proposed a scheme for a chain of small towers or forts designed to be difficult to hit from the sea and built at such intervals along the foreshore that a single gun on top of two adjoining towers could protect the beach with crossfire at vulnerable points. The concept of coastal defences of this sort was not exactly new. Fortified towers had been used for centuries and in the Mediterranean they had long been used to combat piracy and to protect places of strategic importance. There is an irony in the fact that Captain Ford apparently got the inspiration for his proposed scheme from a French-built structure. He, and many other military engineers, had been highly impressed by the performance of a fortified tower on the island of Corsica – the birthplace of Napoleon, this being another irony – which had withstood heavy bombardment by Royal Navy vessels in 1794. The tower was situated at Mortella Point in the Bay of Fiorenzo. With just one 6-pounder and two 18-pounder guns and a garrison of thirty-eight, this tower had repulsed an attack by HMS *Fortitude* of seventy-four guns and a frigate, HMS *Juno* of thirty-two guns, both of which were forced to withdraw with sixty casualties and serious damage. The tower was eventually captured but only after two days of continuous bombardment from land forces with heavy artillery at almost point blank range and after a fire had broken out inside, forcing the occupants to evacuate and surrender. Captain Ford was of the opinion that if one tower could drive off two heavily armed warships, a series of such towers would provide an effective defence against a lightly-built French invasion fleet, even one operating gunboats.

Ford drew up a plan and submitted it to his Commanding Officer, Brigadier-General William Twiss, a capable and open-minded man who elicited a favourable response when the proposal was shown to senior officers in the Royal Engineers. Very quickly, the Duke of York, Commander-in-Chief of the Army and the First Lord of the Admiralty, agreed to the plan which next had to be submitted to the new Prime Minister, William Pitt. He gave his approval in October 1804. Work on the English towers started early in 1805 under the direction of the Board of Ordnance and the Royal Engineers. Twiss was given the responsibility for building the towers. The specification described them as, 'bomb-proof towers for the defence of the coast'.

Each tower needed half a million bricks which is the rough equivalent of fifty modern three-bedroom houses and these were initially shipped down the Thames from brickworks in the London area. A massive building plan was embarked upon. The resulting structures very quickly gained the name of 'Martello Towers', a corruption obviously of the original tower at 'Mortella'.

Napoleon's invasion plans in the autumn 1805 were thrown into total disarray when the French suffered a crushing naval defeat at the Battle of Trafalgar in the autumn of 1805. This wrecked Napoleon's plan which had been to lure the Royal Navy away from the Channel and defeat them in one major battle which would rob them of their control of the Channel. This would have provided the opportunity for the fleet of vessels carrying the invasion force to slip across the Channel when the weather was right.

However, Trafalgar provided demonstrable evidence of Britain's naval superiority and Napoleon, grinding his teeth in exasperation, was forced to accept that there was no immediate prospect of the invasion of England. The massive forces of men and materiel encamped along the north French coast were withdrawn and deployed elsewhere. On a grand historical scale we can see that Trafalgar was an extremely large nail in the coffin of Napoleon's schemes for world domination because it meant that Britain's control of the seas allowed her to continue to blockade France and to move troops and supplies to other spheres of war with almost total impunity. Equally, some time later, Napoleon made his ill-judged decision to march on Moscow and thereby taking on not only the Russian army but their deadly allies, Generals 'Janvier' and 'Fevrier'.

It is to the credit of the British for once that although they realised that the immediate threat of invasion was over, they also understood that they could not afford to be complacent. For this reason, they continued to commit considerable resources to building the line of forts which had originally been decided upon, even if we can now see that such towers would actually go on to be white elephants for two reasons. The first was that, although hugely expensive, they were never actually used to repel invaders. The second was that the onward march of technology in gunnery, rockets and ballistics rendered them obsolete as effective tools of defence within a very short time.

Seventy-three Martello towers had been erected along the South Coast by 1808. They were supplemented by two circular redoubt forts at Dymchuch and Eastbourne which served as supply and control points. The towers were numbered 1–73 from east to west. Work then commenced on the East Coast chain of twenty-nine towers in Essex with, in addition, a powerful circular redoubt at Harwich. The East Coast towers were built slightly larger than their South Coast counterparts, with extra windows and greater capacity for additional armaments, but the general design was much the same. The East Coast towers were given letters starting with 'A' at Brightlingsea in Essex and finishing with 'CC' near Aldeburgh in Suffolk. This last-mentioned structure was the odd-man out in the chain of forts; it was placed 10 miles away from tower 'BB' and its quatrefoil design was totally different from any other Martello tower.

By the year 1812, the work was completed but, as is the way of things, the cost of the project escalated as it proceeded. The overspending on the towers brought forth much criticism from MPs and others who doubted the usefulness of the project. William Cobbett, who systematically lambasted those things that he disapproved of, and they were many, described them as 'piles of brick in circular form ... I counted upwards of thirty of these ridiculous things'.

With the exceptions mentioned, they followed the same design. They were over 30 feet tall with stuccoed walls curved and tapered to deflect cannon shot and to provide a wider angle of downward fire. The outer walls were slightly oval with the inside almost circular, the thickest part of the wall facing the sea. The thickness of the walls was up to 13 feet on the seaward side and 6 feet to the landward. To make the towers even more resistant to bombardment, the bricks of which they were built were bonded with hot lime mortar which gave the walls a steel-like hardness. The ingredients of hot lime mortar were lime, ash and hot tallow.

All the towers had three levels. The entrance was at first-floor level and was reached by a ladder which was pulled up should the tower come under siege. Twenty-one of

the towers were surrounded by a dry ditch or moat and were entered via a drawbridge which was raised and lowered by chains. The first floor was divided into three sections to form living quarters for a garrison of twenty-four men and one officer, the officer having almost as much space for himself as the rest of the men put together. The remainder of the space on this level was used as a storeroom. The ground-floor basement was approached by a ladder below a trap door. It was here that provisions, ammunition and gunpowder were stored, lowered down by an overhead pulley. To alleviate the danger of explosion, the magazine was lit by a lantern behind a glass window.

The upper floor – the gun platform – was reached by a stairway built into the wall which ran from the first floor. Mounted on the roof was a 2½-ton cannon which could fire a 24-lb shot a mile out to sea. The gun was mounted on a central pivot which allowed it to be manoeuvred so as to fire in any direction. The gun on the top of the tower only needed a crew of two while the rest could stay under cover and help with hoisting up the ammunition. The East Anglian towers had three guns. Rainwater collected on the gun deck passed down a lead pipe to fill a cistern in the basement and ventilation was provided by shafts in the wall with vent holes on both floors.

These towers were manned by trained soldiers of the Royal Artillery. Any vessel approaching could come under the attack of several of these towers at once at the points where they were concentrated and it should be remembered that a static gun platform such as a Martello tower provided a much more stable basis for artillery than a ship. In simple terms this means that trained gunners in one of these towers were much more likely to be able to hit a ship bobbing up and down on the waves than vice versa. Any forces that landed would have to struggle over shingle while under fire and this would not be easy. In recognition of the towers' defensive capabilities, the French called them 'bulldogs' and conceded that they presented a formidable challenge.

In the event, Napoleon's invasion never took place. The largest and most costly coastal defence system in English history remained waiting for an invader who never came. However, they did find other uses. Some became official homes for retired soldiers and some were used as naval semaphore stations. They were also used as bases and lookouts for the forces used to counter the smuggling trade which reached its peak in the period after the French wars ended. Later the Coastguard Service was established and the Martello towers served the same sort of purpose for this new force. In 1940 history repeated itself with a very potent threat of invasion this time by Hitler's armies. So it was that more than 130 years after they had been built, the Martello towers were requisitioned by the War Department for possible use against German invaders. Some became bases for the Home Guard and had searchlights and anti-aircraft guns fitted.

Since that time, the number of Martello towers has declined. Many have succumbed to coastal erosion, a few have been demolished, albeit with considerable difficulty, some have been converted into private homes and a few are museums. So it is that of the total of 103 towers built along the South and East Coasts, only forty-three remain today.